American Views

GLORIA-GILDA DEÁK

American Views

Prospects and Vistas

With an Introduction by James Thomas Flexner ~ The City in the American Land

A STUDIO BOOK

The Viking Press and The New York Public Library

New York

Publication of this volume was assisted by a grant to The New York Public Library from The East New York Savings Bank.

The prints and drawings from the Prints Division of The New York Public Library were photographed by Alfred F. D'Addario of the Library's Photographic Service.

Designed by Jacqueline Schuman.

Library of Congress Cataloging in Publication Data
Deák, Gloria-Gilda, 1930–
　American views.
　(A Studio book)
　Includes bibliographical references and index.
　1. United States in art. 2. Art, American.
　I. Title.
N8214.5.U6D42　704.94'9'973　76-40041
ISBN 0-670-12091-X

Acknowledgments

The publication of any book is a collective effort, and this book began by collecting the talents of Miss Ella Milbank Foshay. Her erudition, judgment, and open optimism are reflected in every page. A special appreciation must go to the Keeper of Prints, Miss Elizabeth E. Roth; to Mr. Robert Rainwater and Dr. Roberta Waddell, Prints Specialists; and to Miss Barbara Bienkowski of the Prints Division staff. A desk, a shelf, and weekly doses of encouragement were provided by Mr. Donald F. Anderle, Chief of the Library's Art and Architecture Division; each member of that staff, in particular, Mr. David B. Combs, was unfailingly helpful.

Appreciation also goes to a large number of other colleagues in the Library: to Mr. Edward E. White, Jr., Chief of the Public Relations Office; to Mr. Joseph Mask of the Stack Maintenance and Delivery Division; to Mr. William L. Coakley of the Editor's Office; and to every member of the staff of the Rare Book Division, the Local History and Genealogy Division, the Manuscripts and Archives Division, and the American History Division. The Library itself deserves long mention. A stately pleasure dome of learning, it appears to have everything ever printed nestling within its walls. One feels exhilarated and privileged to work here.

Thanks go to friends outside the Library: Mr. A. Hyatt Mayor, Professor Richard B. Morris, Mrs. Zoya Kaplan, Mr. Richard Whelan, and Mr. Robert Rainwater (this time as friend). Appreciation goes in abundance to the members of my family, István and Éva Deák.

A very special acknowledgment is extended to The East New York Savings Bank and to the Chairman of its Board of Trustees, Mr. John P. McGrath. A generous grant from the Bank assisted in funding this volume and made its publication possible. This gesture was yet another expression of public service by the Bank in support of one of the nation's distinguished cultural institutions, and the Library is proud to claim the Bank as a friend.

G.-G. D.

Preface

The historical images chosen for reproduction in these pages offer a modest introduction to the many treasures in The New York Public Library's print repository. There are over 150,000 engravings, drawings, and lithographs housed in the Prints Division, available to all who are drawn to them out of curiosity or scholarship. Familiar and very rare items, representing the output of artists both famous and forgotten, are among its holdings. Here one can find works by Albrecht Dürer, Lucas Cranach, Pieter Breughel, Jacques Le Moyne, and fellow visionaries from the fifteenth century onward: Whistler, Utamaro, Picasso, and Cassatt among them. In portfolios, protective mats, mammoth drawers, and bound volumes, the works of six centuries of artists and craftsmen present a comprehensive spectrum of the wide world of printmaking through woodcuts, copper engravings, aquatints, mezzotints, etchings, steel engravings, linoleum cuts, lithographs, chromolithographs, and the variations ad infinitum that are constantly coaxed from these basic techniques. Keyed to the perfecting of multiple impressions, all of these forms of prints enlarge the scope of art and augment the possibilities for its prolonged enjoyment.

Prints that serve both as documents and as art are featured in this volume. In a sense all art is documentation, but some art, by nature of the artist's purpose, is distinctly so. When William Birch, John Hill, and Robert Havell, for example, prepared prints of the American cities they lived in or visited during the eighteenth and nineteenth centuries, they created by their efforts a high form of imaginative topography. The fund of American iconography to which they and earlier artists contributed allows us to assemble a visual narrative of the nation's development, though only a small part of that material— leaping over decades and lingering in others—can be presented here.

Two notable donations have added to the wealth of historical views in the Library's possession: the collection of Amos F. Eno, whose assemblage of over 450 prints celebrates the growth of New York City, and that of Isaac Newton Phelps Stokes, architect and historian, whose larger collection embraces four centuries of America's history. The Stokes gift is rich in colonial maps and in early views of the nation's cities. Mr. Stokes not only ferreted out treasures of Americana, but he went on to a careful study of the works in his collection. With the collaboration of Daniel C. Haskell, he published his findings in *American Historical Prints*, a scholarly catalogue published by the Library that is now the standard reference work in its field. The 1933 edition is the nucleus of a much larger Library publication now under preparation by the author of this volume. The new, fully illustrated catalogue will offer a still wider spectrum of the historical views in the Library's print repository.

<div align="right">G.-G. D.</div>

Contents

The City in the American Land

James Thomas Flexner

During the first two hundred and fifty years of settlement on this continent, community building was the basic physical activity of the American people. Every area wished to grow in population and importance. Of this activity the city was the ultimate expression.

This book reminds us that all American communities, however impressive now and wherever situated, were in quite recent history small. Actually, the cities were once tinier than can here be shown. Before a picture is created and preserved, there must be a conviction that what is depicted is worth memorializing. The early inhabitants, however, cherished a growing community not because of how it then appeared but in anticipation of what they hoped it would soon be. And in any case, the basic requirement for the creation of an engraved image—the existence of a market for a considerable number of impressions—was hostile to beginnings. Thus our earliest pictures of nascent cities show them at least a generation after the first ground was broken and the first house built.

American history as it is written and taught tends to obscure the unity of the process according to which our communities grew. We get the impression that the frontier emerged as a new phenomenon when settlement crossed the Alleghenies after the Revolutionary War. Actually, the "Wild West" opened on the Atlantic coast when the very first settlers lighted their very first fires on American soil. Thence, the frontier began its march to the Pacific, moving most rapidly along the banks of rivers, temporarily halted where mountains rose. Different areas and climates demanded different solutions to immediate problems—some settlers had to battle to conduct sunlight to the ground through primeval forests, others to find shade and wood in a parched land—yet in every region the progression from small community to large was in essence the same.

Although much celebrated in song and story, the front wave of settlement was likely to be ephemeral: the true pioneer was more an adventurer than a builder of institutions. But we should not visualize him as an adventurer in the romantic sense. Men who came to the frontier to test themselves, see strange things, feel new sensations were usually visitors from more stable areas who would return east to rehearse their stories to shining eyes in warm drawing rooms. The true frontiersman was a poor man of limited outlook who had often failed in more civilized pursuits. He achieved satisfaction from the rigors around him in exact proportion to his temperamental aversion to the institutions of organized society. When settlement began to collect around him, the archetypical frontiersman moved on to a farther frontier where social amenities were not required or even observed.

Left behind were those of the original inhabitants who had least enjoyed and been least fitted for original pioneering. They became part of the second wave of settlement into which their children com-

pletely merged. It was this wave that built roads, established banks and law courts and libraries, that put on the ground prepared by the pioneers the true seeds of community growth.

Once a community was rooted, the issue was how large it would grow and what functions it would serve. Villages separated themselves off from farmland, and some of the villages expanded, upon occasion slowly, upon occasion with explosive violence, to become cities. On a small scale the location of the center could be altogether determined by the settlers, as when the location of a church established a village, but the larger the eventual growth, the more it was influenced by geographic absolutes. The most ubiquitous of these, during the period of time this book covers, was the behavior of water. If water concentrated itself into a considerable stream and then dashed down a declivity, there was a site for mill wheels—industry small or large was beckoned. Even more influential was water broad enough to be navigable and quiet enough to be navigable in two directions.

Before the invention of the railroad there was no practical way to move large cargoes except in boats. (Whiskey became a very important commodity beyond the Alleghenies at the end of the eighteenth century because only when distilled did grain become compact enough to be carried across the mountains in pack trains.) But navigable water was not by itself enough to make a site for a city. The river had to go from a source of marketable goods to a place that had access to the market. And since a boat that sailed by a community without stopping contributed nothing, there had to be some geographic reason for the shipping to come to a halt. Prosperity would be best served if cargoes had to be unloaded: changed from one size of boat to another, or between water and land transport. Then the local inhabitants could, if they had what was known as "git-up-and-git," build warehouses. They could reship goods to other parts of the world, or they could buy wholesale and sell retail to country merchants. Competition sometimes arose between sites that had the same (or almost the same) advantages, but without cooperative geography, no true urban growth was possible.

Cities thus grew up where rivers entered the ocean through harbors in which merchant ships could easily unload and remain safely anchored during storms; or at the fall lines of rivers, where navigation by ships had to cease. Boston, New York, San Francisco, New Orleans were great ocean harbors. Hartford and Philadelphia were examples of cities that grew up at the farthest point that ocean vessels could penetrate upward on rivers. The various cities on the Mississippi and the Ohio had to wait for true expansion until steamboats were invented that could navigate up the river system as well as down.

Although railroads, after they had taken over in the mid-nineteenth century, fostered some cities of their own and killed off others, in areas where urban patterns were already well established (as on the eastern seaboard) the rails served concentrations of population that already existed. In fact, the greatest metropolis of all was handed on to the railroads by a previous invention.

At the beginning of the nineteenth century New York was a secondary center, far behind Philadelphia and Boston in riches, in population, in political and cultural influence. It had been occupied by the British during most of the Revolution and was suffering from an aristocratic land-owning system that had descended from grants made by Holland when New York was New Amsterdam. The lordly Hudson, so flat that Atlantic tides pulsed all the way up to Albany, ran nowhere but to newly opened areas on tributary rivers or to the northern wilderness. However, an undeveloped opportunity existed: if a boat turned left onto the Mohawk River, and then was carried across a narrow piece of land, and then proceeded through the tortuous but still flat waters of Wood Creek, it came out on the Great Lakes.

And access could be achieved from the Great Lakes to the river system that dominated the central valley of North America.

From the time that numbers of people began moving across the Allegheny Mountains, it was realized that any eastern center could achieve unbounded prosperity if it could open water transportation between the central valley, the mature settlements on the eastern seaboard, and a comfortable outlet to the Atlantic Ocean. George Washington tried boldly to create a canal along the Potomac River which would bring world trade to Mount Vernon's doorstep, but the Potomac flowed too steeply down mountainous declivities. Nature had put in her silent and irrevocable vote for the almost level route from the Great Lakes to the Hudson. The opening in 1825 of the Erie Canal finally carried western water to the city of New York. New York was elevated overnight into the great American metropolis, achieving such hegemony that, although canals have become obsolete and inland water travel has almost died, it is still the economic and cultural center of the United States.

Since people get bored without division, envy, and distrust, there has long been a tendency in American life to postulate a fundamental conflict between urban and rural society. It is difficult, however, to say where one ends and the other begins. How large does a center have to be before it becomes an enemy of the hills and fields? Actually, although there are differences of function and interest, there is no more basic a conflict between city and country than there is between a man's arms and legs.

The development of centers—village, town, local city, regional city, national city—has been as much an integral part of the growth of America as the spread of rural areas. And always the function of centers has been the same. They have never been economically or culturally self-sufficient. They have received impulses from the world around them and pulsed them out again in a synthesized form. The difference between the large centers and the small is that the former carry out this process on a larger scale.

This book exemplifies the situation. It contains illustrations of cities at various stages of their development from all over the American continent. But the originals of the pictures are the more usable because they are gathered in one place, The New York Public Library. The Library is, of course, physically in New York, but it is far more than a New York institution. Because of the resources of the great city it inhabits, The New York Public Library is a world center, gathering in and making available materials on paper not only from its own natural hinterland (which is the entire United States) but from all the world. And a student anywhere in America can have access at no charge to this local foundation that is also a great national treasure.

Centers not only draw together ideas and commerce but they draw together people. The fact that I was actually born in New York City is, if mentioned, usually a source of surprise to my New York neighbors. I cannot claim, however, to be a New Yorker in the sense that many of my summer neighbors in northern Connecticut are products of their region. My mother was born in Maryland and my father in Kentucky. They came to New York in middle age, when my father was called to create and head an institute for medical research.

American cities have always drawn to them people from their hinterland: the larger the hinterland, the greater the area from which the urban population comes. New York draws from all over the nation

and also from Europe because it opens so many opportunities to those who wish to rise in so wide a choice of endeavors.

The outlanders who come to a city, whether it be large or small, are, of course, changed by their new environment. The most important changes are caused by a mingling together, from day to day, often from moment to moment, of men and ideas from many sources. In presenting these, the city functions as a container being perpetually refilled. How much do traditions that have risen within the city itself impinge? The answer seems to be, at least in the United States, that the less extensive the hinterland a city serves, the more it presents and imposes a specific flavor.

The contrast between Boston and New York presents an apt example, since the very geographic happening that made New York the national city isolated Boston. The route of the Erie Canal, as it proceeded down the Mohawk River, pointed directly at the New England city, but water could not flow that way. The Berkshires stood in the path. And so the route turned, almost at a right angle, south into the Hudson River. That turn separated Boston from the whole western expanse of the continent. Losing all claims to being a national center, Boston became (except for the nearby universities that have established their own hinterland) an epitome of one admirable aspect of American culture.

What happened to New York when it was thrown high as the national city can be extrapolated from the history of American painting. It was to be expected that the city would produce a school of artists who were, like itself, national in their influence, but it might have been also expected that the school would reflect in its outlook and subject matter the rise, the glories, and the squalor of urban life. In fact, the New York school, which emerged almost simultaneously with the opening of the Erie Canal, was less concerned with urban taste than was the art that had reigned in the smaller and more local earlier New York. The megalopolis created America's first school of landscape painting, the now famous Hudson River School.

What seems a paradox is not a paradox at all. The trade of New York had previously been a swapping back and forth with Europe, and the leading dwellers had been much more familiar with London than any of the communities to the west of them. But now New York had become the capital (except in politics) of a vast, rural continent. The change brought flooding in a new population. Since the city had become in effect a huge rural store, men trained in rural storekeeping became the rising merchant class and were soon rivaling and even pushing to one side the former leading families. And also into New York came painters who had communed with Nature humbly, reverently, and at firsthand. The contact of country-born artists with country-born patrons in a city that was, like a burning glass, concentrating the rays coming in from a still-rural America naturally created a landscape school.

The artists spent their summers hiking through wild nature, filling their sketchbooks with material to be painted. But their actual canvases were created in the city. Working side by side in a few studio buildings, they solved practical and philosophical problems in unison, creating that communal achievement which is a school of painting. But this was only one aspect of the advantages presented to the painters by urban life. Artists in other fields—writers and sculptors and musicians and architects—dropped in of an evening. Through proximity the painters were enabled to educate (and be educated by) a group of patrons. They were brought into contact with informed leaders of many aspects of American and international life. And they had access to media of communication which made their reputations and their works better known even in the counties whence they had come than would have

been the case had they not moved to the national city. Although none of the Hudson River School artists was born in New York and none painted the city, the school could not have existed without the city.

It is tremendously important for our understanding of American life to take into serious consideration the phenomenon this exemplifies. Cities are not inhabited by a special race; they do not spout ideas alien to their rural neighbors. Cities are part of the countryside, centers where the feelings and conceptions are gathered in and concentrated. It is this concentration that establishes culture. If American cities are allowed to fall apart, they will carry down with them American culture.

Dates used in the headings of the essays and in the captions are dates of depiction unless otherwise noted. The number following the period in the measurements in inches refers to sixteenths of an inch, not decimals (e.g., *10.4 inches* should be read *ten and four-sixteenths inches*).

American Views

Fruitful Beginnings: Hospitality of the Indians

[Mayport, Florida], *1564*

In the sixteenth century, as America rotated east into the sun of European civilization, the Indians greeted their conquerors with grace. "We saw many people on shore making various signs of affection as they motioned us to them," reported Giovanni da Verrazano to his patron, Francis I of France, "and I saw a magnificent deed, as Your Majesty will hear." What His Majesty heard was of the hospitality of the Indians, extended to the Europeans who had landed weary and bewildered in a strange new continent.

Verrazano's voyage of discovery began on January 17, 1524, when he set out in great secrecy from Europe to locate a passage to Asia. Fifty days later he sighted the seaboard of an unnamed country. Beginning at a latitude of 34°, he made seven landings along the coast, dropping anchor in accommodating harbors from the Carolinas to Maine. The Florentine navigator reported all his experiences to the French monarch, and in a language fresh and direct gave us our first prose portraits of the Indians of the New World. He wrote of his landing in the waters of New York Bay with great enthusiasm:

> We entered only with the small boat in the said river and saw the land much populated. The people were like the others, dressed with the feathers of birds of various colors, and they came towards us joyfully, uttering very great exclamations of admiration, showing us where we could land with the boat more safely. We approached the land about half a league by the same river which made a beautiful lake of a circuit of about three leagues. They [the Indians] came in thirty of their little barges on this lake, going from one side to the other, and there were innumerable people passing now from one part of the shore, now to the other, in order to see us.[1]*

Within a few decades of Verrazano's visit, the French, under Charles IX, sent several expeditionary forces to Spanish-held Florida. Their mission was to create a haven in the dominion of the New World for a colony of French Huguenots. The first expedition, sailing under Captain Jean Ribaut, dropped anchor in 1562 at the mouth of the St. Johns River (Mayport) and farther north in Parris Island, South Carolina. This initial exploration of the coast was brief, but, before returning home, Ribaut managed to erect a fort and plant a

* The figures refer to the References, which begin on page 131.

marble column with the French king's arms in each of the two sites. The second expedition arrived in Florida two years later under the Huguenot sea captain René Goulaine de Laudonnière. This time an artist was aboard: Jacques Le Moyne de Morgues, whose task it was to record whatever he could of the new and exotic habitation, portray the appearance and customs of the natives, and map important navigational features. Le Moyne carried out his instructions in a series of mannered artistic drawings, and posterity reaped the double fortune of a visual and prose account of an historic journey.

As with Verrazano and his crew, the Huguenots were equally delighted by their encounter with the New World Indians:

> Laudonnière . . . went on shore with five and twenty arquebusiers . . . obtaining friendly signs from the Indians, who had gathered in crowds to see them. . . . After an exchange of presents had been made, accompanied by demonstrations of all manner of kind feelings, the chief [Athore] gave them to understand that he wished to show them something remarkable . . . He . . . conducted them directly to the island where Ribaut had set up on a mound a stone column ornamented with the arms of the King of France. On approaching, they found that these Indians were worshipping this stone as an idol. . . . Before the monument there lay various offerings of the fruits, and edible or medicinal roots, growing thereabouts; vessels of perfumed oils; a bow and arrows; and it was wreathed around from top to bottom with flowers of all sorts, and boughs of the trees esteemed the choicest. . . . This chief, Athore, is very handsome, prudent, honorable, strong, and of very great stature, being more than half a foot taller than the tallest of our men; and his bearing was marked by a modest gravity, which had a strikingly majestic effect. He had married his mother, and had by her a number of sons and daughters, whom he showed to us, striking his thigh as he did so.[2]

Le Moyne made forty-two drawings of his New World experience, and later in the sixteenth century engravings were made based on these drawings. Each of the engravings was published with a lively Latin narrative. Except for this gouache all the original drawings are now lost.

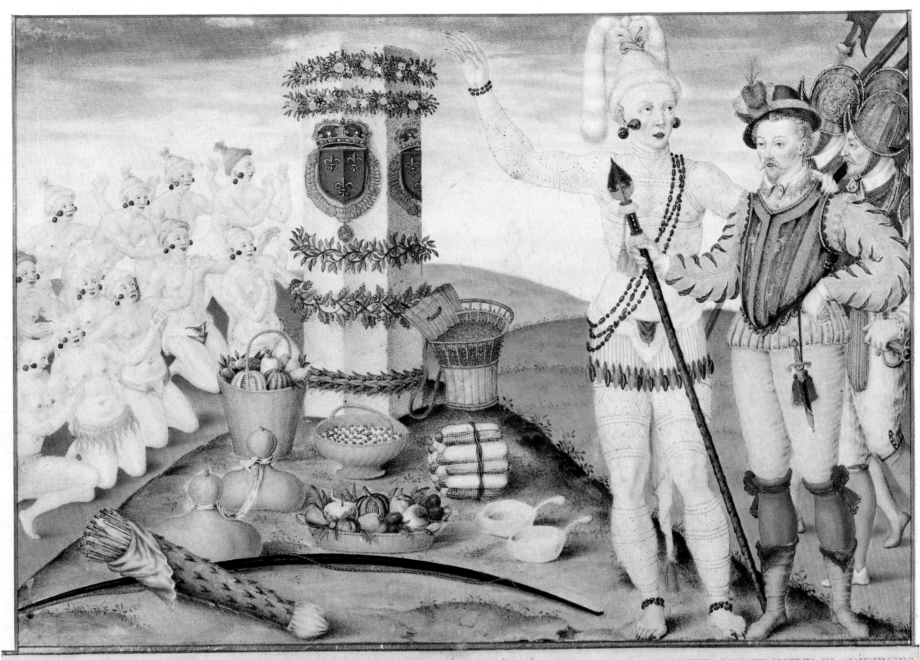

LAUDONNIERVS ET REX ATHORE ANTE COLVMNAM A PRAEFECTO PRIMA NAVIGATIONE LOCATAM QVAMQVE VENERANTVR FLORIDENSES

Jacobus Le Moyne dictus de Morgues ad vivum pinxit

LAUDONNIERUS ET REX ATHORE ANTE COLUMNAM A PRAEFECTO PRIMA NAVIGATIONE LOCATAM QUAMQUE VENERANTUR FLORIDENSES . . . [*the Latin title was not part of Le Moyne's work but was added much later; it first appeared on the sixteenth-century engraving based on his gouache and published by Theodore de Bry*].

Artist: Jacques Le Moyne de Morgues. Gouache painting on parchment. 1564. Size: 7 × 10.4 inches; 188 × 261 mm. Bequest of James Hazen Hyde, Prints Division, The New York Public Library.

The Town of Mannados

New York, New York, 1661–1664

Peter Stuyvesant and his countrymen were reasonably well settled in their transplanted Dutch city when this survey of southern Manhattan was made. From the artist's Icarian height we look down on the neat rows of houses, the intimate streets, the windmill, the governor's mansion, the star-shaped fort, and the gardens with their formal flower beds that graced the diminutive city. We can identify Broadway and Broad Street, two roadways born of the sea, making their ascent northward from the water's edge. The Dutch made a canal of Broad Street, digging it far up into the town. Colorful ships and billowing sails remind us how busy an artery of trade and travel the harbor has always been. Pleasure sloops side by side with the full-rigged vessels remind us, too, that Manhattan's waters were once a source of beauty and relaxation. The sloops can be seen in both the Hudson and the East rivers. The long wall joining these rivers was built by the Dutch to protect their city. Entrance at the eastern end of the wall was past a guardhouse and through a gate known as the Water Gate. That protective wall subsequently ceded its place and name, and indirectly its function, to Wall Street.

The Dutch were not successful in safeguarding their city despite the wall. The English had long had their eye on Manhattan, and, although England and Holland were at peace in 1664, King Charles II ordered five warships to cross the Atlantic and take possession of the island. There was little resistance. Because they were surrounded by English colonies, because there were poor defenses and a food shortage, and because, as the Dutch said, the city's foun-ders in Amsterdam had neglected and forgotten them, it was not possible to hold out. The British envoy accepted Stuyvesant's proposal for a treaty of surrender in order, as the Dutch governor said, "to prevent the effusion of blood, and to improve the good of the Inhabitants." At eight o'clock on the morning of August 27, 1664, the articles of surrender were arranged by the joint Dutch and English commissioners at Stuyvesant's own farm, the Bou-wery.

Soon after the takeover the conquerors were demanding an oath of allegiance to the British king. The Dutch, who had been promised the "liberty of their Consciences in Divine Worship" and the right to "Enjoy their owne Customes," were horrified. Objections and squabbles ensued, but there was little the vanquished could do. The burgomasters and schepens had no choice but to take the oath, and they even approved a letter to the Duke of York. In it they declared themselves fortunate that the Duke had provided them "with so gentle, wise and intelligent a gentleman" for governor as Colonel Richard Nicolls. They were confident that "under the wings of this valiant gentleman," the former Dutch city would "bloom and grow like the Cedar on Lebanon." Under Nicolls the city did prosper. His administration was marked by fairness and justice. It was most likely under his instructions that this survey of Manhattan, made by a Dutchman in 1661, was redrawn and embellished for sending to his royal patron, the Duke of York. The date on it is now 1664, and the Union Jack flies over the Dutch-built fort.

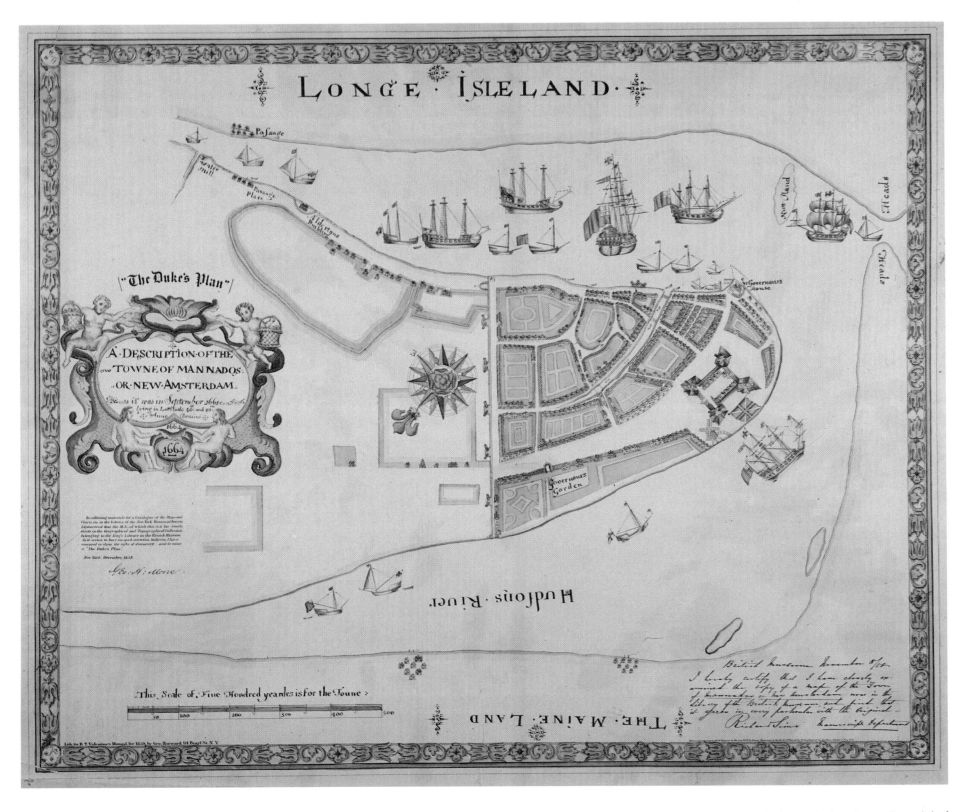

["THE DUKE'S PLAN"] A DESCRIPTION OF THE TOWNE OF MANNADOS OR NEW AMSTER-DAM AS IT WAS IN SEPTEMBER 1661 LYING IN LATITUDE 40DE AND 40M ANNO DOMINI 1664. LITH. FOR D. T. VALENTINE'S MANUAL, FOR 1859, BY GEO. HAYWARD. . . .

Artist: unknown; possibly Jacques Cortelyou. Lithograph based on the original Dutch drawing. 1661–1664. Size: 22.2 × 27.13 inches; 561 × 705 mm. Eno Collection, Prints Division, The New York Public Library.

Baltimore: The Early Town

Baltimore, Maryland, 1752

There were several Lords Baltimore involved in Maryland's history. George Calvert, the first lord, who petitioned the British monarch for the territorial charter, never visited the site, nor did his son. The third lord did. When he arrived from England, a boundary squabble with William Penn unfortunately caused him to recross the Atlantic in an effort to settle the controversy at home, and he never returned. By the time the town of Baltimore was founded in 1729, the first three lords were dead, and it was named, not after the fourth Lord Baltimore, but after the fifth. The sixth and seventh lords were also involved in Maryland's history and resumed the quarrel with William Penn's sons.

The name Baltimore is Irish. It was acquired by the Calvert family, along with the peerage, from a seaport in the County of Cork. A bird, the most melodious oriole in America, was given the name, and so was a railroad. When the Baltimore & Ohio was launched in 1825, it set Maryland's prosperity for the rest of the nineteenth century.

The fledgling metropolis of Baltimore did not grow in leaps and bounds after its founding on the west shore of Chesapeake Bay, despite its distinct advantage of having two outlets to the sea. When it was sketched by a town resident in 1752, it had a very rural aspect and almost all of it could be described in the keyed legend to the drawing. The most elegant house was the tavern kept by Mr. William Rogers near the northeast corner of Baltimore and Calvert streets; above it, on the elevated ground, rose St. Paul's Church. Fellow town residents felt that the artist ought to have included more shipping in the harbor: the

Philip and Charles, the brig belonging to Mr. Nicolas Rogers, and Captain Darby Lux's sloop, the *Baltimore*, were not enough to indicate the brisk shipping activity then taking place on the Patapsco River. In one month alone, remarked Thomas Griffith, "upwards of 69 wagons loaded with Flax Seed came to town."[3] That year, too, the tobacco inspection house was erected and the artist must have included it with enormous pride.

Though Baltimore grew in importance as a port of entry, it lagged in cultural activity as compared with its northern neighbors. To get in stride with Philadelphia, New York, and Boston, the first issue of *The Baltimore Weekly Magazine* was launched at the turn of the century. The new *Weekly*'s editor asked for the same kind of local support that permitted the many literary publications in the North to flourish, and, being convinced that a lot of local talent was there to be tapped, he put the facts straightforwardly:

> In the first two or three numbers, it must be expected that I shall not be expected to give the readers of the Magazine so much *originality* as will hereafter be in my power, when its circulation has become more extended, and dormant abilities aroused from their stupefaction. . . .[4]

The editor, John Colvin, must have been right about the dormant talent. Baltimore eventually became one of the chief educational centers of the nation and the distinctive north-south flavor of the city, apparent in the cultural pages of Colvin's *Weekly*, still persists.

BALTIMORE IN 1752,

From a Sketch then made by John Moale Esq deceased corrected by the late Daniel Bowley Esq from his certain recollection, and that of other aged persons well acquainted with it, with whom he compared Notes.

1 N.º 2 Row Houses near Forest Lane & Baltimore Street
3 Near the corner of Sharpe & Baltimore Streets
4 Brewers Hanover Street opposite the Indian Queen
5 House in German Lane opposite the Stables of the Indian Queen
6 A House which stood in Baltimore St
7 The first Tobacco inspection House in Chatham Street
8 One or more Indian Alleys
9 Capt. Darby Lux's opposite Bowl Street and west of Light Street

10 Near the corner of Chatham Street and S.ᵗ Pauls Lane
11 S.ᵗ Pauls Church the first built
12 W.ᵐ Rouses N.E Corner of Baltimore Street & S.ᵗ Pauls Lane
13 Kaminskas Tavern in Bank near Light S.ᵗ
14 S.E Corner of Bank and Calvert Streets
15 The first brick House built in Baltimore, erected about 30 feet south of the New Court House, the brick & corner stones were imported
16 M.ʳ Yorks Houses on the ground of the brick buildings in N.ᵗ Paul St.

17 Reed the Barbers on ground N.ᵍᵗ Baltimore Street
18 opposite Maryland Insurance Office
19 Near the corner of South and Water Streets
20 South East corner of South & Baltimore Streets
21 On or near Holliday Street opposite the Theatre
22 Part of Old or Jones Town up the Falls
23 The Cool spring generally used by the Town at the head of the Bason, a few feet west of Charles S.ᵗ

24 Deep point, where the 1ˢᵗ wharf was built
25 Meldum of the Sloop from the first vessel belonging to Baltⁱ
26 Sloop Baltimore the 1ˢᵗ Vessel
27 Brig of M.ʳ Nic. Rogers the first square built vessel & the only one of that time
28 Jones Falls as then appeared at that time from Ireland Hill, whence M.ʳ Moale made his Draft. 30 Philadelphia Road
29 Calvert Street Wharf 31 Arch of the Battle Monument

BALTIMORE IN 1752, FROM A SKETCH THEN MADE BY JOHN MOALE, ESQR. DECEASED, CORRECTED BY THE LATE DANIEL BOWLEY ESQR. . . .
Engraver: William Strickland. Aquatint [published 1810s]. 1752. Size: 17 × 29.1 inches; 432 × 738 mm. Stokes Collection, Prints Division, The New York Public Library.

The Moravians

Bethlehem, Pennsylvania, 1757

The *Unitas Fratrum* brought music to Pennsylvania and a Latin title. The title says less about the brethren's particular set of religious beliefs than of their determination to meet life's challenges and rewards strongly banded together. This early Protestant sect has a very long history, predating Martin Luther's Reformation and layered with persecutions and vicissitudes stretching through three centuries. In their wanderings through Bohemia, Moravia, Poland, and Austria, the United Brethren swelled the multi-national membership of their society, a fact not reflected in the simple and affectionate title by which they are known: the Moravians.

Count Nikolaus Ludwig von Zinzendorf befriended the group when they were threatened with extinction and became their spiritual leader as well as patron. In 1740 (or perhaps 1741) the Austrian nobleman made the uncomfortable journey across the Atlantic to visit his flock in Pennsylvania. There a group of the United Brethren had begun a missionary settlement on the banks of the Lehigh River. He arrived in time for their joyous celebration of the Christmas Love Feast, and named the settlement Bethlehem.

Only the most rudimentary beginnings of a Moravian community were in evidence when Bethlehem received its name. Less than twenty years later an orderly village arose from the wilderness. It was a village, as we see from the drawing by a contemporary Moravian artist, that had strong architectural affinities with Europe. The evidence of a closely knit and self-contained society is there in the neatly grouped buildings, the lands under cultivation, the lush meadows, the stocks of animals, the ample orchards, and the proximity to the most indispensable of all resources: water. The quality and furnishings of the buildings, their placement in an open rectangle, and the architectural cohesion of the settlement gave Bethlehem a reputation for being superior in elegance to any other American country place of equal population and size. Foreigners who traveled to Pennsylvania inevitably headed for Bethlehem. In September 1799 a sophisticated churchman from New York remarked that he could no longer put off a visit to Bethlehem. The Moravians, he said, had been the subject of conversation for months. Even Benjamin Franklin and George Washington had admired their astounding industriousness. He made the journey by stagecoach "with great ease & comfort" and left a book-length account of his impressions. He was pleased with what he found:

> The large well built, well finished and furnished houses, both public and private—the instruments of music, the garden walks, small parties on the island, and the devout scenes connected with their religion, afford that novelty and exchange of occupations, which must remove gloom, superstition, satiety or disgust.[5]

There could have been very little gloom in a community so active. The Moravians were less concerned with doctrine than with the conduct of their everyday lives, and the intellectual gifts they brought with them made their center in Bethlehem hum with activity: the running of printing presses, the establishment of schools, the learning of Indian dialects, the translation of books, and everywhere the sound of song.

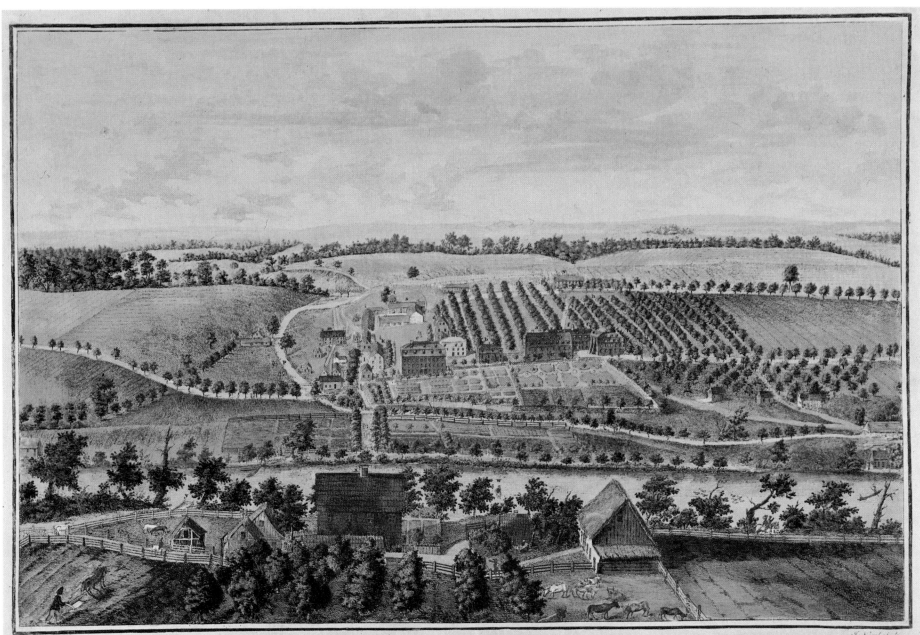

A VIEW OF BETHLEHEM, ONE OF THE BRETHREN'S PRINCIPAL SETTLEMENTS, IN
PENNSYLVANIA, NORTH AMERICA. . . . N[ICHOLAS]. GARRISON DELINT. I. [OR J.]
NOUAL SCULP. LONDON PRINTED FOR ROBT. SAYER NO. 53 FLEET STREET.
Etching with Engraving. 1757. Size: 13 × 18.12 inches; 328 × 478 mm. Prints Division, The New York Public Library.

The Boston Massacre: The Original View

Boston, Massachusetts, 1770

Paul Revere knew how to package his art as well as his patriotism. His vividly colored engraving of the Boston Massacre, with red equating blood, the British militia, and violence, and with a further garnishing of inflammatory verse, had a calculated impact. It sent shivers of patriotism up the spines of many who had not yet declared themselves against the British, and it gave enormous vigor to already-existing rebellious sentiments. Seen by multitudes after the incident occurred, it has become a highly prized document of revolutionary history.

There is no denying that the engraving is powerful. Even today as we look at it, prepared to point out some of its seeming absurdities—Is that outstretched hand meant to stop a volley of gunfire?—we are moved by it. British redcoats, lined up at the right with loaded muskets, are set apart from the dead, the wounded, and the bewildered by halos of billowing gunsmoke. There is so much unbridled hostility in so small a space.

The drawing from which Revere made his protest engraving was not, however, his own. It was the work of a Tory. "When I heard that you was cutting a plate of the late Murder," wrote Henry Pelham to Revere in a rage, "I knew you was not capable of doing it unless you coppied it from mine."[6] The Boston patriot had, indeed, filched the work of a friend. Revere had not been in King Street when the clash occurred, and when he saw Pelham's drawing of it, he immediately understood the volcanic effect it would have. He quickly set to work to make an engraving on copper, added his name, ran it off the press, advertised it, and sold it. In the process he upstaged his friend. Pelham's engraving of his own drawing appeared on the market only later, and to this day the scene of the Boston Massacre is indelibly associated with the name of Revere.

But how could a drawing so passionately indicting the British be the work of a Tory, and who was Henry Pelham?

An American, born in Boston, Pelham was the half-brother of John Singleton Copley and the son of the famous mezzotint artist Peter Pelham. In the two portraits of him made by Copley, we are introduced to a sensitive and very handsome young man. His engraving, indicting the British for the King Street bloodshed, stemmed from a horror of violence and from the specter of a civil war that he viewed as "the most dreadfull of temporal Evills." It was Pelham's judgment that the British, with authority and guns ranged in their favor, had options in dealing with the taunts of the mob on that March fifth day. They fired. Whether the attack was the result of confusion or a deliberate order, for Pelham it was not a partisan issue but an ethical one, and he invoked the Bible in his broadside to strengthen his protest: *They break into peices thy people O Lord and afflict thine heritage.* After the King Street bungling, Pelham felt there was still time for England to back down from her imperial posture, and he applauded the demonstration that took place in London on behalf of the colonies. When the Revolution with all its attendant suffering inevitably came, he could only despair that it was an "unnatural Dispute," and he took no part in the fighting on either side. By 1775 Pelham was writing to Copley in London that the Boston he loved had been turned into a garrison, that his property had been entirely destroyed, and that the only clothes he had left were those on his back. He was quick to add that there were many others in similar circumstances. His sympathies were now clearly with the British, and soon after he sailed for England.

At one time there were 575 prints of Pelham's engraving. Only two copies now exist, one of which, owned by The New York Public Library, is shown here. It is quickly distinguishable from the Revere by its lack of incendiary verse.

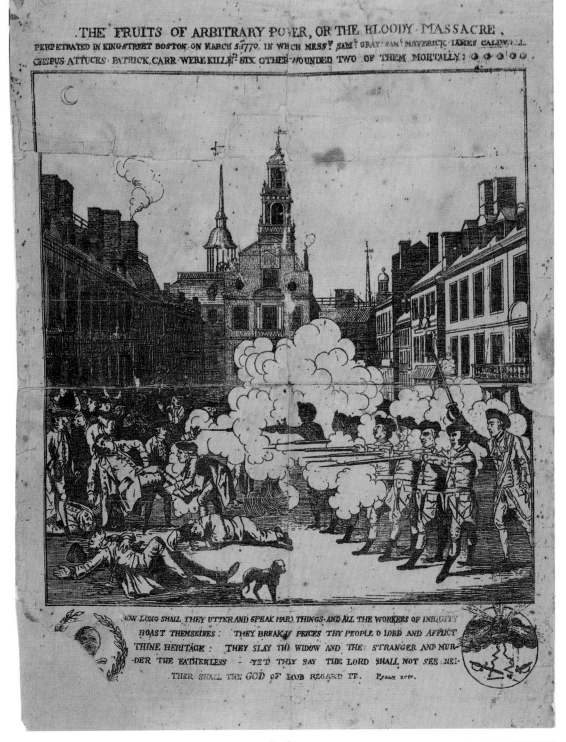

THE FRUITS OF ARBITRARY PO[W]ER, OR THE BLOODY MASSACRE, PERPETRATED IN
KING STREET BOSTON ON MARCH 5TH, 1770. . . .
Artist: Henry Pelham. Engraving. 1770. Size: 13.6 × 9.10 inches; 340 × 245 mm.
Stokes Collection, Prints Division, The New York Public Library.

Toppling George III

New York, New York, 1776

Almost fourteen months elapsed between the beginning of the Revolutionary War and the signing of the Declaration of Independence. The indignation of the colonies over the transgression of their liberties did not for quite some time foster ideas of separation from England. No ground had been laid for so radical a step, since no European colony had ever weaned itself from the imperial breast, or even wished to. Loyalty to the king and to England was still so deeply rooted in the colonies that only a few thought in terms of independence and less than a few dared breathe that word. Americans saw themselves as *British* Americans, tied to the glories of English culture and to the poetry of the English tongue. When the notion of independence gathered momentum, it was an independence to be won under the Crown: The enemy was not George III but his misguided counselors. The war was being fought not for glory or conquest but in resistance to the tyranny of George's ministers. At his officers' mess in Cambridge, General George Washington, Commander in Chief of the Continental Army, was still raising his glass in a toast to the king.

The man bold enough to suggest that George III was a brutal tyrant was Thomas Paine. "A thirst for absolute power is the natural disease of monarchy," he reasoned in *Common Sense*, prodding those who had long suspected it to become thoroughly convinced. Not long after, independence was voted as the only course for the colonies, and Thomas Jefferson was asked to write the first draft of this heady decision.

The Declaration of Independence was first printed in Philadelphia. When a courier arrived in New York on July 9 with a copy of the document, Wash-ington ordered that it be read aloud to his troops then stationed in the city. In that document Jefferson had not minced words with regard to George III: "The history of the present King of Great Britain is a history of repeated Injuries and Usurpations, all having in direct Object the Establishment of an absolute Tyranny over these States." That evening, a two-ton, gilded lead statue of George III erected in Bowling Green at the foot of Broadway was exultantly toppled. Soldiers mixed with citizens in the iconoclastic gesture, and the statue was carted off to be melted for bullets.

Washington was not very pleased with the behavior of his troops. In the orders for the next day he made his feelings clear:

> Tho the General doubts not the persons, who pulled down and mutilated the statue, in the Broadway, last night, were actuated by Zeal in the public cause; yet it has so much the appearance of riot, and want of order, in the Army, that he disapproves the manner, and directs that in future these things shall be avoided by the Soldiery, and left to be executed by proper authority.[7]

His aide-de-camp, writing in his journal the same day, noted that the soldiers had long wanted to "behead" the equestrian statue and had finally found the right opportunity.

News of the happenings in America were followed with avid interest in Europe. A German engraver who imagined the scene from abroad has given us a George III without his horse and a New York that is totally unrecognizable.

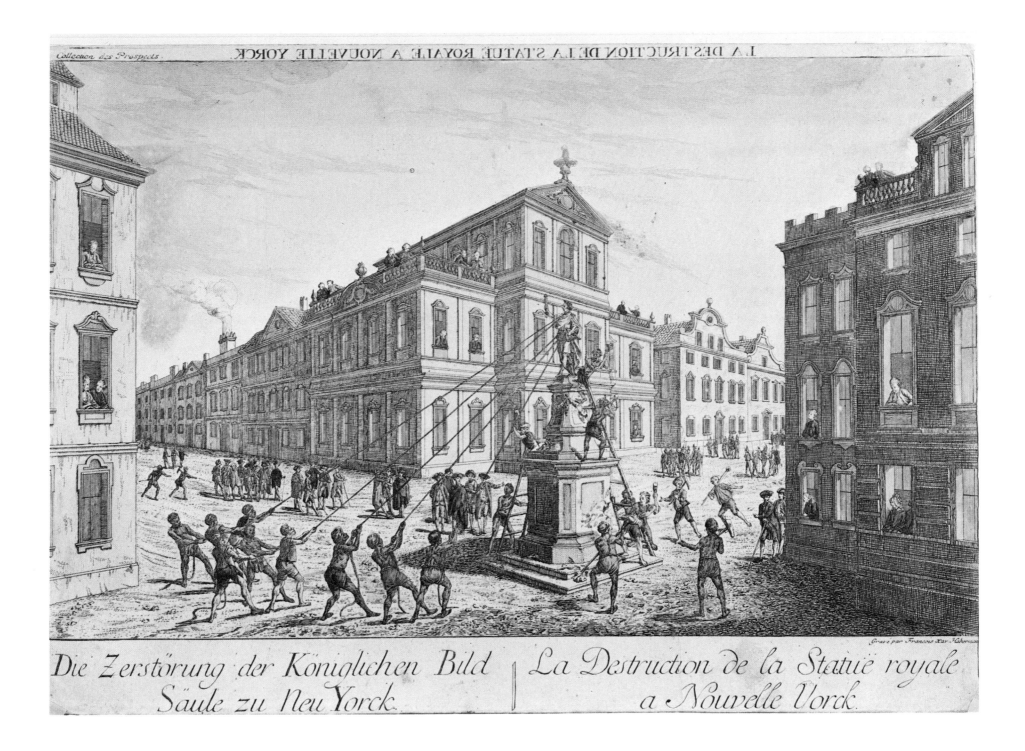

Gravé par Francois Xav. Habermann

Die Zerstörung der Königlichen Bild | La Destruction de la Statue royale
Säule zu Neu Yorck. | a Nouvelle Yorck.

LA DESTRUCTION DE LA STATUE ROYALE A NOUVELLE YORCK. . . . GRAVÉ PAR FRAN-
COIS XAV. HABERMANN.

*Artist: Franz Xaver Habermann. Etching. 1776. Size: 11.11 ×15.12 inches; 208 × 400
mm. Eno Collection, Prints Division, The New York Public Library.*

The *Phoenix* and the *Rose*

Hudson River, near New York, New York, 1776

A formidable number of His Majesty's ships surrounded New York in the summer of 1776 to quash the rebellion of the colonies. Sailing down from Halifax with more than one hundred vessels, General William Howe arrived at Sandy Hook late in June and there awaited the reinforcements that his brother, Admiral Richard Lord Howe, was bringing from England. The rendezvous took place in July. When the two fleets combined, a virtual armada threatened New York. "Every Tide we expect an Attack will be made on this City from the piratical Fleet at Staten-Island," fumed the *New York Mercury* during the month of August. Tensions mounted. Since June there had been no telltale signs from the spectacular forest of masts assembling in the harbor as to when the British troops would descend on the colony.

Washington, in the meantime, was vigorously setting up measures to defend the city. Batteries were stationed along the rivers on both sides of Manhattan, and barricades were erected in the streets leading up from the water. King's College downtown was converted into a general hospital, and a fort named after Washington was built at the northern end of the island. But there were many problems to overcome. Within the city Washington had to contend with disaffected citizens, some of whom he put in jail. Worse still, he had all the tribulations of directing a poorly disciplined, poorly paid, and poorly equipped fighting force. The difficulty of holding New York against an enemy that controlled the harbor was recognized, but military opinion held that Manhattan would make a defensible battleground.

Sometime in July two men-of-war slipped away from the assembled British fleet for maneuvers. Passing along the majestic Jersey Palisades, the *Phoenix* and the *Rose* managed with their three tenders to make their way up into the Hudson. Then, on August 16, somewhere south of Tappan Zee, two American fire ships attempted to ignite them. The men commanding the fire ships were Captains Fosdyke and Thomas, gentlemen volunteers of rank. According to a later account, the British did not perceive them until the Americans had brought their vessels well alongside. Fosdyke grappled the *Phoenix*, but she was able to fight off the fire and disentangle herself. One of the tenders of the *Rose* did burn, but Thomas, unfortunately, fell in battle on board her. After passing once again through the gauntlet of the shore batteries, the *Phoenix* and the *Rose* rejoined their fleet. The American action had been audacious, but, as Nathan Hale commented, "The night was too dark, the wind too slack for the attempt."

A day after this incident, a soldier of the Provincials who escaped from New York and joined the army under General Howe, wrote from Staten Island to a friend in London:

> A few days ago I left our devoted City, where every Means of Defence has been concerted to secure it, and the whole Island of New-York, from an Attack of the Royal Army. Should General Howe succeed in that Enterprise, his Antagonist, Mr. Washington, has provided a Magazine of Pitch, Tar, and Combustibles, to burn up the City before he shall retreat from his present Station; the Numbers of his Men are daily diminishing; they desert in large Bodies, are sickly, filthy, divided, and unruly; putrid Disorders, the Small-pox in particular, have carried off great Numbers; when I left the City there were six thousand in their Hospitals, to which Use they have converted King's College; they have not now quite 25,000 Men in Arms.[8]

The attack was finally launched by the British fleet on August 22, and the Americans were disastrously defeated in the opening battle on Long Island. General Howe did, indeed, succeed in that particular "Enterprise," the city did burn, but the origin of the conflagration is to this day a moot question.

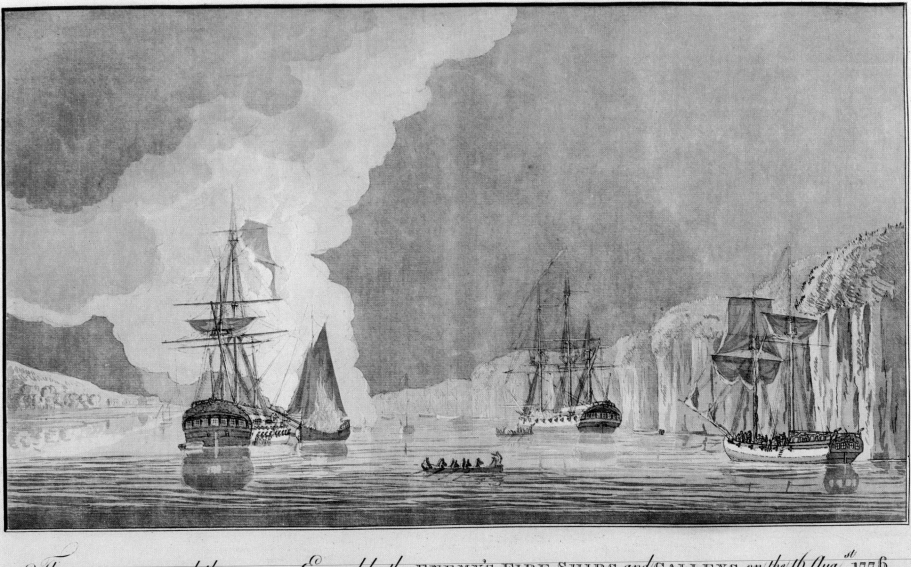

The PHŒNIX and the ROSE Engaged by the ENEMY'S FIRE SHIPS and GALLEYS on the 16 Aug.ˢᵗ 1776.

Engrav'd from the Original Picture by D. Serres from a sketch of Sir James Wallace's.

THE PHOENIX AND THE ROSE ENGAGED BY THE ENEMY'S FIRE SHIPS AND GALLEYS ON THE 16 AUGST. 1776. ENGRAV'D FROM THE ORIGINAL PICTURE BY D. SERRES FROM A SKETCH OF SIR JAMES WALLACE'S. PUBLISH'D . . . APRIL 2, 1778 BY J. F. W. DES BARRES, ESQR.

Aquatint. 1776. Size: 11.2 × 19.12 inches; 283 × 502 mm. Stokes Collection, Prints Division, The New York Public Library.

The Attack against Fort Washington

New York, New York, 1776

Along with professional training at the Royal Military Academy at Woolich, British army officers were taught to draw. Before the days of photography, artistic instruction was an important part of the curriculum, and some of the officers with more than routine talent who crossed the Atlantic left vivid sketches of the war scenes they witnessed during the American Revolution.

Officer-artist Thomas Davies was on his third tour of duty in America when the British stormed New York. He took an active part in the artillery's attack against Fort Washington, and the experience so exhilarated him that he left both a drawing and a description. His drawing is a remarkably detailed rendering: with brushstrokes so precise that we can see each man and each oar, Davies shows us British soldiers making their way across the Harlem River. Looking in their diminutive red coats like a colorful swarm of beetles, they are to join Hessian mercenaries in battling Americans on the high ground of what is now City College. In the opening to the Hudson River at the right, the billowing sails of the British frigate *Pearl* can be seen against the heights of the Jersey Palisades. It is the artist's way of reminding us that New York was surrounded by a fleet of the Royal Navy. In the description that accompanied his water color, Davies proudly wrote that a battery of four medium twelve-pounders was commanded by "your Humble Servant."

Davies must have been pleased to record a battle that ended in disaster for the Americans. About twenty-five hundred were taken prisoner in the capture of the fort. The disaster came hard on another that had occurred less than two months earlier in Brooklyn Heights. It had very nearly crushed both Washington and the cause. General William Howe had routed the Continental Army and forced it to evacuate Long Island in August. Nine thousand men with field artillery, provisions, cattle, horses, and wagons were transferred across the East River to Manhattan in thirteen hours. The massive operation was attended by Washington himself. It was skillfully executed but very grim, and was similar to what the British themselves would experience in 1940 at Dunkerque.

Following the withdrawal from Long Island, the Americans decided to fight it out in Manhattan. At the upper end where 180th Street meets the Hudson, a position was strongly fortified and named Fort Washington, and across the river another was named Fort Lee. Washington was not so sanguine as General Nathanael Greene in thinking that these positions could be held. When Fort Washington was eventually stormed and taken in a matter of hours, all Manhattan was lost. From then on, New York was to remain in British hands until the close of the war. "I feel mad, vexed, sick, and sorry . . . ," commented Greene. "This is a most terrible event."[9]

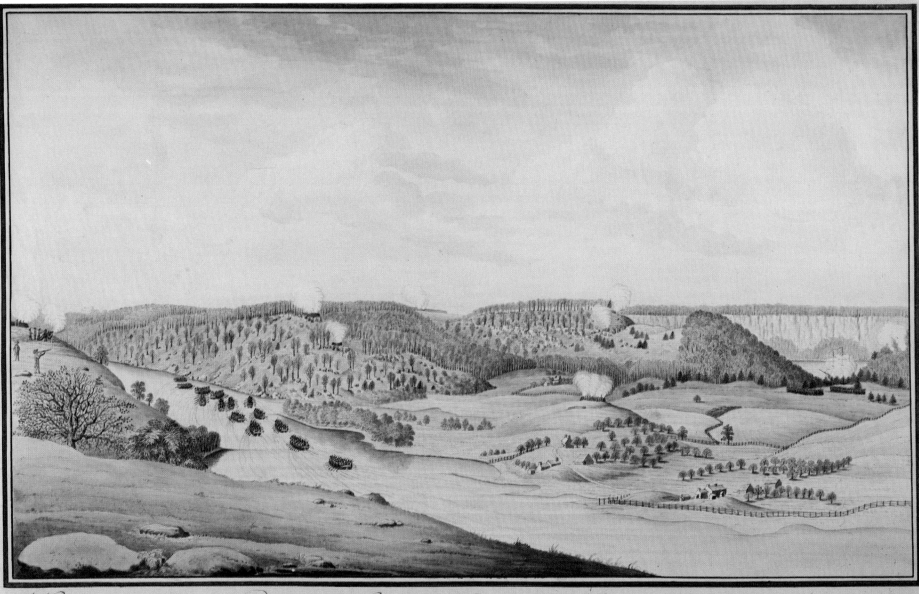

A View of the Attack against Fort Washington and Rebel Redouts near New York on the 16 of November 1776 by the British and Hessian Brigades Drawn on the Spot, by Thos Davies Capt R: R: of Artillery.

A VIEW OF THE ATTACK AGAINST FORT WASHINGTON AND REBEL REDOUTS NEAR NEW YORK ON THE 16 OF NOVEMBER 1776 BY THE BRITISH AND HESSIAN BRIGADES DRAWN ON THE SPOT, BY THOS DAVIES CAPT R: R: OF ARTILLERY.

Water-color drawing. 1776. Size: 11.9 × 18.12 inches; 294 × 476 mm. Stokes Collection, Prints Division, The New York Public Library.

The Ruins of Trinity Church

New York, New York, about 1780

In a dispatch to England confirming the successful occupation of the city of New York by His Majesty's forces, the British commanding officer reported that at midnight, between the twentieth and twenty-first of September 1776, "a most horrid attempt was made by a number of wretches to burn the town of New York."[10] The fire broke out near Whitehall Slip, ranged up Broadway and Broad Street to the City Hall, and consumed nearly one third of the city in its rage. The British had no doubt that the wretches were American patriots who wished to leave their conquerors a city in ashes.

Trinity Church, which had so long and so gracefully dominated the skyline of colonial New York with its elegant steeple, was now in ruins. Virtually all the buildings between Broadway and the Hudson River as far north as St. Paul's Church were destroyed. Fortunately, though, the fire was checked by the open spaces above the grounds of King's College at Barclay Street.

Already having a hard time of it with the war, New York found its miseries were doubled by the fire. In spite of relief measures there was much suffering among the poor: many had lost their homes in the blaze and others had been thrown out of employment by the war. The Americans captured by the British in and around New York were confined in ships and in various city buildings used for prisons under conditions too appalling to relate. Then, too, some harsh winters increased their plight. In 1780 the winter was so severe that the Hudson River entirely froze over.

But there was another side to the city's life: the Tory side, which was considerably less grim. In an effort to relieve the tedium of garrison duty in a "provincial" town, British officers adopted a spirit of gaiety and supported a number of social functions and sporting events. There was a "bathing ma-chine" at the North River near Vauxhall, and a stage wagon made regular, scenic trips between New York and Kingsbridge. Cricket matches were played between English and American teams, and bull-baiting was occasionally offered as a special diversion. At the little theater in John Street, comedies were presented in which officers of the Royal Army and Navy performed. The orchestra from the theater played in Trinity churchyard, where the walks that passed the charred ruins of Trinity were railed off. Benches were placed there and lamps fixed in the trees for an evening promenade.

From the beginning Trinity numbered among its parishioners the city's most distinguished personages, some of whose descendants still worship there today. It got off to a good start when Queen Anne gave the young parish a generous tract of land in 1705. Trinity then became the parent of seven subsidiary chapels, which include some of the largest and most beautiful church structures in New York. One is St. Paul's Chapel. After the fire of 1776 Trinity lay in ruins for some time. The tower had crumbled away so that only a jagged section remained standing, and this was ordered to be taken down by the vestry long before the church was rebuilt. The present building of dark brownstone, finished in 1846, was designed by Richard Upjohn in a free rendering of English Gothic.

Today Trinity Church and its churchyard offer a retreat to workers as they make their way during lunch hour through the swirl of activity in New York City's financial district. They sun themselves on the benches along the paths or on the steps and railings of the porticos. Facing Broadway at the head of Wall Street, the church still has the commanding location it has had from the beginning.

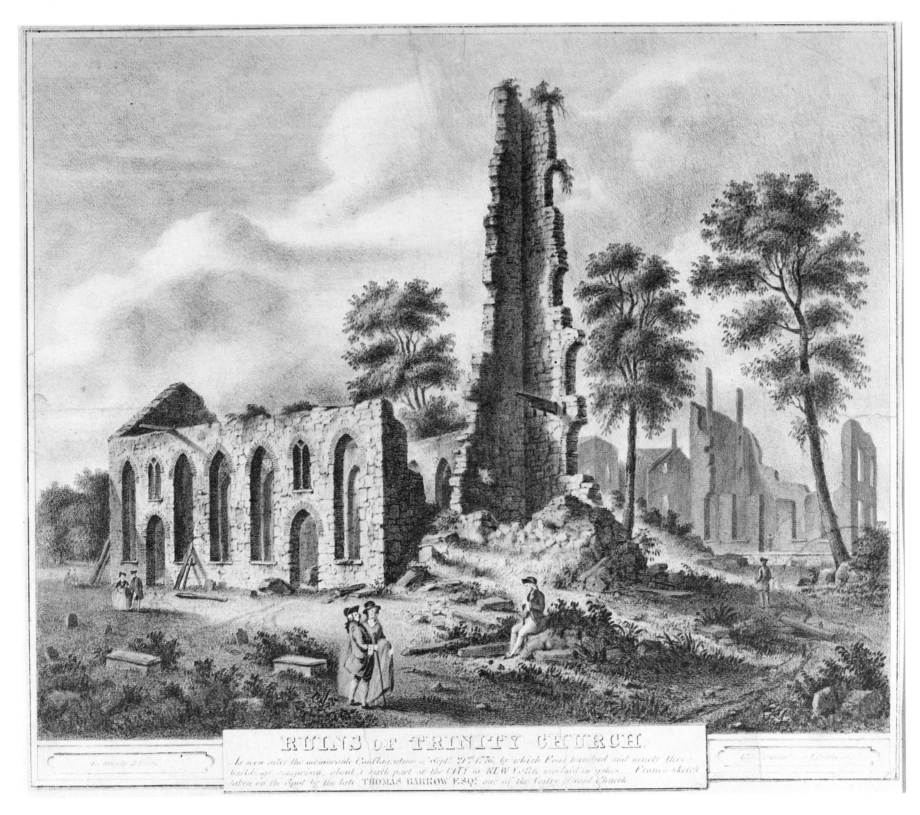

RUINS OF TRINITY CHURCH.

As seen after the memorable Conflagration of Sept.ʳ 21.ˢᵗ 1776, by which Four hundred and ninety three buildings comprising about a sixth part of the CITY of NEW YORK was laid in ashes. From a sketch taken on the Spot by the late THOMAS BARROW ESQ.ʳ one of the Vestry of said Church.

RUINS OF TRINITY CHURCH. AS SEEN AFTER THE MEMORABLE CONFLAGRATION OF SEPTR. 21ST. 1776. . . . FROM A SKETCH TAKEN ON THE SPOT BY THE LATE THOMAS BARROW ESQE. . . . ON STONE BY J. EVERS. VIEW PUBLISHED BY J. CHILDS N. Y.

Lithograph [published 1840–1845]. About 1780. Size: 10.4 × 12.3 inches; 260 × 310 mm. Stokes Collection, Prints Division, The New York Public Library.

Broad Street, Wall Street, and City Hall

New York, New York, 1797

Looking up Broad Street, one of New York's oldest thoroughfares, we come upon a cluster of colorful buildings. Houses with sloping roofs and stepped gables stand as reminders of a Dutch past, with large iron numbers, often found on the upper façades, announcing their age. Two of these Dutch houses are on the right side of the street, the more prominent one telling us it was all of a century old at the time this drawing was made. Though it was not actually constructed during the time of Dutch rule, it was built by a Dutch resident and lasted well into the nineteenth century. Across the street is an unruly though friendly assortment of eighteenth-century dwellings, which belong to the succeeding British era.

The building with the new and distinctly American look frames the view at the top. It was originally the City Hall, occupied by British troops during the Revolution. At war's end, when New York was chosen as the nation's capital, the building—fronting on Wall Street—was designated the seat of the new government. Renovated by Pierre Charles L'Enfant and renamed Federal Hall, it gave its name to a style in architecture which was to dominate the look of American public structures well into the present century. In that building George Washington was inaugurated as the first President of the United States on April 30, 1789. The oath of office was administered on the festooned balcony by Robert R. Livingston, with masses of exultant citizens jamming the streets for a glimpse of their hero. One observer, Eliza Morton (later Mrs. Josiah Quincy), who was then fifteen years old, recorded the event:

I was on the roof of the first house in Broad Street, which belonged to Captain Prince, the father of one of my school companions, and so near to Washington that I could almost hear him speak. The windows and the roofs of the houses were crowded; and in the streets the throng was so dense that it seemed as if one might literally walk on the heads of the people. The balcony of the Hall was in full view of this assembled multitude. In the centre of it was placed a table, with a rich covering of red velvet; and upon this, on a crimson velvet cushion, lay a large and elegant Bible. This was all the paraphernalia for the august scene.[11]

Eliza was in luck to have had such a good view and to have been lodged by a friend. Many could get nowhere near the doings on Broad Street, and those who had come from out of town for the historic occasion complained that no rooms could be had in New York "for love, money, or the most persuasive speeches."

Broad Street, with its winding hill of skyscrapers, is still one of New York City's most colorful thoroughfares. It begins near Manhattan's edge, offering a broad view of the bay, and then twists upward to meet Wall Street. At its base is Fraunces Tavern, where Washington bid farewell to his officers and in which life bustles to this day. Farther on, the Stock Exchange beckons the visitor with its imposing nineteenth-century splendor and with the mystery of the money drama played daily inside. At the top of the street Federal Hall no longer exists, but a similar, classic-revival building has replaced it on the same spot. In it is preserved the ornamental iron balcony that held, huddled together, a group of America's most distinguished citizens one inaugural, April day.

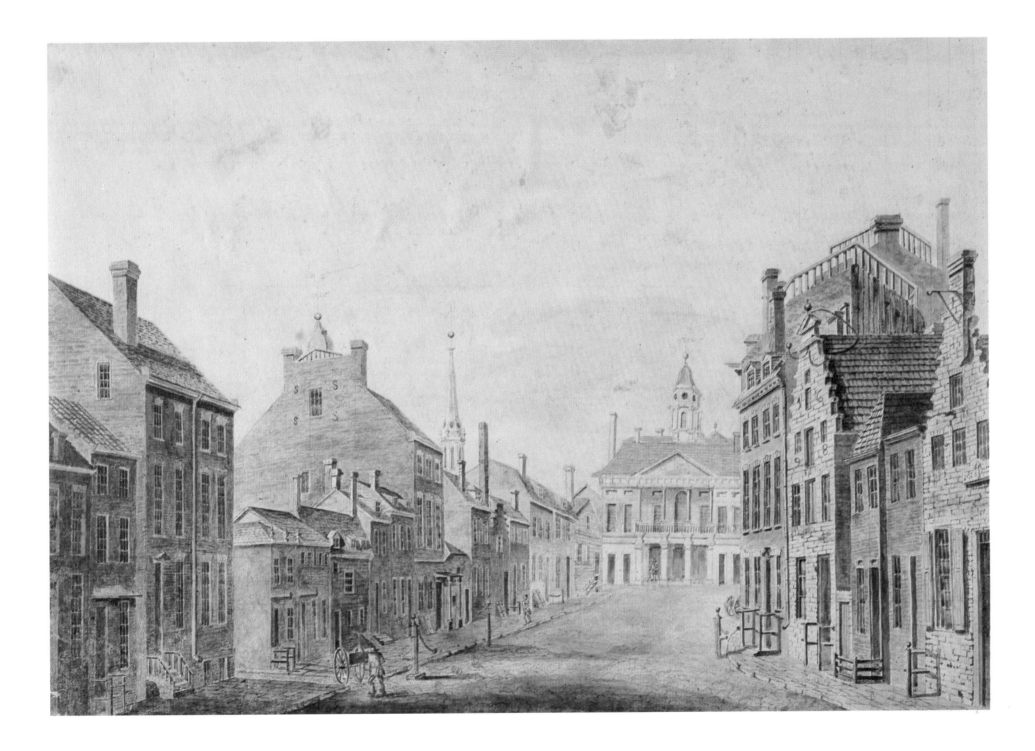

[A VIEW OF BROAD STREET, WALL STREET, AND THE CITY HALL]
Artist: probably John Joseph Holland. Water-color drawing. 1797. Size: 11.12 × 17 inches; 299 × 432 mm. Stokes Collection, Prints Division, The New York Public Library.

Philadelphia: The Birch Views

Philadelphia, Pennsylvania, 1798–1800

Philadelphia is the only eighteenth-century American city that can lay claim to an official iconographer. Boston, New York, and Charleston—cities painted and engraved just as often by visiting and resident artists—were not to enjoy the systematic dedication that went into the work of William Russell Birch.

Birch was an artist from England, where he had been quite successful. He had exhibited his miniatures at the Royal Academy, had been a protégé of Sir Joshua Reynolds, and knew Benjamin West. His specialty was enamel painting, "the unick Art of Heightening and preserving the beauty of tints to futurity,"[12] as he described it, and the Royal Academy's rejection of the best efforts in enamel art, as a form of copying, irked him. He enjoyed extensive patronage both at home and abroad, and felt no particular urge to leave England. But following the upheaval of the French Revolution and the loss of some cherished friends, he found himself at odds. In 1794 he booked passage on the *William Penn* and settled his family in Philadelphia. In a short while, the storied Schuylkill River and the surroundings of the city that Thomas Jefferson considered fairer than any in Europe became the source of endless artistic inspiration. By the time Birch set about preparing a portfolio of views of Philadelphia, he knew the city well, and he depicted it with all the meticulousness of a commissioned salon portrait.

What fascinated the English artist about America was the leap from wilderness to grace. "The ground on which [Philadelphia] stands, was less than a century ago, in a state of wild nature; covered with wood, and inhabited by Indians. It has in this short time, been raised, as it were, by magic power, to the eminence of an opulent city. . . ."[13] He recorded this fascination in the introduction to his portfolio, binding together twenty-eight views that gave as rounded a picture of Philadelphia as his talents and industriousness allowed.

Three prints are hardly a fair showing. It is in the combination of all the Birch views that one responds to the animation of the eighteenth-century city. The very choosing of characteristic aspects of Philadelphia was a difficult step in an artistic venture that was risky, arduous, and without precedent. But Birch chose well. In the subsequent phases of preparing the portfolio, he had the help of his son and the services of an engraver. There had been vexations in procuring the materials—the copper and the heavy paper—and there was still the crucial phase of soliciting subscribers, but he gladly gave credit to his collaborators for their share of the work. When he guided his son Thomas in the preparation of the drawings, Birch placed as much emphasis on people as on buildings, on leisure as on industry, on triflings as on grandeur—all without loss of focus.

The portfolio was a success. This first attempt at the iconography of a city that was an early center of culture encouraged Birch to look toward New York. "I had nearly completed a sett of drawings of that city which I meant to publish as a companion Vollum to the Philadelphia,"[14] he wrote, but he never published them. His name would be forever linked to Philadelphia and his portrait-portfolio of that erstwhile capital.

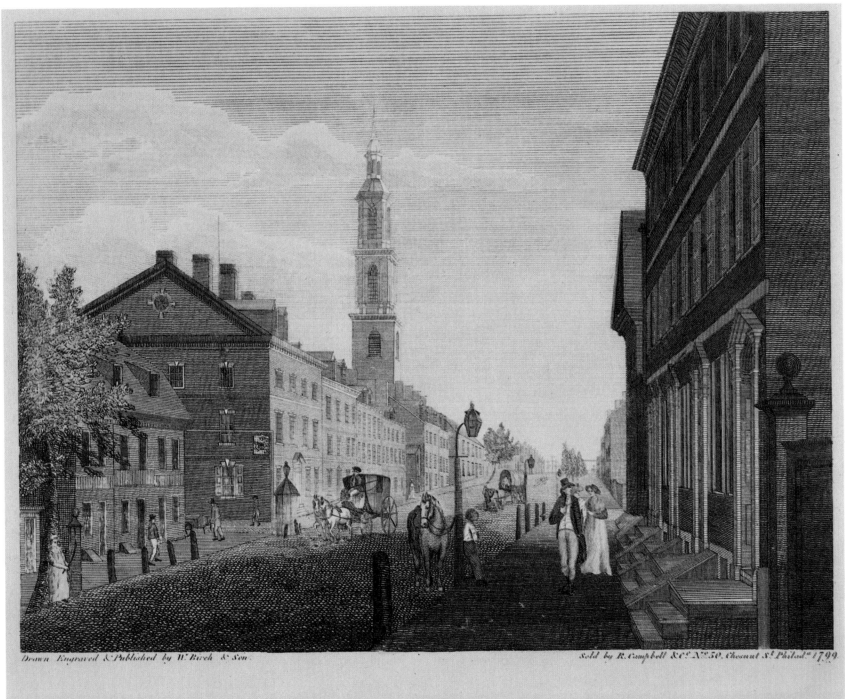

Drawn Engraved & Published by W. Birch & Son. Sold by R. Campbell &Cᵒ Nᵒ 30. Chesnut Sᵗ Philadᵃ 1799.

ARCH STREET, with the Second Presbyterian CHURCH.

PHILADELPHIA.

BIRCH, WILLIAM, & SON [PORTFOLIO]. THE CITY OF PHILADELPHIA . . . IN THE YEAR 1800 . . . : 4. ARCH STREET, WITH THE SECOND PRESBYTERIAN CHURCH. PHILADELPHIA.

Artists: William and Thomas Birch. Etching and Engraving. 1798–1799. Size: 10.13 × 13.6 inches; 274 × 341 mm. Stokes Collection, Prints Division, The New York Public Library.

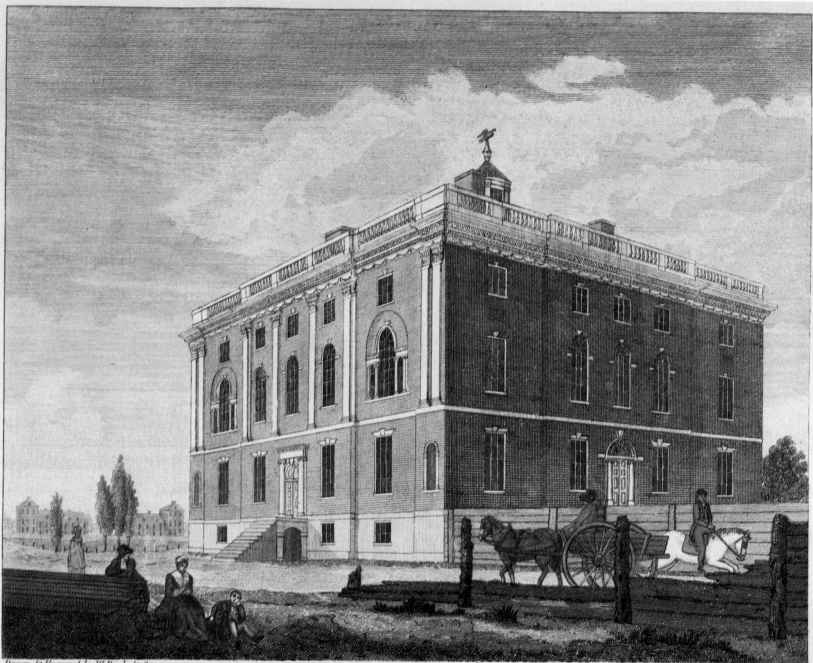

Drawn & Engraved by W. Birch & Son.

Published by R. Campbell & Co. No. 30, Chesnut Street Philada. 1799.

THE HOUSE intended for the PRESIDENT of the UNITED STATES,

in Ninth Street PHILADELPHIA.

BIRCH [PORTFOLIO] . . . : 12. THE HOUSE INTENDED FOR THE PRESIDENT OF THE UNITED STATES, IN NINTH STREET PHILADELPHIA.

Artists: William and Thomas Birch. Etching and Engraving. 1798–1799. Size: 10.13 × 13.6 inches; 274 × 341 mm. Stokes Collection, Prints Division, The New York Public Library.

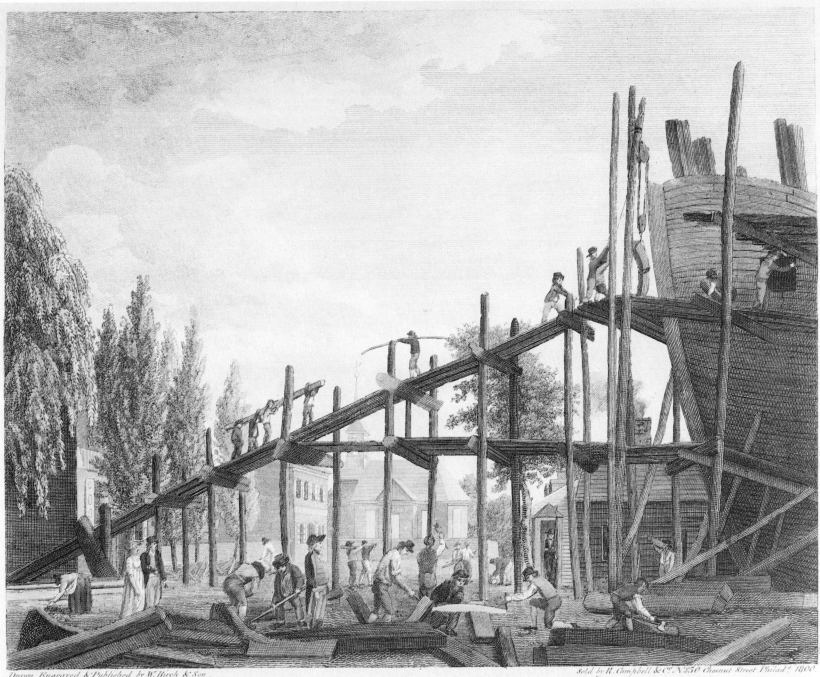

Drawn Engraved & Published by W. Birch & Son.

Sold by R. Campbell & C.º Nº 30 Chesnut Street Philad.ª 1800.

Preparation for WAR to defend Commerce.

The Swedish Church Southwark with the building of the FRIGATE PHILADELPHIA.

BIRCH [PORTFOLIO] . . . : 29. PREPARATION FOR WAR TO DEFEND COMMERCE. THE SWEDISH CHURCH SOUTHWARK WITH THE BUILDING OF THE FRIGATE PHILADELPHIA. *Artists: William and Thomas Birch. Etching and Engraving. 1798–1800. Size: 10.13 × 13.6 inches; 274 × 341 mm. Stokes Collection, Prints Division, The New York Public Library.*

Annapolis: A Georgian Showpiece

Annapolis, Maryland, about 1800

Annapolis is constantly likened to the city of Bath in southwestern England. The comparison was originally made by John Bernard, a British actor who crossed the Atlantic in 1797 and lived for a time in Maryland's capital. Coming from the south of England himself, he recognized the appealing traces of medievalism in some of the manor homes of Annapolis where he was often entertained. "In this little spot"—as he referred to Annapolis—"all the best of Philadelphia and Virginian Society [is] concentrated." When he met Charles Carroll, one of the signers of the Declaration of Independence and a wealthy resident of the town, he was very effusive: "From the refinement of his manners, a stranger would have surmised that he had passed all his days in the salons of Paris. He had all that suavity and softness, in combination with dignity, which bespeak the perfection of good taste. This attested the character of his society."[15] The city so suited Bernard's lively personality that he felt it made amends for much that he had lost in quitting England. (The fortune he accumulated in America also helped.)

Annapolis antedated Baltimore as a colonial center of culture and until the end of the Revolutionary War surpassed it. It was settled in 1649, at a time when the defeat of the Spanish Armada and the death of Queen Elizabeth were still topics of discussion. In appearance the city still perpetuates some of the flavor of the seventeenth century, when the government of Maryland was a palatinate. Lord Baltimore, the proprietor, had semiregal power: he could create courts, titles, manors, and estates. The institution of the manor system was in itself an aristocratic feature belonging to no other English colony in America. The manor houses of Annapolis were particularly splendid, always much talked and written about, but few of them remain today. The city is admired more for its handsome red-brick houses, which date predominately from the eighteenth century. Of course the city is known, too, as the location of the United States Naval Academy, but this is a comparatively recent addition. The magnificent group of buildings that form the Academy date from 1845.

The water color we see here has failed to do justice to the charm of Annapolis. It is a very early drawing, done close to the time when John Bernard was comparing the city with Bath, but those who know Annapolis well can perhaps identify some of the buildings. At the left of the view, forming a strong border for the drawing, is a corner of Reynold's Tavern, built in 1737. Between the tavern and the dominant red-brick building of St. Anne's Church is the Maynadier House and the steeple of the McDowell Hall. To the right of St. Anne's is the monumental cupola of Maryland's Stadt House, which was completed after the Revolution and which still graces the city to this day. The two-chimney brick structure, between Church and the Duke of Gloucester streets, is now a part of the Maryland Hotel.

The Stadt House is of more than passing architectural interest. It was in the Senate Chamber of this building that Washington surrendered his commission as Commander in Chief of the Continental Army. On the day of December 23, 1783, the assembled Congress was to hear him say, "Having now finished the work assigned me, I retire from the great theatre of Action. . . ."[16] He would not be allowed to retire: there was another "great theatre of Action" he would soon be entering.

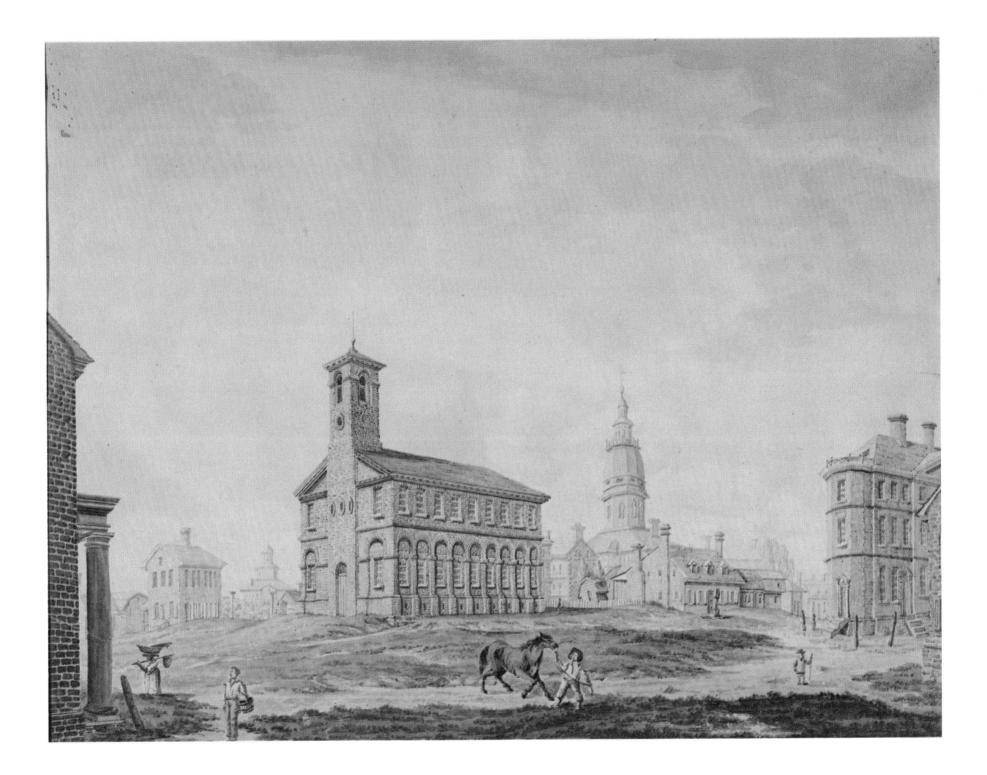

[VIEW OF ANNAPOLIS, MARYLAND.]
Water-color drawing. About 1800. Size: 14.8 × 18.13 inches; 368 × 473 mm. Stokes Collection, Prints Division, The New York Public Library.

Church and Market Streets

Albany, New York, 1805

It was at the age of eighteen, and in the autumn of the year eighteen hundred, that I first set my foot within the precincts of the ancient and far-famed city of Albany. It is true, I had passed *through* the city some ten or twelve years before, but 'twas on a rainy day, and in a covered wagon; and as the only glimpse I had of the town was obtained through a hole in the canvas, I set it down as nothing. . . .[17]

Thus wrote Gorham A. Worth, whose impression of Albany was of a city completely Dutch "in its moods and tenses." There was no hurry or confusion, no noise, strutting, or rowdyism, no putting up or pulling down, no excavations, and no unsettling improvements. The streets and the buildings, noted the young traveler, were not only Dutch in style, they were Dutch "in position, attitude and respect."

Albany was indeed very Dutch, despite its Indian origins, an early French settlement, and the English name forced upon it in 1664. In that year, along with the colony of New Amsterdam at the foot of the Hudson, it was captured by the troops of Charles II. When the city received its colonial charter in 1686, local government was lodged in the hands of the colony's industrious Dutch residents. By that time Albany already had a neat pattern of streets and houses, a town hall, a watchhouse, a ferry, a church, a cemetery, a market, several public buildings, and a network of outlying pastures, highways, and bridges. Like the English-named city of New York, it, too, was walled in by wooden palisades for defense and had a fort. The charter recognized the strategic crossroads location of the city and the great potential of its already flourishing fur trade by granting that Albany "shall henceforth extend and reach itself . . . as well as in length and in breadth, as in circuit. . . ."

Albany did just that. It not only extended itself in size, in trade, and in manufacture, but it extended its fame by its recurring historic roles. It was there that Henry Hudson made his landing in 1609, the defeated John Burgoyne came as a prisoner in 1777, the seat of state government was moved in 1797, and Fulton's steamboat completed a successful run in 1807. It was also there that George Washington, Aaron Burr, John Armstrong, Robert Livingston, and the Marquis de Lafayette came as guests and received a gracious welcome, and there that Alexander Hamilton came as a suitor and received a wife. It was there that everyone who traveled to America went, because everyone knew of Albany and the charm of its persistent traditions.

Visitors to Albany in 1805 could still see the city's market house and curious Gothic church. The church, which looms in the middle ground of the delicately tinted lithograph, had an uncommon history. In 1715 its foundations were put down around an earlier church that had become too small for the congregation. Church services were held uninterruptedly in the smaller one within until the walls and roof of the new structure were completed. If we look beyond the church and wagonload of hay, we can see just a glimpse of the market that gave the street its name. When all signs of commerce had ceased for the day, its archways served as a social gathering place where residents would bring their chairs, smoke, and gossip for hours. At the extreme right is the two-story peaked-gable house that belonged to Henry Lansing; it may be that gentleman himself who is giving us a look. A keeper of dry goods and teas, Mr. Lansing, with his eccentric ideas of shopkeeping, seldom allowed customers across his threshhold. He would assemble whatever merchandise was required and sell it at the door. Evidently, the characteristic Dutch doorways of Albany, which gave the shopkeeper and his neighbors a window onto the world, could also serve to guard them against it.

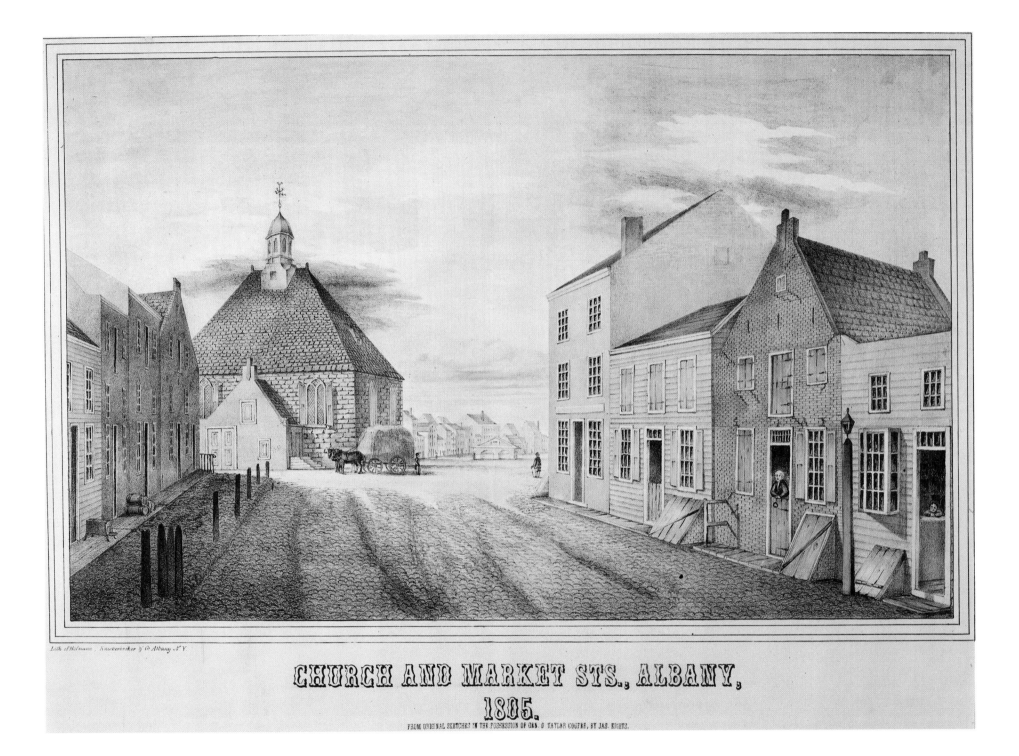

CHURCH AND MARKET STS., ALBANY,
1805.

FROM ORIGINAL SKETCHES IN THE POSSESSION OF GEN. O TAYLER COOPER, BY JAS. EIGHTS.

CHURCH AND MARKET STS., ALBANY, 1805. FROM ORIGINAL SKETCHES IN THE POSSESSION OF GEN. O TAYLER COOPER, BY JAS. EIGHTS. LITH OF HOFMANN, KNICKER-BOCKER & CO . . ALBANY N. Y.
Lithograph [published about 1857–1858]. 1805. 11.13 × 19.1 inches; 300 × 485 mm.
Stokes Collection, Prints Division, The New York Public Library.

New Bedford: The Main Street

New Bedford, Massachusetts, about 1807

"If I had been astonished at first catching a glimpse of so outlandish an individual as Queequeg circulating among the polite society of a civilized town," wrote Herman Melville in *Moby-Dick*,

> that astonishment soon departed upon taking my first daylight stroll through the streets of New Bedford. . . . There weekly arrive in this town scores of green Vermonters and New Hampshire men, all athirst for gain and glory in the fishery. . . . Look there! that chap strutting round the corner. He wears a beaver hat and swallow-tailed coat, girdled with a sailor-belt and sheath-knife. Here comes another with a sou'-wester and a bombazine cloak. . . . But think not that this famous town has only harpooneers, cannibals, and bumpkins to show her visitors. . . . The town itself is perhaps the dearest place to live in, in all New England . . . nowhere in all America will you find more patrician-like houses; parks and gardens more opulent, than in New Bedford. Whence came they? how planted upon this once scraggy scoria of a country?[18]

"Scraggy scoria of a country?" It did not appear so to the early explorers. When Bartholomew Gosnold arrived from England in 1602 and anchored his ship in Buzzards Bay, he found the area "the goodliest continent" he had ever seen. He talked of the mainland's fair fields with fragrant flowers, the meadows hedged in with stately groves, the pleasant brooks, and the beauty afforded by "two main rivers." It was a land far and away more promising than anything expected by those who had put to sea from far-off England. Then, too, Gosnold and his men were welcomed most cordially by the Indians they met on arrival. They received presents of furs, tobacco, sassafras root, turtles, and hemp, and for many years enjoyed the friendship that the Indians offered them as well. It was a hospitality that made it possible for the English to settle and for villages to slowly develop along the coast. In 1652, leaning on this friendship with the Indians, they purchased from the Wampanoag the tract of land of which New Bedford was originally a part—known as the territory of Dartmouth. In exchange for "thirty yards of cloth, eight moose skins, fifteen axes, fifteen hoes, fifteen pairs of breeches, eight blankets, two kettles, one cloth, 22 in wampum, eight pairs of stockings, eight pairs of shoes, one iron pot, and ten shillings in another commoditie," John Cooke and John Winslow signed a deed with Wamsutta, son of Wesamequen, for the territory.

In the course of time, New Bedford became independent and did not forget the name "Wamsutta." With the creation of the Wamsutta Mills in the nineteenth century, the town glorified its history and gilded its pockets. There was another name, too, that swelled the glory of the town: that of Rotch. While New Bedford was still a mere hamlet, Joseph Rotch came with his capital, his energy, and his enterprise to establish himself in the whaling business. He did so well that at the height of the American whaling industry no seaport could match New Bedford in the hustle and bustle of goods-laden ships. Even Melville complained that "New Bedford has of late been gradually monopolizing the business of whaling, and though in this matter poor old Nantucket is now much behind, yet Nantucket was her great original. . . ."

The chap in the lithograph taking a daylight turn down Main Street in the luxury of an English chaise is William Rotch, with his two-chimney mansion looming large at the top of the view. He has wheeled out of his garden and gone past George Sisson's corner grocery in the three-story building, past the town pound, past Bosworth's boot shop in the steep-roofed cottage, and past Nathaniel Cole, who is busy dressing his meats. He is now passing the shop of Jahaizel Jenney who stands outside chatting with Peter Barney (Jenney is the man with the iron foot). Just around the corner in Jenney's building is the barber shop of Nathaniel Rogers, and pausing outside of it with Abraham Russell is Mr. Rotch's son. In the foreground the fellow forming part of an animated trio is Paul Cuffee, a man of vision prominent among his people. The two ladies with whom he is talking are unnamed, but we can think of them in the prose of Melville's praise: "And the women of New Bedford, they bloom like their own red roses . . . the fine carnation of their cheeks is perennial as sunlight in the seventh heavens."

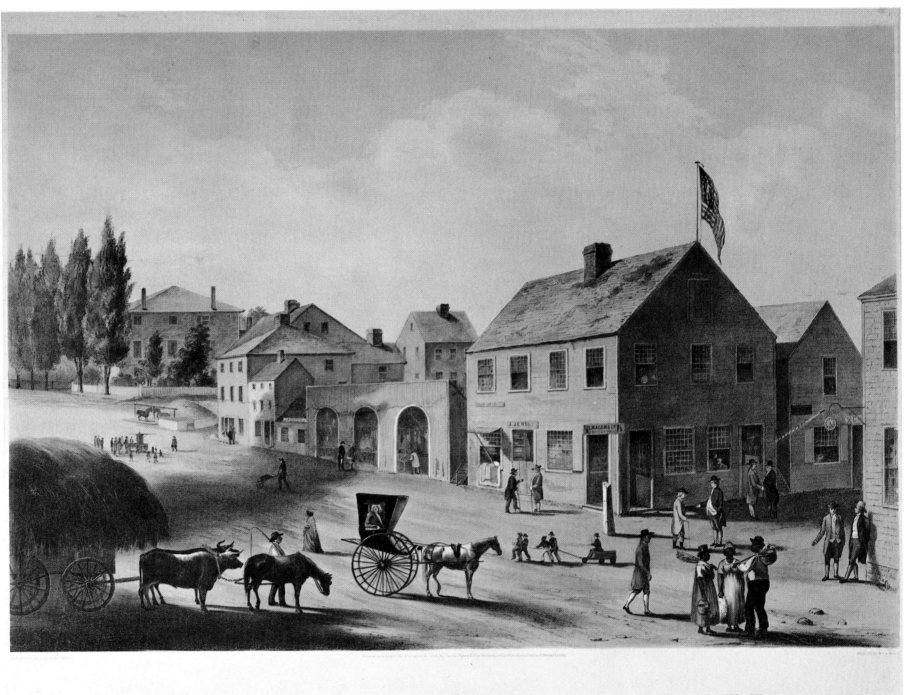

NEW BEDFORD, FIFTY YEARS AGO.

NEW BEDFORD, FIFTY YEARS AGO. PAINTED BY WM. A WALL. ENDICOTT & CO. LITH.
NEW YORK. ENTERED . . . 1858. . . .
Lithograph. About 1807. Size: 15.15 × 23.11 inches; 405 × 603 mm. Stokes Collection, Prints Division, The New York Public Library.

The Corner of Greenwich and Dey Streets

New York, New York, 1810

French travelers of the early nineteenth century were very much taken by the vitality of the country that they had recently helped to achieve independence. Those who were refugees from the revolutionary upheaval in France settled down for their temporary stay with open optimism about the New World's way of life. Even the aristocrats among them were often less inclined than British visitors to present themselves as propagandists of European culture.

In 1807 Jean Guillaume, Baron Hyde de Neuville, was banished from France on an accusation of being involved in conspiracies against Napoleon. He took refuge in the United States and stayed for seven years until the restoration of the Bourbon monarchy. In exile with him was his young and talented wife, Anne Marguerite Henriette Rouille de Marigny. While in America the baron and baroness made their home in a variety of locations. At one point they even raised merino sheep on a farm in New York State. Wherever they set up house and wherever they traveled, the young baroness took her brush and water colors along.

The two French exiles were very much intrigued by their American experiences, by the mixed population of the new nation, and particularly by the American attitude toward work. "In Europe," remarked the baron in his *Mémoires,* "we have been permitted some grandiose ideas whereby we deem useful occupations debasing."[19] A beribboned French girl would feel herself disgraced if asked to churn her own butter, he said, but here in the American countryside a pretty girl puts down her embroidery and, with equal aplomb, leads her cows to the fields. It was just such fleeting moments in the lives of ordinary people that drew the baroness to her easel, and she was interested not only in pastoral personalities that were quite new to her but also in the anonymous pedestrians of the cities.

In this drawing we are led to the corner of Greenwich and Dey streets, where the baroness fixed her attention on the comings and goings of anonymous New Yorkers. The scene is a mild winter's day. The trees are leafless, wood is being carted for a fire, but there is no snow and no one is bundled in heavy wraps. The two-story shuttered houses are fronted with spindle-legged gossip benches and, leaning over one of them, a couple gaze through a half-swinging Dutch doorway at their playing child. At the next house near the cellar opening, a solitary Oriental unknowingly poses for his portrait. Not too far to the right of him, a young lady is framed between two trees as she passes by in her stunning bonnet. At the corner, a boy presses hard on the lever of the city water pump to fill his bucket, while other neighborhood residents wait their turn. Across the way, fronting Greenwich Street, the imposing town house of John Stoutenburgh flaunts a weather vane, drain pipes, an iron fence, and a Federal-style entrance.

The artist has dated her diminutive watercolor "Janvier 1810," and we can well wonder what was happening in New York during her residence there in that month of January. One of the issues being debated at that time was food, and another was the level of the city's morals. The Common Council had just passed a law regulating the inspection of bread: all bread was now to bear the baker's initials and to be made from "good & wholesome flour." As to ethics, masked balls in taverns and boarding houses were henceforth prohibited. They were considered "of immoral and pernicious tendency, subversive of all just and honourable discrimination of character and calculated to encourage the profligate, seduce the youth of both sexes and promote licentiousness & disorder."

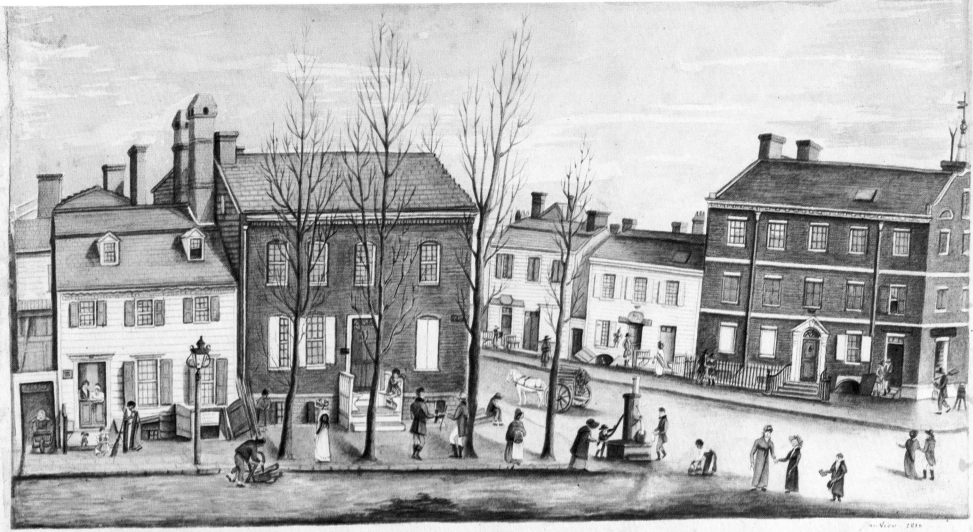

Corner of greenwich Street

CORNER OF GREENWICH STREET JANVIER 1810.
Artist: Baroness Hyde de Neuville. Water-color drawing. 1810. Size: 6.12 × 12.12 inches; 172 × 324 mm. Stokes Collection, Prints Division, The New York Public Library.

The Bombardment of Fort McHenry

Fort McHenry, near Baltimore, Maryland, 1814

Let Henry Clay, the politician from Kentucky and youthful Speaker of the House, explain the United States's entry into the War of 1812: "because England persisted in the practice of impressing American seamen; because she had instigated the Indians to commit hostilities against us; and because she refused indemnity for her past injuries upon our commerce."[20] These combative incidents that drew the United States into war were largely the outgrowth of a struggle between Britain and France to regulate the trade of neutral goods in Europe. The United States, the most important neutral nation engaged in commerce, found her goods subjected to a range of restrictive measures—including tariffs, protective insurance rates, blockades, and outright capture—imposed first by one side then the other. In short, American ships became the pawns of a power struggle between France and Great Britain. If a Yankee headed his ship directly for Europe, he was liable to have it seized by the British. If he sailed first to an English port, he would have to pay a fee before getting permission to proceed. If he then went on to the continent, he ran the risk of losing everything to the French.

The New England states did not go along with Henry Clay's clamor for war. Because northern shipping interests were better served by a program of peace and trade, even at the risk of seizure of ships on the high seas, there were threats of secession. By contrast, Clay reflected the southern attitude when he declared on the floor of the House, "I verily believe that the militia of Kentucky are alone competent to place Montreal and Upper Canada at your feet." When the War Hawks got their way, enthusiasm was high in Baltimore. There was an unprecedented rush of volunteers and a bustle to make ready for combat. Fort McHenry, in particular, needed attention—it was hardly in combat readiness. Located about three miles outside the city, the fort's water battery was totally destroyed, one of the platforms rotten, and some of the gun carriages unfit for service. There were also no furnaces. Two years later Baltimore had become an active military camp, and the fort was able to resist a heavy bombardment by a British fleet. Within a few months after the attack, the war was over.

The five arcs with their flares and bombs, issuing from the swarm of British ships in this rather primitive aquatint, are too decorative to evoke the deafening scream of the shells, the incessant roar of the cannon, and the terror of incendiary havoc that arose when Fort McHenry was besieged on September 13–14, 1814. The bombardment lasted about twenty-four hours, and probably few in Baltimore slept through the terror and the tension. Watching the scene from a truce boat behind enemy lines was an American lawyer-poet named Francis Scott Key. When at battle's end the flag had not been hauled down in victory by the British, he heaved a sigh of relief and expressed his delight in lines of verse jotted down on the back of an envelope.

Key's jubilant poem eventually became the national anthem. The verse was set to the music of an English drinking song that had been imported to America in the eighteenth century. "The Star Spangled Banner" honors the oversized (30-by-42-foot) flag commissioned especially for Fort McHenry. Made by Mary Young Pickersgill, a widow of Baltimore, the flag is prominent in the center of the engraving.

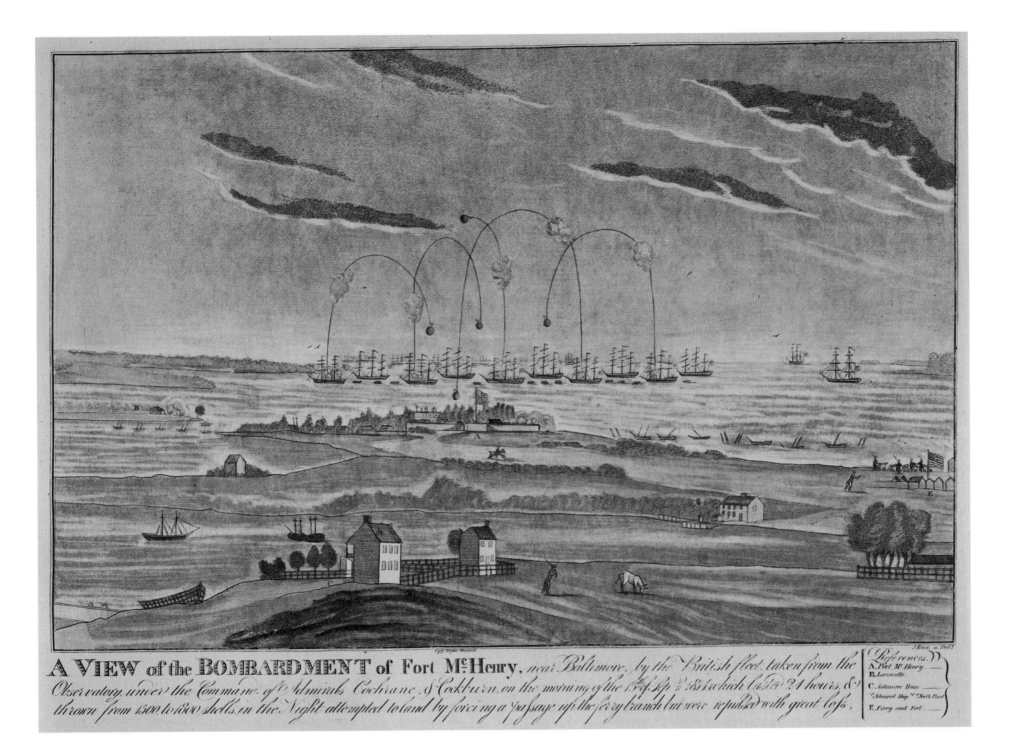

A VIEW of the BOMBARDMENT of Fort McHenry, near Baltimore, by the British fleet, taken from the Observatory, under the Command of Admirals Cochrane & Cockburn, on the morning of the 13th of Sepr. 1814 which lasted 24 hours, & thrown from 1500 to 1800 shells, in the Night attempted to land by forcing a passage up the ferry branch but were repulsed with great loss.

References.
A. Fort McHenry.
B. Lazaretto.
C. Salamore House.
D. Admiral Ship & North Point.
E. Ferry and Fort.

A VIEW OF THE BOMBARDMENT OF FORT MCHENRY, NEAR BALTIMORE, BY THE BRITISH FLEET, TAKEN FROM THE OBSERVATORY . . . ON THE MORNING OF THE 13TH OF SEPR. 1814. . . . J. BOWER, SC. PHILA. . . .

Aquatint. 1814. Size: 11.1 × 17.3 inches; 281 × 437 mm. Stokes Collection, Prints Division, The New York Public Library.

The Palisades

Hudson River, New Jersey, 1820

"Turtles scrambled out of the way as I stepped ashore from my boat for a close view of the formidable Palisades,"[21] wrote Jacques-Gérard Milbert, a French traveler who made a leisurely trip up the Hudson in the early nineteenth century, observing and sketching the myriad wonders of the eastern waterway. The spot where he sent turtles scurrying was at a landing opposite Yonkers, and as he stood at the foot of the towering Palisades, he felt them more imposing the closer he approached. The masses of gray rocks—with hickory, dwarf oak, and stunted cedars clustering and twisting within their crevices—presented pentagonal and hexagonal prismatic forms to him that suggested a basalt content. As he continued his way up the river, he found that the Palisades extended northward for about fifteen miles, rising in elevation from 200 to 600 feet. In some places, he calculated, an extra layer spiraled up as high as 668 feet. The fact that these bluffs, remarkable for their perpendicularity, were an exclusive feature of the western shore intrigued Milbert, though his training as a naturalist offered no explanation for the phenomenon. The eastern bank of the Hudson, which was neither so high nor so steep, contained no fragment of the kind of rock that the French traveler had closely observed on the other side.

Milbert was but one in a long line of distinguished visitors who observed the silent gray cliffs. The very first to enter the mouth of the Hudson was Giovanni da Verrazano, though he never managed to proceed upstream to the Palisades. As the depth of the river was unknown to him, he did not dare to risk entering it with his hundred-ton, trans-Atlantic caravel. He put out in a small boat instead, and guided by friendly Indians, ventured "half a league" up the new waterway when an unfavorable gale suddenly arose. Cautious and fearful for his men, he abandoned his notion of exploring the river and returned to his waiting *Dauphine*. That was in 1524. In the following century Henry Hudson, acting on behalf of the Dutch East India Company, pushed his luck way up the unfathomed river. Sailing past the towering Palisades in his *Half Moon*, the Englishman succeeded in getting as far north as Troy. It was a trip that would memorialize his name forever, but for Hudson it was a nautical dead end. He found the river navigable, but it was not a route to the Orient. Within a month he was sailing downstream past the Palisades again. In 1776 an entire army of Englishmen not only reached the Palisades but scaled them. With heavy cannon in tow, they made their way up the steep granite wall, routed the Americans, and captured Fort Lee. From their victorious foothold on top of the precipice, they looked down over the very spot where a French traveler would one day send innocent turtles scampering for cover.

Not long after the Revolution the Palisades were mute witnesses to an event of international impact: the successful run of a vessel under the power of steam. "The moment arrived in which the word was to be given for the boat to move," wrote Robert Fulton, describing the afternoon of Monday, August 17, 1807. "My friends were in groups on the deck. There was anxiety mixed with fear among them. They were silent, sad and weary. I read in their looks nothing but disaster, and almost repented of my efforts. The signal was given and the boat moved on a short distance and then stopped and became immovable. . . . I could hear distinctly repeated—'I told you so; it was a foolish scheme; I wish we were well out of it.'" But the problem with the mobility of the *Clermont* was only slight and Fulton managed to adjust it. To the amazement of all, including the inventor, the boat moved again. "We left the fair city of New York; we passed through the romantic and ever-varying scenery of the Highlands; we descried the clustering houses of Albany; we reached its shores. . . ."[22] In an afternoon of almost unbearable anxiety, Robert Fulton inaugurated a procession of steamers that would be passing beneath those noble Palisades again and again.

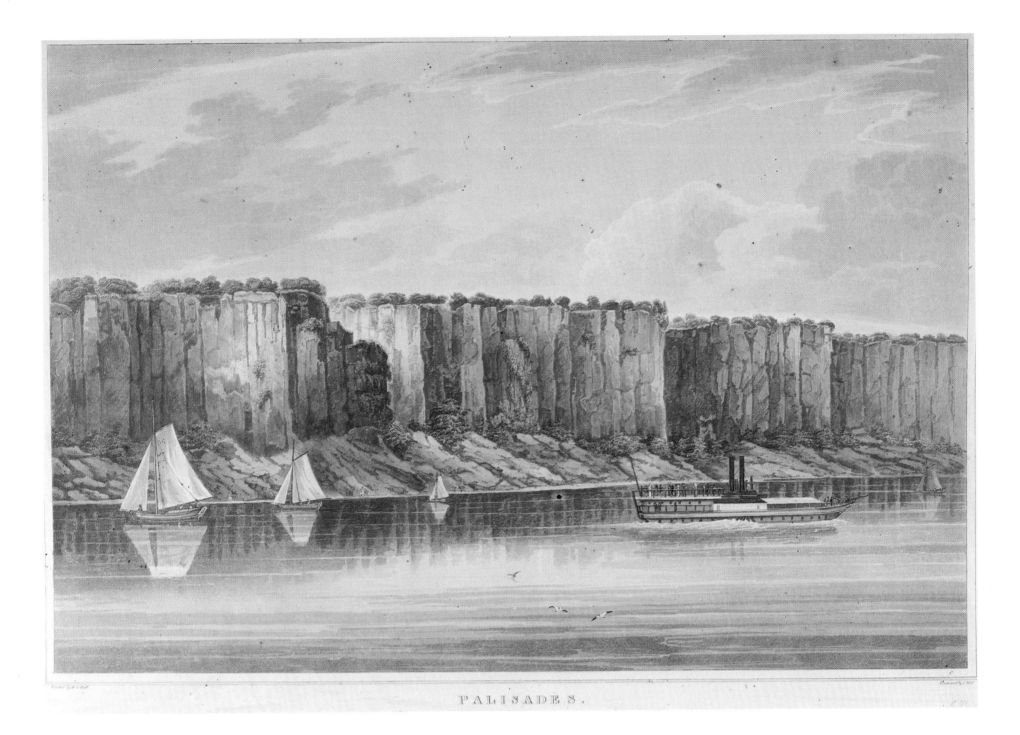

PALISADES.

PALISADES. PAINTED BY W. G. WALL. ENGRAVED BY I. [J.] HILL. NO. 19 OF THE
HUDSON RIVER PORT FOLIO. PUBLISHED BY HENRY I. [J.] MEGAREY NEW YORK.
Aquatint [published about 1825]. 1820. Size: 14.8 × 21.6 inches; 369 × 543 mm.
Stokes Collection, Prints Division, The New York Public Library.

Castle Garden and the Battery

New York, New York, about 1825–1828; 1838

This has been a gala-day in New York. The British steamer "Great Western," [and] Captain Hoskin, sailed at two o'clock from Pier No. 1, North River. All the city went to behold the sight. The Battery was a mass of living witnesses to this event. Castle Garden was filled, and all the adjacent wharves and houses were thronged with spectators. When the steamer started she was accompanied by a dozen large steamboats with crowded decks and ornamented by flags, among which the loving embraces of St. George's Cross and the Stars and Stripes were conspicuous in every instance.[23]

So wrote Philip Hone in his diary for May 7, 1838. The famous diarist had promoted New York in deed as well as word following his election as the city's mayor in 1825.

It was not only a gala day, but a gala year for coming down to the Battery, pressing against the railing at Manhattan's water edge, and watching some breathtaking nautical events. The *Great Western* was causing excitement because she was the second ship to cross the Atlantic under the exclusive power of steam. The first such ship had been the *Sirius,* which arrived from Cork on April 22 after having made the crossing in a record eighteen days. The very next day the *Great Western* arrived, virtually in the first ship's wake. She was a much larger vessel, with an engine of four hundred horsepower, and so ornately decorated that her principal saloon looked like "a cabinet of old Dresden china." With the arrival of the two ships and the excitement of crowding aboard to inspect them, the city was in a ferment the whole week. And, from the mayor's diary, the departures of the ships were clearly as tumultuous as the arrivals.

Castle Garden was a good lookout point. Located on the Battery, it was a sort of pleasure dome; it was there that trans-Atlantic visitors, like the Marquis de Lafayette and Jenny Lind, were exultantly received. Fortunately, the Battery view and the drawing of Castle Garden from a decade earlier are not too crowded with spectators for us to look at them, in turn, with curiosity, as New Yorkers, both male and female, were very much admired at this time by visitors from abroad. There were many comments on their good looks, their costumes, and their animation, and on their role in giving the city its heightened ambience. One English visitor, James Silk Buckingham, found that the women were almost uniformly attractive. In England, he said, they would be called pretty, "something between good-looking and handsome, in the nice distinctions of beauty." He also found that a generalization could be made about their figures "which are almost universally slender and of good symmetry. Very few large or stout women are seen, and none that we should call masculine." The men, in his view, did not come off so handsome as the women, but he found them well turned out and the fashionable among them more expensively dressed "than the same classes in England."[24]

The bay of New York, however, was not exclusively a background for the latest fashions on parade or a docking place for the latest in ships. Immigrants were arriving in packets that were hardly Dresden china shops. Of the five thousand or more who had landed at the port of New York in the first half of May 1837, one hundred had immediately applied for relief at the Almshouse, and some had begun to beg the very day they reached the city. To counter the situation, captains of these packets were required to report to the mayor himself on the background of each of their passengers. This was to be done within twenty-four hours. Every alien, under penalty of one hundred dollars' fine, was also required to report personally within that same period of time. As the entry regulations became more stringent, shipmasters evaded the law by landing their passengers in New Jersey, from where they immediately made their way to New York. For there, after all, was America's center of the expanding market for cheap manual labor.

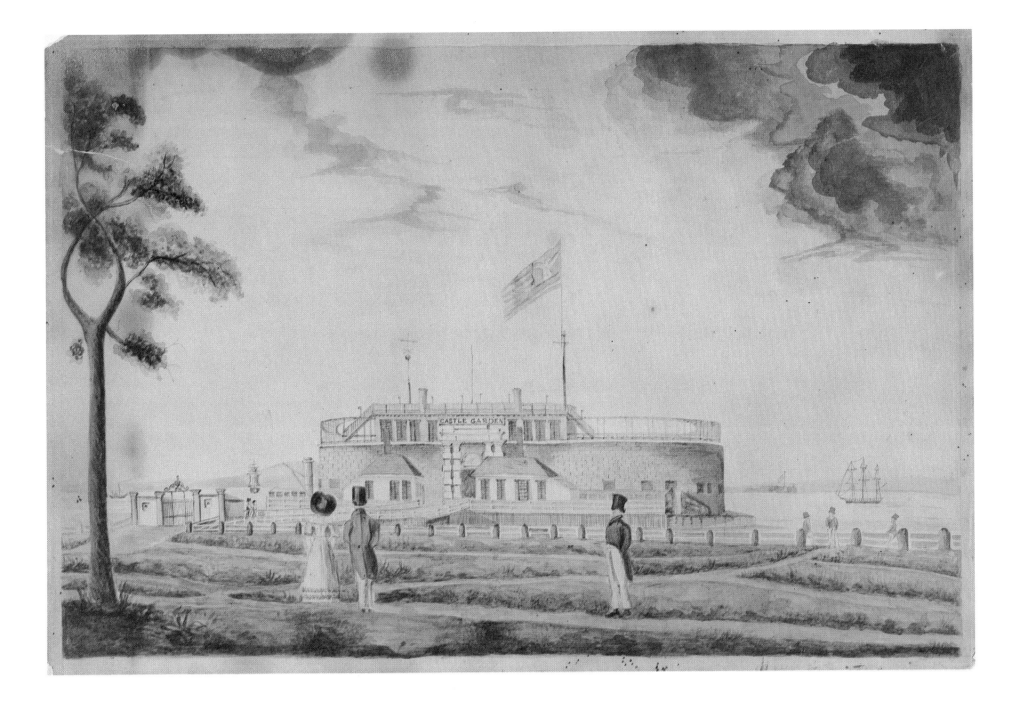

[CASTLE GARDEN, NEW YORK.]
Water-color drawing. About 1825–1828. Size: 9.11 × 14.8 inches; 246 × 368 mm.
Stokes Collection, Prints Division, The New York Public Library.

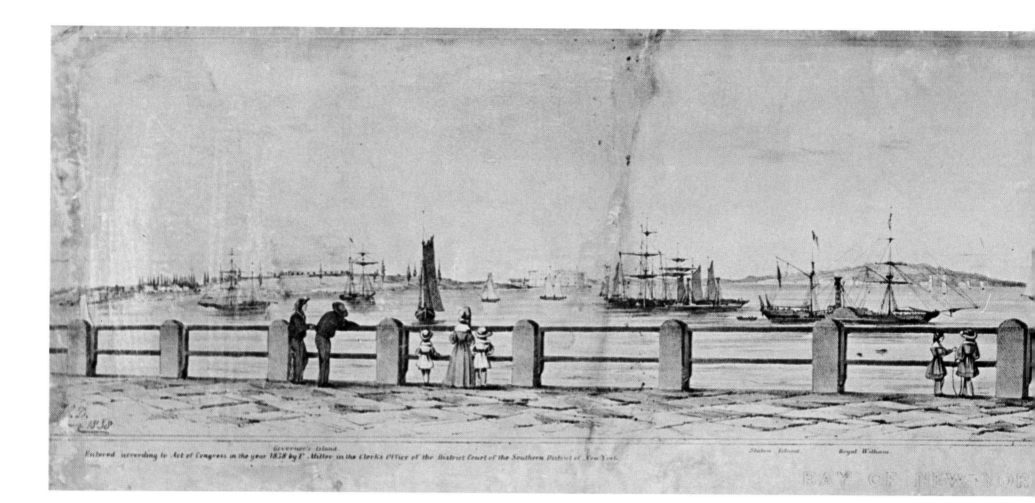

Governor's Island. Staten Island. Royal William.

Entered according to Act of Congress in the year 1838 by P. Miller in the Clerk's Office of the District Court of the Southern District of New York.

BAY OF NEW YORK

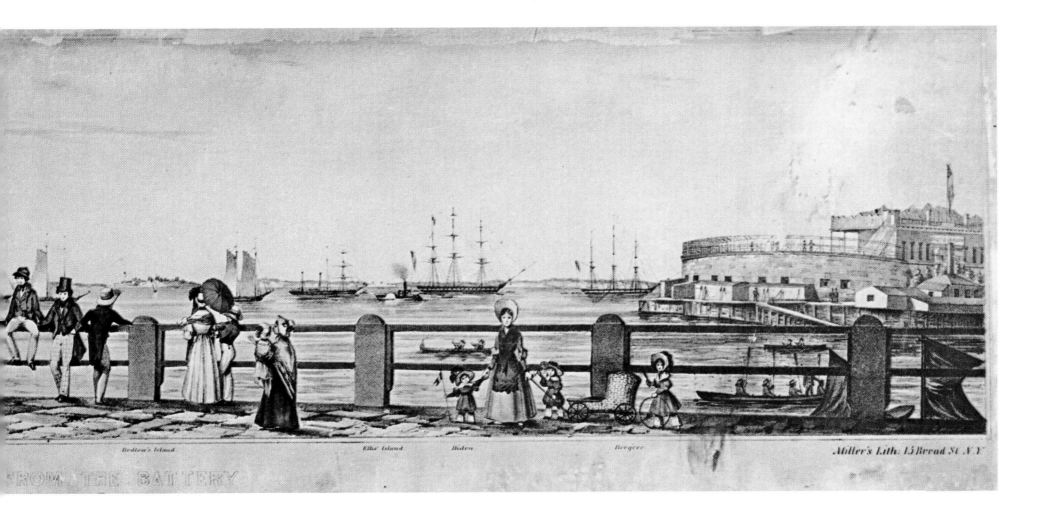

BAY OF NEW YORK, FROM THE BATTERY. H. D. 1838. ENTERED . . . 1838 BY P.
MILLER . . . MILLER'S LITH: . . . N. Y.
*Lithograph. 1838. Size: 6.11 × 33.13 inches; 170 × 859 mm. Stokes Collection, Prints
Division, The New York Public Library.*

Broadway from the Bowling Green

New York, New York, about 1826

The period of depression immediately following the War of 1812 eventually gave way to wonderful prosperity, and New York grew in leaps and bounds. In 1825 the population reached 162,000, and its commerce expanded to remarkable proportions. Sixteen packets made regular trips between New York and Liverpool, four more were in the trade to Le Havre, seven to Savannah, ten to Charleston, and four to New Orleans. Sailing vessels of all descriptions made regular trips to intermediate points of importance on the coast. About thirteen hundred vessels entered the port of New York annually, and the city's inland trade, transported by way of the Hudson River and the Erie Canal, was equally remarkable. Even domestic chores could be accomplished through frequent local service on the waterways. When Washington Irving was building his dream house near Tarrytown, N.Y., on the Hudson, he asked his brother Ebenezer to send up an inscription stone from town "by the Friday sloop or Saturday morning steamboat." New York's finances were in such viable shape that the duties on goods collected in one year exceeded the dollars collected in the five cities of Boston, Philadelphia, Baltimore, Norfolk, and Savannah together. Merchants from every part of the country came to the city to transact their business. New York had become the metropolis of the growing nation.

Wealth meant showing off wealth, and Broadway was just the street for it. Beginning with No. 1 Broadway at the Bowling Green, there was an elegant parade of town houses to match the parade of elegant people. Parasoled ladies in their slim, uncluttered dresses of the period, accompanied by pantalooned daughters and broad-hatted sons, promenaded in the open afternoon air. Men made their way about town garbed with a Beau Brummell nattiness, escorting their ladies by coach, astride a horse, or by the ever popular transport: walking. Going up Broadway toward Trinity Church, the town strollers passed the Bowling Green, lush now with the trees that replaced the statue of George III.

The first house to the left, the Kennedy mansion, had a Revolutionary history. George Washington lived there after its British occupation by Sir Henry Clinton, Sir Guy Carleton, and Sir William Howe. Built in the mid-eighteenth century, it was bought by Archibald Kennedy from Abraham De Peyster at a time when the property included several small dwellings facing Battery Place. We see the house with its original eighteenth-century construction; a third and fourth story were added later. No. 3 Broadway, just north of this mansion had also been owned by Archibald Kennedy. He sold it to John Watts, and the house in this view is the one built by the new owner. Farther on is a large white building where the Washingtons lived in 1789 when George became President. Publicity-shy Martha was lonely when her husband was absent. In a letter dated October 22 she confessed: "I lead a very dull life here and know nothing that passes in the town. I never goe to any publick place,—indeed I think I am more like a state prisoner than anything else, there is certain bounds set for me which I must not depart from—and as I cannot doe as I like I am obstinate and stay at home a great deal."[25]

William Bennett probably made his drawing prior to 1827: he does not show the gas lamps that were put up that year on Broadway from Battery Place to Canal Street. Nor are there clues to the many problems existing in the city. Keeping the streets clean was one of them: The Common Council had recently resolved to purchase "a sufficient number of horses and carts, not exceeding 40, to remove the street manure." It is the social and architectural glamour of New York that Bennett wished us to see in his finished aquatint.

[BROAD WAY FROM THE BOWLING GREEN. WM. I. [J.] BENNETT PINXT. ET SCULPT. HENRY I. [J.] MEGAREY [PUBLISHER] NEW YORK.]

Aquatint [proof before caption, about 1834]. Probably drawn in 1826. Size: 9.7 × 13.6 inches; 241 × 304 mm. Eno Collection, Prints Division, The New York Public Library.

The Erie Canal

Erie Canal, New York, 1830–1832

Arranged for The New York Public Library by Ella Milbank Foshay

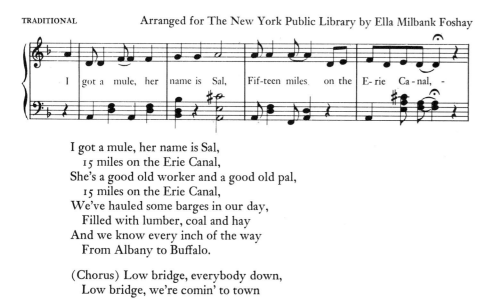

I got a mule, her name is Sal,
 15 miles on the Erie Canal,
She's a good old worker and a good old pal,
 15 miles on the Erie Canal,
We've hauled some barges in our day,
 Filled with lumber, coal and hay
And we know every inch of the way
 From Albany to Buffalo.

(Chorus) Low bridge, everybody down,
 Low bridge, we're comin' to town

And you'll always know your neighbor, you'll always know your pal
If you've ever navigated on the Erie Canal.

Canals are elaborate ditches that were first dug for irrigation almost as soon as men learned that the land could be sown. Examples of this primitive type of canal, dug by the Indians of North America long before the arrival of settlers, can still be found in New Mexico and Arizona. Canals dug wide and deep enough for transportation by water through landlocked interiors were a much later development.

Amsterdam and Venice, which have canals for streets and which transport their residents in water buses, water taxis, or graceful gondolas, are among the most picturesque cities in Europe. New York, Dutch in origin, had a canal almost from the beginning. Used for transport and fire fighting, the waterway extended from the harbor right up Broad Street and was long enough to warrant three bridges. When a stench arose from the rubbish and dead animals often thrown into it, placards were posted threatening the culprits with fines.

A canal that stirred the imagination of everyone was the Erie, and it prompted a frenzied chain of canal building in the nineteenth century, halted only by the success of the railroads. When the possibility of linking the Atlantic with the Great Lakes was first put forward, even George Washington concerned himself with the daring idea. He saw it as a means of political unity as well as of commercial expansion. In 1784 he made a tour through the Lake George and Lake Champlain region and personally explored part of the route that would eventually be considered by the canal commissioners. During his trip he was very taken with the vast extent of the country's waterways and remarked soon after, when writing to the Marquis de Chastellux, "Would to God we may have wisdom to improve them!"

The wisdom was there, along with the energy and even the money. Ground was broken at Rome, New York, on July 4, 1817, in the presence of great crowds of cheering citizens. Part of organizing the work had been to divide the line of the proposed canal into four sections and appoint engineers to each. As separate portions of the new waterway were completed, they were put into operation. The tolls collected were so large that the financial success of the undertaking was early assured, and in 1825 the job was done: a waterway had been built connecting Lake Erie with the Hudson River, at a cost of seven million dollars.

The expectations of what the canal would do for the country were realized. It opened eastern markets to the farm products of the Great Lakes region, facilitated immigration to the west, and helped to create numerous large cities. It also gave the young country a strong sense of economic independence. In New York, where there was great state pride in the achievement, towns and little hamlets—with their busy barges and pastoral charm—sprang up all along the line of the canal from Albany to Buffalo. The city of New York probably reaped the greatest benefit from this invigoration of the economy. The three hundred and fifty miles of the Erie Canal brought such a monopoly of rich trade to the city that it was able to wrest from Philadelphia final claim to the rôle of metropolis of the New World.

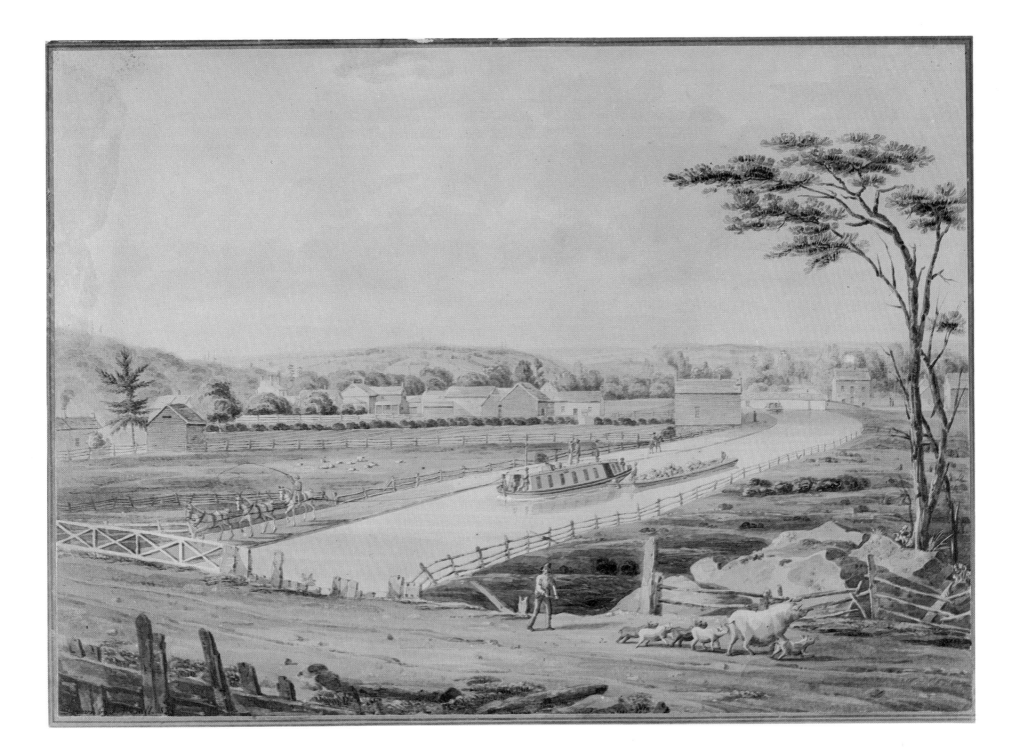

[VIEW ON THE ERIE CANAL.]
Artist: J. W. Hill. Water-color drawing. 1830–1832. Size: 9.10 × 13.9 inches; 244 × 345 mm. Stokes Collection, Prints Division, The New York Public Library.

A Prospect of Richmond

Richmond, Virginia, probably 1833

Richmond occupies a very picturesque and most beautiful situation. I have never met with such an assemblage of striking and interesting objects. The town, dispersed over hills of various shapes, . . . the river descending from west to east and obstructed by a multitude of small islands, clumps of trees and myriads of rocks, among which it tumbles, foams and roars, constituting what are called the falls. . . . the same river, at the lower end of the town, bending at right angles to the south, and winding reluctantly off for many miles in that direction, . . . then again, on the opposite side, the little town of Manchester, built on a hill, which, sloping gently to the river, opens the whole town to the view, interspersed as it is, with vigorous and flourishing poplars, and surrounded to a great distance by green plains and stately woods. . . . all these objects falling at once under the eye, constitute, by far the most finely varied and most animated landscape that I have ever seen. A mountain, like the Blue Ridge, in the western horizon, and the rich tint with which the hand of a Pennsylvanian farmer would paint the adjacent fields, would make this a more enchanting spot than even Damascus is described to be.[26]

The description was provided by William Wirt, a lawyer living in Richmond in 1803. The aquatint of the Virginia capital was executed three decades later just as Wirt would have wished it to be, and just as he had described the city. It was not done by a Pennsylvania farmer, but by George Cooke, a Maryland painter, and by William James Bennett, an engraver born in London. The happy result of their artistic collaboration brings us directly to the Richmond of Edgar Allan Poe and to lines from his early *Tamerlane*:

> In Spring of youth it was my lot
> To haunt of the wide world a spot

> The which I could not love the less—
> So lovely was the loneliness.

Poe may have found the spot he sought in Richmond, the city where he spent most of the "Spring" of his youth. The loveliness he writes of is in the majesty of Richmond's buildings, and the "lovely" loneliness in the romance of the sheltering surroundings. It is a city that belonged not only to Poe but to a whole roster of historic personalities who in one way or another left their mark there: the powerful Indian Powhatan, the settler William Byrd, George Washington, Patrick Henry, Thomas Jefferson, Benedict Arnold, Lord Cornwallis, among them. The names and deeds tied to Richmond's early history are long and impressive, and they stretch from the sixteenth century through the whole course of the terrible Civil War.

In 1833, however, Richmond was a peaceful city. What Poe saw from the wooded heights was a pastoral scene, almost overwhelming in its luxuriant shades of green. He could follow the leisurely path of the canal with its dainty bridge, glance left at the familiar white walls of Benjamin Latrobe's Penitentiary festooned with a garland of forest and, straight ahead of him, gaze on the domed City Hall and the State Capitol designed by Jefferson. These classic buildings, standing in unobscured splendor, overlooked a descending cluster of mills and factories powered by water.

> Fair River! in thy bright, clear flow
> Of crystal, wandering water,
> Thou art an emblem of the glow
> Of beauty.

Poe was soon to leave the James River and the majestic Virginian city, but he was never to forget them. "I am a Virginian . . .," he wrote in 1841, "for I have resided all my life, until within the last few years, in Richmond."[27]

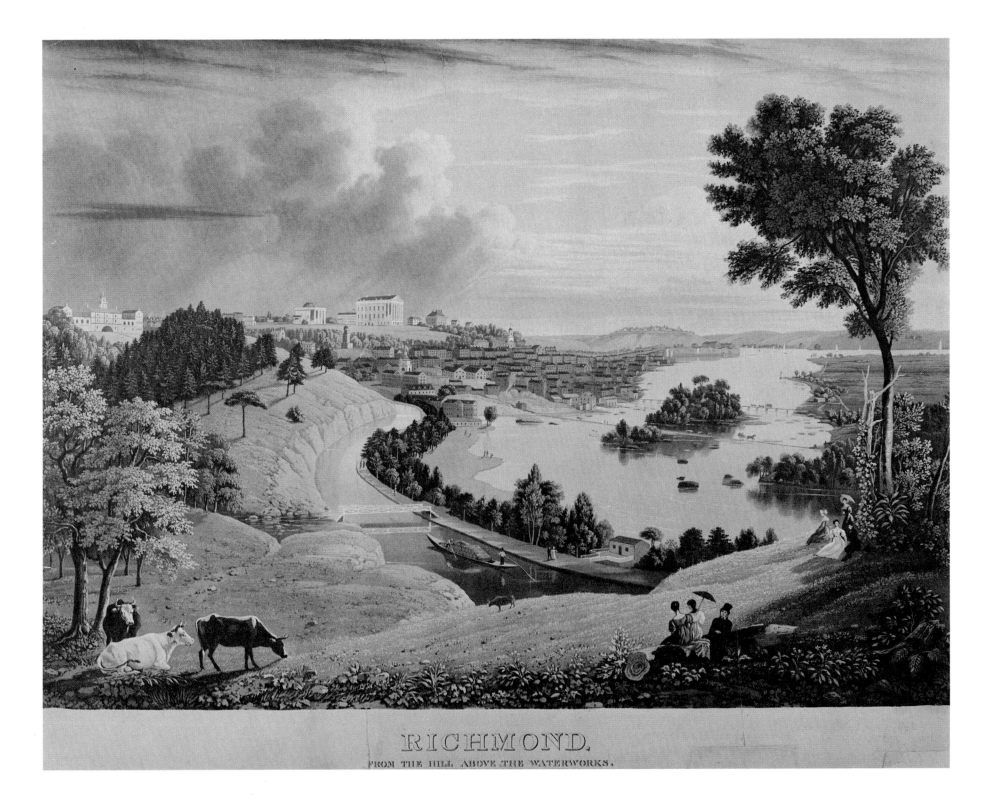

RICHMOND,

FROM THE HILL ABOVE THE WATERWORKS.

RICHMOND, FROM THE HILL ABOVE THE WATERWORKS. [ENGRAVED BY W. J. BENNETT FROM A PAINTING BY G. COOKE. ENTERED . . . 1834 . . .].
Aquatint. Probably 1833. Size: 17.13 × 25.1 inches; 452 × 637 mm. Stokes Collection, Prints Division, The New York Public Library.

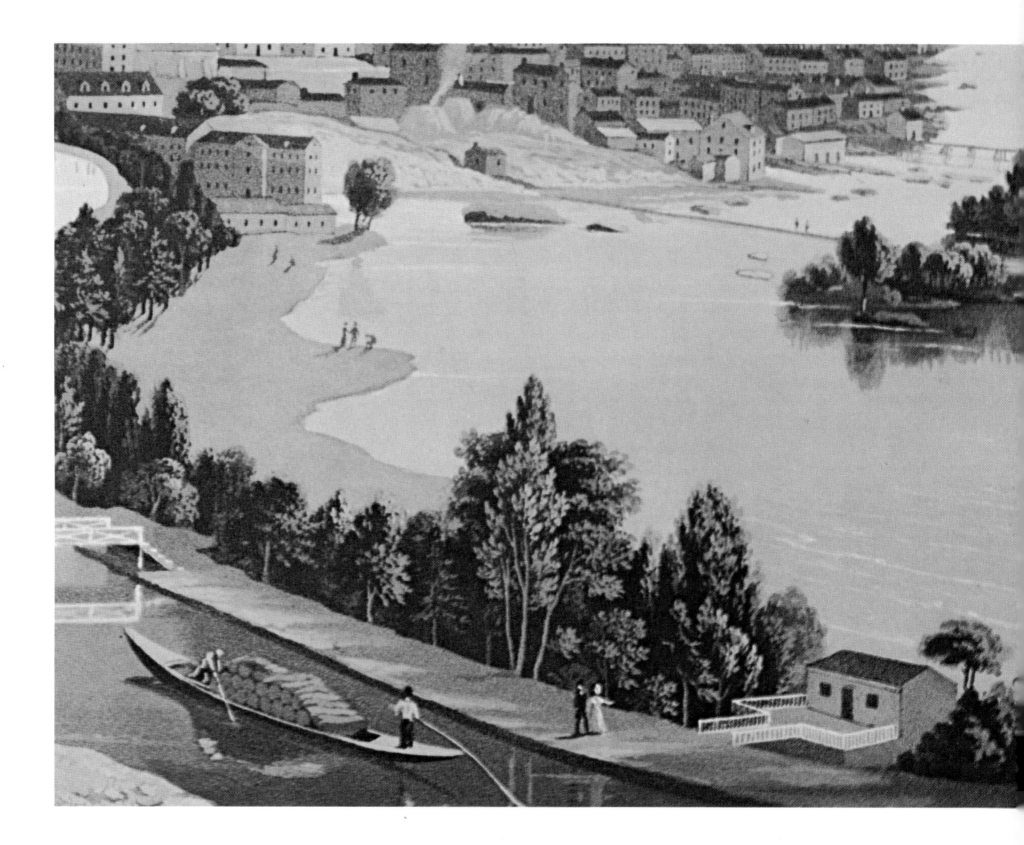

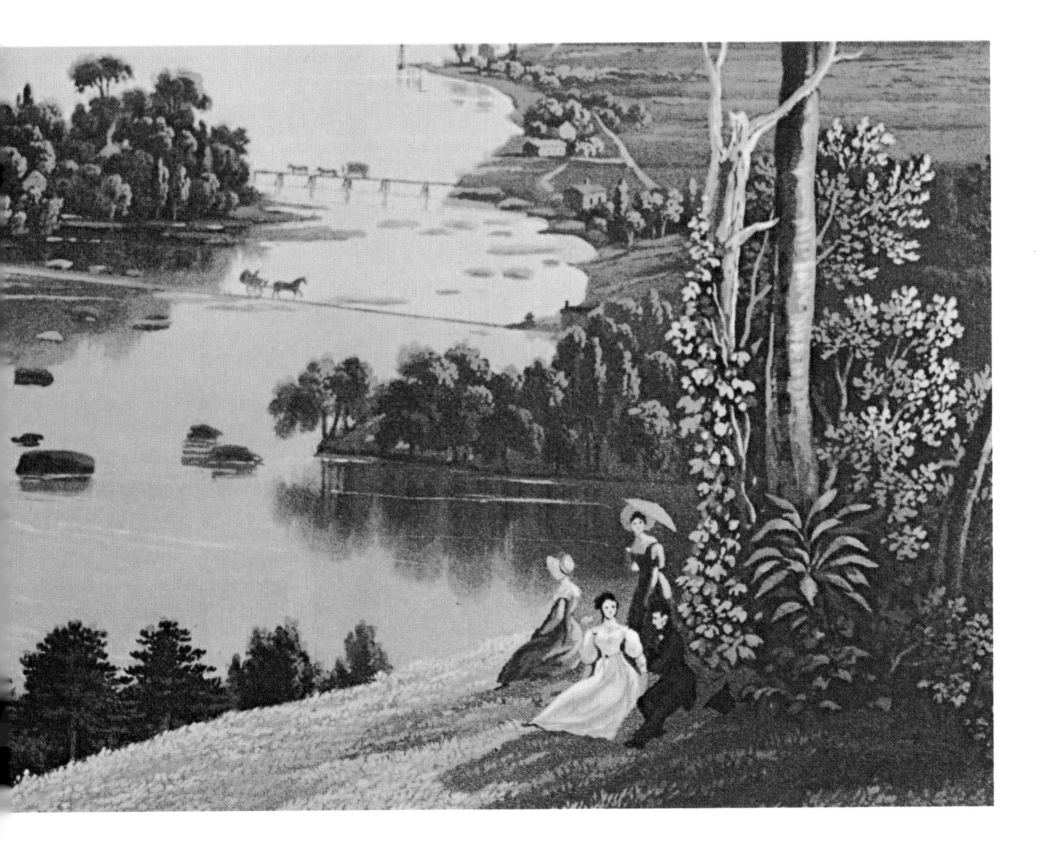

A Hudson River Baptism

New York, New York, 1834

The ceremony was due to take place at ten o'clock in the morning; it was around the end of September then, the weather was humid and very cold, and a heavy fog clouded the air. Covered in a garb of black wool, and led by two companions dressed the same way, the young [eighteen-year-old] girl left her home where parents, friends and ministers had assembled. Her somber costume, and the reticence of those who accompanied her gave the ceremony the air of a funeral rather than a celebration. The procession arrived at the river bank; the minister, after having said a prayer, entered the river to choose a suitable place; then he returned to fetch the convert to have her enter the water with him . . . grabbing the young girl by her waist, he plunged her completely and repeatedly in the waters of the river. She screamed so loud at this sudden immersion, she could be heard far down the shore. . . . Shivering with cold and drenched with water, she was conducted on the arms of her companions to a house in the village where she was warmed and changed. . . . I was told soon after that she refused to allow herself to be stripped of her baptismal garments for a very long time.[28]

The year was 1815, and the place Sandy-Hill, somewhere along the upper reaches of the Hudson River. Jacques-Gérard Milbert, a French traveler, had accepted with curiosity and delight the invitation to attend an immersion ceremony. It would be a particularly exciting opportunity for him as France had no Baptist community and would have none until two decades later. New York City, on the other hand, could boast of one for more than a century. It is true that Baptists did not exist in any great numbers but, then, few of the many religious sects that flourished side by side in colonial Manhattan had large followings: the religious spectrum to choose from was wide. "New York has first a Chaplain belonging to the Fort of the Church of England," reported Governor Thomas Dongan to London in 1687, "secondly a Dutch Calvinist, thirdly a French Calvinist, fourthly a Dutch Lutheran—Here bee not many of the Church of England; few Roman Catholicks; abundance of Quakers preachers men and Women especially; Singing Quakers; Ranting Quakers; Sabbatarians; Antisabbatarians; Some Anabaptists some Independants; some Jews; in short of all sorts of opinions there are some, and the most part, of none at all."[29] And Governor Sir Edmund Andros later complained that "Ministers have been so scarce & Religions many that noe acct cann be given of Childrens births or Christenings."

One of the reasons for the scarcity of ministers was the riskiness of the profession. Although the English were more relaxed than the Dutch in tolerating a variety of religious opinions, the practice of religion was strictly controlled. In 1709 there was a Baptist minister in the city, but because he had no license from the royal authorities to preach, he was jailed. Compared with John Bunyan's, his sentence was light—three months as opposed to twelve years. As the wave of imprisonments and fines for Baptists diminished and as the number of those with Baptist sentiments swelled in colonial New York, meetings that were first held in private houses could now be held in a William Street loft. In 1762 the First Baptist Church was built on a plot of ground purchased on Gold Street. It was used as a stable when the British occupied the city during the Revolution, the victors having confiscated most of the churches for military use. The Baptist congregation, like others, was then widely scattered. Out of two hundred registered members of the church, only thirty-seven could be rounded up when hostilities ended. But it was not long after the war that the number of Baptist registrants increased considerably: by 1834 there were as many as seventeen churches in the city of New York alone. The northernmost of these Baptist churches, located on Bedford Street at the corner of Christopher, was called the North Baptist Church and its minister was the Reverend Jacob H. Brouner. It may be that the young lady in white baptismal garments and her attending minister, whom we see here waist-deep in the waters of the Hudson, belonged to that parish. The church was not far from the White Fort, erected during the War of 1812, at the foot of Gansevoort Street. We can see the fort jutting out into the River, providing a good staging area for those who have come, like us, to witness a Baptist immersion.

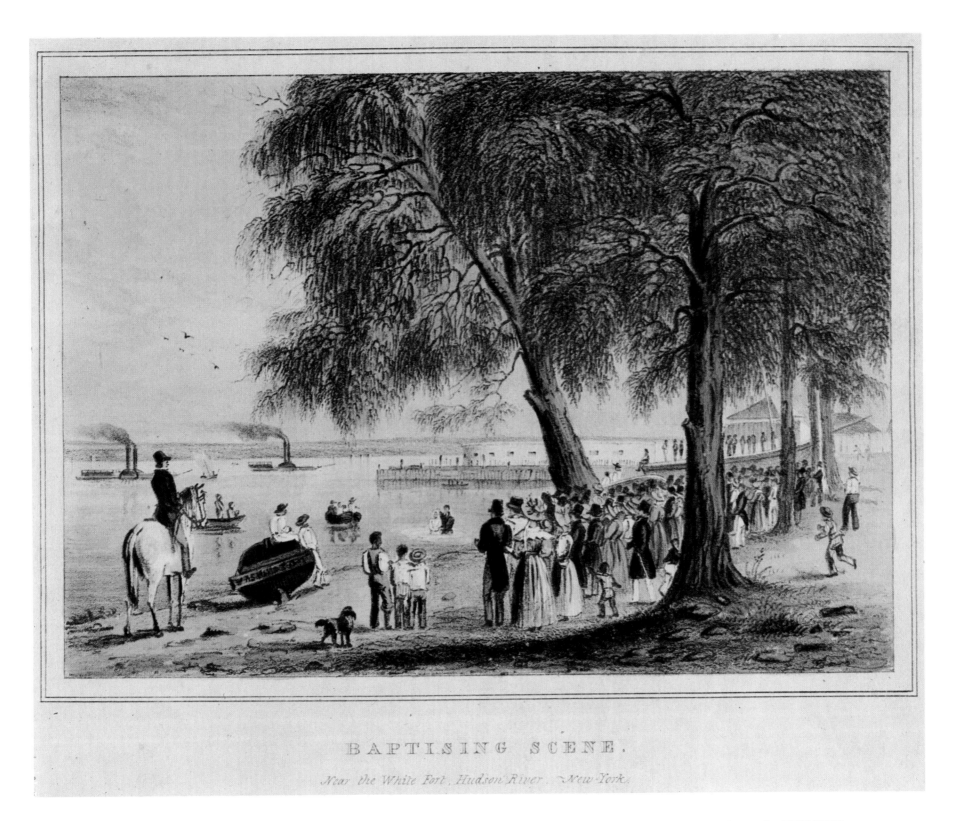

BAPTISING SCENE.

Near the White Fort, Hudson River.—New-York.

BAPTISING SCENE. NEAR THE WHITE FORT, HUDSON RIVER.—NEW-YORK.
Lithograph. 1834. Size: 6.5 × 8.15 inches; 160 × 227 mm. Stokes Collection, Prints Division, The New York Public Library.

The Shops of Broadway

New York, New York, probably 1835

We are looking north. The city omnibus, with its top-hatted coachman and its four horses moving smartly in a measured trot, has wheeled down Greenwich Street and turned left into the broad thoroughfare of Canal Street. At any moment it will angle another turn down Broadway. It will compete in traffic with a whole assortment of gigs, cabriolets, wagons, carts, and other coaches (usually chased by dogs) before it is pulled into the final stretch of its passenger run on Wall Street. It will compete, too, in noise and bustle with the tradespeople selling their wares in the open and with the hurrying droves of elegant and demanding shoppers. Broadway has always been full of vitality!

If we begin at the right, we are drawn to bootmaker Jonas Greene's outside display of footwear. His shop is next to John Wright's large hat, cape, and fur warehouse. In front of Wright's, an itinerant tradesman stands with a long hand-rack of boots. Will he lure some of the trade away from Greene's shop, or is he himself in Greene's employ? Across Canal Street on the upper floor of the corner building is the Branch of the British College of Health, or Hygeian Depot, a drugstore with a fancy name. On the ground floor is Joseph Stanley, an importer of books, prints, and stationery, whose two storefronts are divided by the Franklin Library and Reading Room. Farther north on Broadway is the Bank Coffee House, and beyond that is Tattersall's, housed in the building with a steep gable roof. Tattersall's, a name taken from a similar establishment in London, was a horse market, riding school, and livery stable. In 1846 it would become the largest horse market in the United States.

Moving to the west side of Broadway, we see a curl and wig shop and, across the street, the large corner store of John J. Marshall. The ladies who have entered Marshall's will probably spend a long time there. They will choose from among the yards and yards of expensive fabrics required for the fashioning of their billowy costumes. We do not see Niblo's Garden, located at the northeast corner of Broadway and Prince Street, in the diminishing perspective of the view. Considered by some to be the best entertainment place in the city, Niblo's consisted of a theater, a hotel, and a garden with walks, flowers, and trees. A good place to entertain distinguished visitors, Niblo's had, not too long before, welcomed President Andrew Jackson during his tour of New York.

But what are those hitching posts lining the streets? A foreign visitor, whose curiosity was also provoked, tells us:

> A custom prevails, in the principal streets for shops, of having wooden pillars planted along the outer edge of the pavement, with horizontal beams reaching from pillar to pillar, not unlike the stanchions and crosspieces of a rope-walk. On these pillars, usually painted white, are pasted large printed placards, announcing the articles sold in the shop before which they stand; and from the under side of the horizontal beam are suspended, by hooks or rings, show boards with printed bills of every colour. This is especially the case opposite the book-stores. Another purpose which these pillars and beams serve is that of suspending awnings from the houses to the end of the pavement in summer, which must make the shade grateful to the foot passenger; but at all other times these wooden appendages, made as they are without regard to regularity or uniformity, are a great drawback to the otherwise good appearance of the streets. Broadway, which is greatly disfigured by these, is therefore much inferior to Regent Street in London. . . .[30]

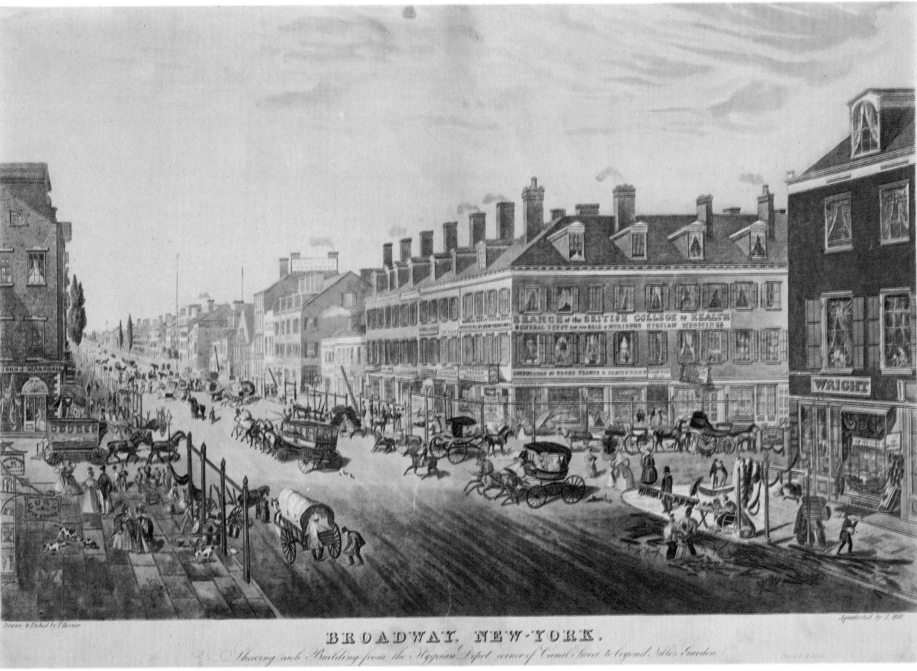

BROADWAY, NEW-YORK.

Shewing each Building from the Hygeian Depot corner of Canal Street to beyond Niblo's Garden.

BROADWAY, NEW-YORK. SHEWING EACH BUILDING FROM THE HYGEIAN DEPOT CORNER OF CANAL STREET TO BEYOND NIBLO'S GARDEN. DRAWN & ETCHED BY T. HORNOR. AQUATINTED BY J. HILL. PUBLISHED BY JOSEPH STANLEY & CO. . . . ENTERED . . . 1836.

Aquatint. Probably 1835. Size: 17.12 × 27.4 inches; 424 × 692 mm. Eno Collection, Prints Division, The New York Public Library.

New York from Brooklyn Heights

Brooklyn and New York, New York, probably 1836

Seventeenth-century Brooklyn Heights was once a bower of wooded loveliness: it teemed with oaks, maples, cedar, birch, and holly, and with a great variety of fruits and berries. The gathering of strawberries was a rollicking festival and the merriment of it pealed with a medieval ring:

> The Fruits natural to the Island are Mulberries, Pesimons, Grapes great and small, Huckelberries, Cramberries, Plums of several sorts, Rasberries and Strawberries, of which last is such abundance in June, that the Fields and Woods are died red: which the Countrey-people perceiving, instantly arm themselves with bottles of Wine, Cream, and Sugar, and instead of a Coat of Male, every one takes a Female upon his Horse behind him, and so rushing violently into the fields, never leave till they have disrob'd them of their red colours. . . .[31]

Daniel Denton, a native of Long Island, published this Pied Piper description in the year 1670. It was calculated to entice settlers from England to the colony of New York and to the "Places thereunto Adjoyning." Although Denton innocently claimed that he had not colored his account of the island, it exhibits the same pride and passion that often embellishes the prose of other natives of the region. "The topography of the City of Brooklyn is very fine," wrote a reporter for the Brooklyn *Standard*, about two centuries later.

> Indeed it is doubtful if there is a city in the world with a better situation for beauty, or for utilitarian purposes. As to its healthiness, it is well known. No wonder it took the eyes of the early Holland immigrants. It is hilly and elevated in its natural state—and these peculiarities, graded down somewhat by the municipal improvements, but still preserved in their essential particulars, give us a sight of unsurpassed advantage and charming scenery.[32]

The reporter was the poet Walt Whitman.

Today's residents of Brooklyn Heights would agree with Whitman that theirs is a more choice location to live in than overcrowded Manhattan. Indeed, Whitman insisted that even the Dutch thought so from the very beginning. They selected Manhattan as a trading post, he said, whereas Brooklyn Heights, with its sweeping panorama of the confluence of waters, was chosen for their *residence*. And in 1836 if one had a fine residence in Brooklyn Heights and stood on the balcony on a fine day, the view, so early admired by the Dutch, was quite breathtaking. Across the western sky, Manhattan's spires, cupolas, domes, and chimneyed buildings had steadily expanded, while the nautical traffic in and out of the harbor had become voluminous and varied. There were packets from New York to London, Liverpool, and Le Havre on regular schedules and packets from New York to the West Indies and South America. The first steamboat across the Atlantic had not yet made its run, but steamboats were serving all important domestic ports. Two thousand two hundred and eighty-five vessels entered the port of New York during the course of the very year that the gentleman, standing on the balcony of his house above Furman Street with his exquisite wife, took out his telescope and took stock of the panorama unfolding at his very doorstep.

If we may borrow the telescope next, we can fix our eye on some landmarks: the domed building to the left is the Merchants' Exchange, which had suffered a fire in 1835; Trinity Church is not far north of it. The six-story white building in line with the smokestack of the steamboat *Boston* is Holt's Hotel. Farther on is the City Hall and, somewhat north of that, the Hall of Justice. Across the Hudson are the towns of Jersey City, Hoboken, and Weehawken, while gliding in and out of the pale blue waters are many pleasure sloops and yachts.

The great financial crash of 1837 was yet to come.

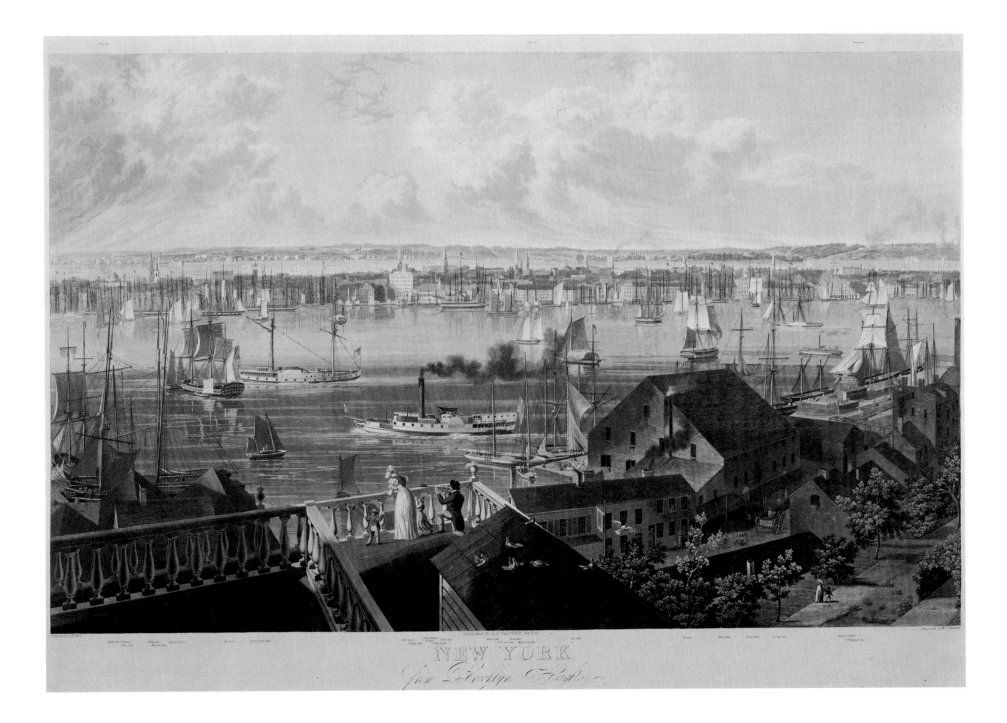

NEW YORK, FROM BROOKLYN HEIGHTS. PAINTED BY J. W. HILL. ENGRAVED BY W. J. BENNETT. PUBLISHED BY L. P. CLOVER NEW YORK. ENTERED . . . 1837. *Aquatint. Probably 1836. Size: 19.8 × 31.12 inches; 495 × 807 mm. Stokes Collection, Prints Division, The New York Public Library.*

Detroit from the Canadian Shore

Detroit, Michigan, probably 1836

SI QUAERIS PENINSULAM AMOENAM CIRCUMSPICE: If thou seekest a beautiful peninsula, behold it here! The motto belongs to Michigan, the scene to Detroit. We are given a view not of the whole peninsula as it reaches northward into the water to be elegantly crowned by two of the Great Lakes, but a sampling of it. We can be content with the sampling, for it is a part of the *peninsula amoena* which tilts eastward toward Canada to show us a fairylike citadel.

The city of Detroit had been slow in the making and slow in the gathering of its charms and wealth. For a long time after it was founded in 1701 by Antoine de la Mothe Cadillac, it remained hardly more than a trading post. To some extent it was prevented from rapid development by the British, who, in anti-French fits, inspired the Indians to raid it, and it was later stifled in its growth by the French and Indian War. The French, who gave Detroit its name and its initial prosperity, were intent on making it permanently theirs in more than just name. Their design, in finding a place in the American sun, was to establish a cordon of posts in the rear of the British settlements, and they planned to do this from Quebec all the way to New Orleans. As they penetrated into the regions to the west, northeast, and southwest, they were determined to hold onto Detroit for strategic ferrying operations. But it was not to be. When the British captured Quebec in 1759, the French lost their hold not only on the remote and little-known peninsular dependency of Detroit but on all of Canada. Detroit became British—so prolongedly British in fact that the Union Jack flew over the town until July 11, 1796, two full decades to the month following the Declaration of Independence.

It was not until the nineteenth century that Detroit was incorporated as a city. The year was 1806, and it followed a year of utter disaster. A fire that started in a stable swept across Detroit on June 11, 1805, and consumed the entire town. The local *Intelligencer* reported: "The flames commenced about 9 o'clock in the morning and within four hours the whole town was laid in ashes. Only two or three buildings, of little value, situated in the borders were preserved. About three hundred edifices, of all kinds, were consumed. . . . In a word, all the space enclosed within picquets, and denominated the town, presents nothing but a heap of ruins, consisting of naked chimneys and cinders."[33] It was a familiar story. The streets of the town were narrow, and the buildings old, all of wood, and crowded together for defense. The one fire engine could hardly be expected to preserve an entire settlement.

It was just as well. The city that took its place resisted hurried rehabilitation. The basic plan of the new and extended metropolis was an equilateral triangle bisected and framed by magnificent avenues with magnificent names—Washington, Adams, Jefferson, Monroe, Madison, Michigan, Macomb. Equally magnificent buildings began to rise, and if we board one of the comfortable steamboats plying the busy Detroit River or sit leisurely (as did the artist William Bennett) on the grassy banks of the Canadian shore opposite, we can have a prolonged look. The dome farthest to the left is that of the State Capitol. Just beyond the unfurled sail is the First Baptist Church, which had been very recently erected. The square tower with pinnacles, framed in the triangle of the ship's shrouds, is St. Paul's Protestant Episcopal Church, and next to it is the graceful steeple of the First Presbyterian Church. It, too, had been recently finished. In the center of the view the twin pointed cupolas belong to St. Anne's Roman Catholic Church, and farther to the right, all the way down the quays, is a parade of masts. There would soon be another kind of parade: in 1837 Detroit would officially be named the capital of Michigan, an honor that would last an entire decade.

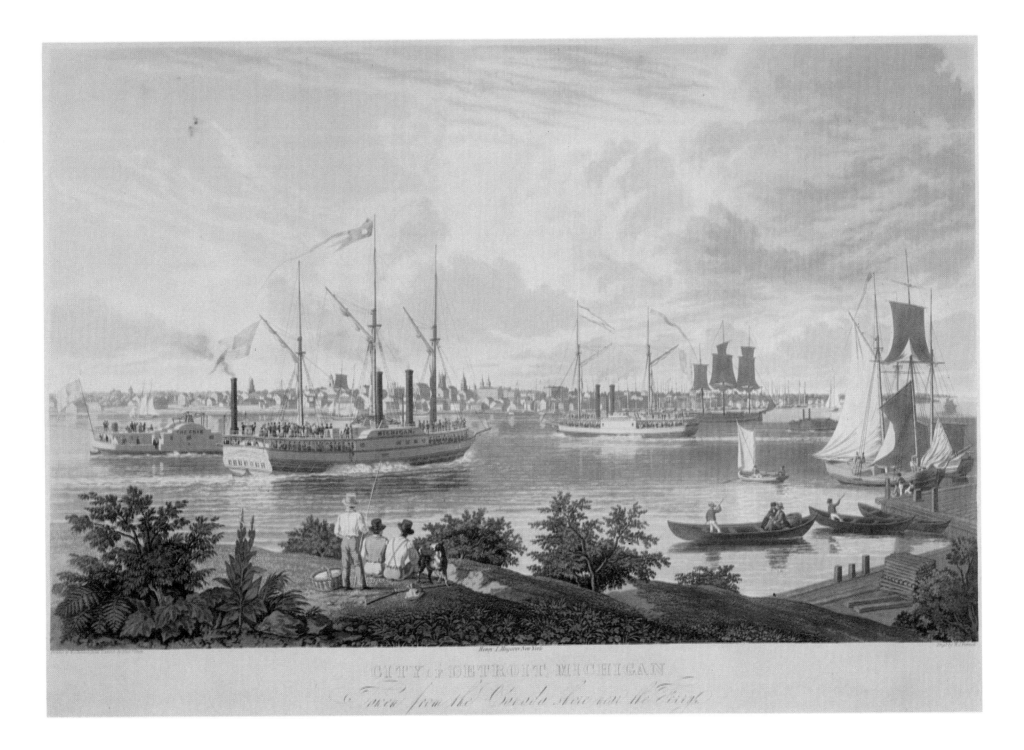

CITY OF DETROIT, MICHIGAN. TAKEN FROM THE CANADA SHORE NEAR THE FERRY.
PAINTED BY W. J. BENNETT FROM A SKETCH OF FREDK. GRAIN. ENGD. BY W. J. BEN-
NETT. HENRY I. [J.] MEGAREY NEW YORK. ENTERED . . . 1837. . . .
*Aquatint. Probably 1836. Size: 15.8 × 24.9 inches; 394 × 624 mm. Stokes Collection,
Prints Division, The New York Public Library.*

Reading: From the West Side of the Schuylkill

Reading, Pennsylvania, 1837

In 1772 a young Philadelphia-trained lawyer, dressed in a common brown homespun, rode to the town of Reading to set up his practice. Through the influence of family and friends who were already well launched in the profession of law, he had been fortunate in obtaining a post in the newly formed county of Northumberland: he was to be prosecuting attorney for the Crown. He was pleased to begin his career in a region that he had already inspected, and found "the Prospect of it from ye surrounding hills very beautiful." He plunged himself into his work, made the rounds of the courts on the rough country roads, enlivened his practice, embellished his purse, and wrote frequently to his family of all his ventures. In less than four years, however, momentous events had overshadowed jurisprudence in the life of Edward Burd.

<p style="text-align:right">Reading 15th Apl 1776.</p>

Dear Sir

You would oblige me very much if you would send me Mr Witman a Copy of the Proceedings in the Case of a Tenant's holding over his Term. I have a Case of that Kind in my Hands and would be glad to have your approved Precedents.

We have had lately an Election for Majors Standard Bearer and adjutant in our Battalion and they have honoured me with an Appointmt to a Majority. I had not a single dissenting Voice out of the Officers of twelve Companies, notwithstanding I had like to be ranked a Tory for supping one Night with the Officers and in drawing up the Regulations for the Guard I did not make it a rule that ye Officers should keep within Doors after 8 o'Clock at Night. I thought such a Measure would be cruel and iniquitous. They are Prisoners. They are confined within a small Distance from ye Town. They have hardly any Society but among themselves and to debar them of the Satisfaction of spending their Evenings together would make them miserable. I therefore maintained my Comduct to be right. It was agitated in the Committee of wh I am not a Member, and a Majority determined in my favor. We have a few John Henry's John Hubley's &c. here. I was attacked in a large Company very warmly for that Conduct and almost branded with the Name of Tory. It alarmed me at first, I feared that the people in genl, open to prejudice were possessed of the Idea of my being that Monster a Tory—But upon a little Inquiry into their Opinion, I found a great many friends and that only 2 or 3 firebrands caused the Noise, who have since declared they did not mean to cast any Reflection on me.

I beg my kind Love to all your Family and am

<p style="text-align:right">Dear Sir
Your affectionate Brother
E. Burd.</p>

P. S. I send this by Mr Simons Mr Witman will be over to Morrow and

call upon you for an Answer, We expect some News of Importance from Boston very soon. General Washington is of the opinion that the Regulars intend to leave that City shortly and intends to give them a Brush before their departure. Common Sense is translated into Dutch and works on the Minds of those People amazingly. For my own Part, I am against Independence, if we can possibly be reconciled upon terms consistent with our safety—but if these Commissioners only offer pardon, or will not treat with the Congress and secure us in our essential Rights. I do not know at present what would be my determination in such a case.[34]

In writing this letter to his family, Edward Burd wrote a chapter of Revolutionary history. It bristles with immediacy. Independence had not yet been declared, but the war was going on: small towns were forming companies to join the Continental Army, and Reading could boast of more than one; the young lawyer had been honored with the rank of major; prisoners of war were quartered near Reading and problems were arising with regard to their supervision; the labels of *Tory* and *firebrand* were on everyone's tongue and were becoming more emotional than political; Washington was confident of victory in Boston and would not be disappointed; and Paine's *Common Sense*, translated into German for the Pennsylvania Dutch population of Reading, was having an electrifying impact. Above all, the question of allegiance to the Crown loomed large: the young lawyer viewed fighting for one's rights essential but separation from the King frightening. In April 1776 the word "independence" was still rather heady.

Here we see Reading long after the question of allegiance was resolved. In 1837, with a good boost from the series of canals that linked the town to Philadelphia and with a steady boost from the skilled craftsmanship for which the town was noted, the Reading of Revolutionary fame had entered an era of lively prosperity. From the bucolic side of the Schuylkill River, we face a tranquil ring of green, patterned hills. Directly across the water, in line with the fisherman's boat, is the two-columned Presbyterian Church. To the right of it is the eighteenth-century Trinity Church, its tiered steeple looming higher than the spire of the First German Reformed Church. In the foreground a young Reading resident, dressed in his Sunday best and ranged among the foliage, has borrowed an expression for the occasion from the brush of da Vinci, while advancing toward him, a Gothic couple lend another bit of Sunday best to the horse that pulls their carriage down the scenic country road. "The whole Road indeed from Philadelphia to Reading," remarked George Washington, "goes over Hilly and broken grounds but very pleasant notwithstanding."[35]

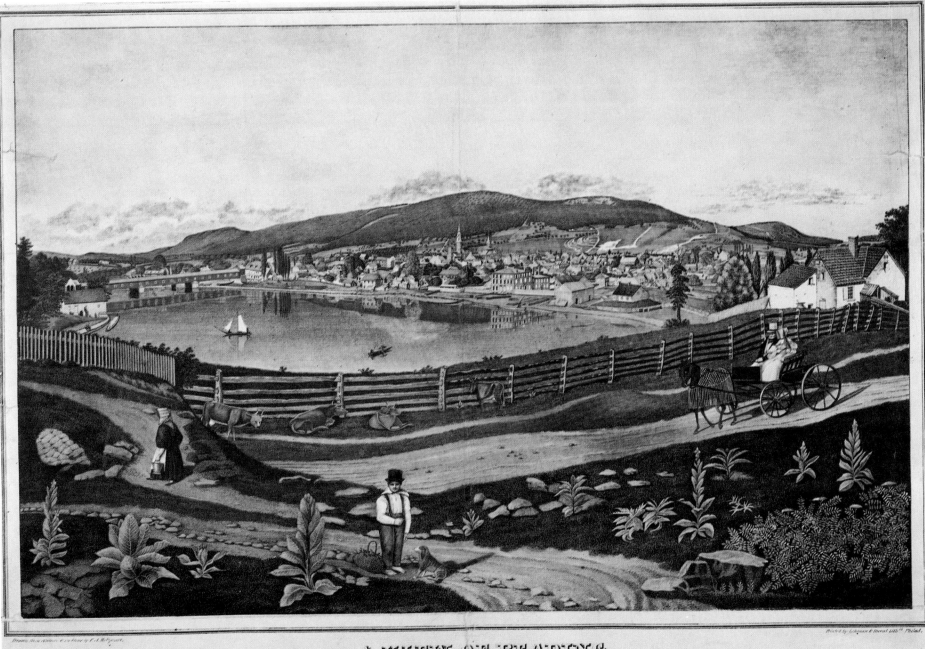

A VIEW OF READING

Taken from the West side of Schuylkill, and most respectfully dedicated to the Citizens of Berks County Pa. By F. A. Holtzwart.

A VIEW OF READING TAKEN FROM THE WEST SIDE OF THE SCHUYLKILL. . . . DRAWN FROM NATURE & ON STONE BY F. A. HOLTZWART. PRINTED BY LEHMAN & DUVAL LITHRS. PHILAD.
Lithograph. 1837. Size: 15 × 22.15 inches; 381 × 583 mm. Stokes Collection, Prints Division, The New York Public Library.

Cincinnati on the Ohio

Cincinnati, Ohio, about 1838

Cincinnati is located at the point where the Ohio River bends to embrace the southern boundary of Ohio state. How many travelers made that bend with the river as they moved westward in the quest for land! Optimism was high, the river accommodating, the journey uncomfortable. The steamboat had not yet been invented. The travelers came on barges propelled by oars and poles, in oblong, flat-bottomed boats, in arks, flats, skiffs, tenders, and rafts. Sometimes a single raft would be turned into an undulating village as it moved down the Ohio carrying two to three families, each with its separate shanties, horses, oxen, dogs, bags, rags, boxes, and bundles. As the travelers poured into the region west of the Alleghenies, Cincinnati served them as a stopping point for the further push west. Land agents and land purchasers filled the lodging houses of the town, and everywhere the topic of conversation was the same: land. By 1819, when the boundaries of the Northwest Territory had long been shifted, Cincinnati had swelled to the size of a city. Robert Fulton in the meantime had changed the whole character of traffic on the Ohio with his steamboat. Paddle wheels and snarls of smoke now dotted the waterfronts.

It was the steamboat that brought Frances Trollope to the Midwest city in 1828. She was an Englishwoman with an energetic personality and an energetic tongue and had come to better the fortunes of her family. "Though I do not quite sympathize with those who consider Cincinnati as one of the wonders of the earth, I certainly think it a city of extraordinary size and importance," she said, and, with that, settled in for nearly two years. She was to complain about everything: the lack of domes, towers, and steeples in the city's architecture, the lack of pumps or drains of any kind, the lack of a dustman's cart, the lack of tea drinking in one's lodgings, the lack of a science, art, or other branch of learning that would seduce Americans from their pursuit of money, and, above all, the lack of manners. Mrs. Trollope complained so much that when she published her complaints, all England rushed to read them. She had an instant best seller on her hands.

The "simple" manner of living in Western America was more distasteful to me from its levelling effects on the manners of the people, than from the personal privations that it rendered necessary; and yet, till I was without them, I was in no degree aware of the many pleasurable sensations derived from the little elegancies and refinements enjoyed by the middle classes in Europe. There were many circumstances, too trifling even for my gossiping pages, which pressed themselves daily and hourly upon us, and which forced us to remember painfully that we were not at home. It requires an abler pen than mine to trace the connexion which I am persuaded exists between these deficiencies and the minds and manners of the people. All animal wants are supplied profusely at Cincinnati, and at a very easy rate; but, alas! these go but a little way in the history of a day's enjoyment. The total and universal want of manners, both in males and females, is so remarkable, that I was constantly endeavouring to account for it. It certainly does not proceed from want of intellect.[36]

One English visitor who found being abroad less painful was Charles Dickens. Visiting Cincinnati in 1842, he wrote of the city's beauty and its animation. At the very first glance his eye was greeted pleasantly, he said, by the broad paved wharf, the clean red-and-white houses, the extremely good shops, the pretty villas atop the hills, and the footways of bright tile. Arriving by steamboat, he noted the large cluster of boats, with churning wheels in their paddle boxes, moving in to discharge hordes of passengers. He did not remark on the Conestoga wagons, which, as we see them here, brought the prairie into the city streets. When not caked by mud from the open trails, they were very colorful vehicles. The scowlike underbody was invariably painted blue, and the inside upper woodwork was red. Six or seven wooden bows were arched to support the bonnet-shaped canvas covering. The six Conestoga wagons here are making their way across the wide and airy thoroughfare of Cincinnati's historic Front Street.

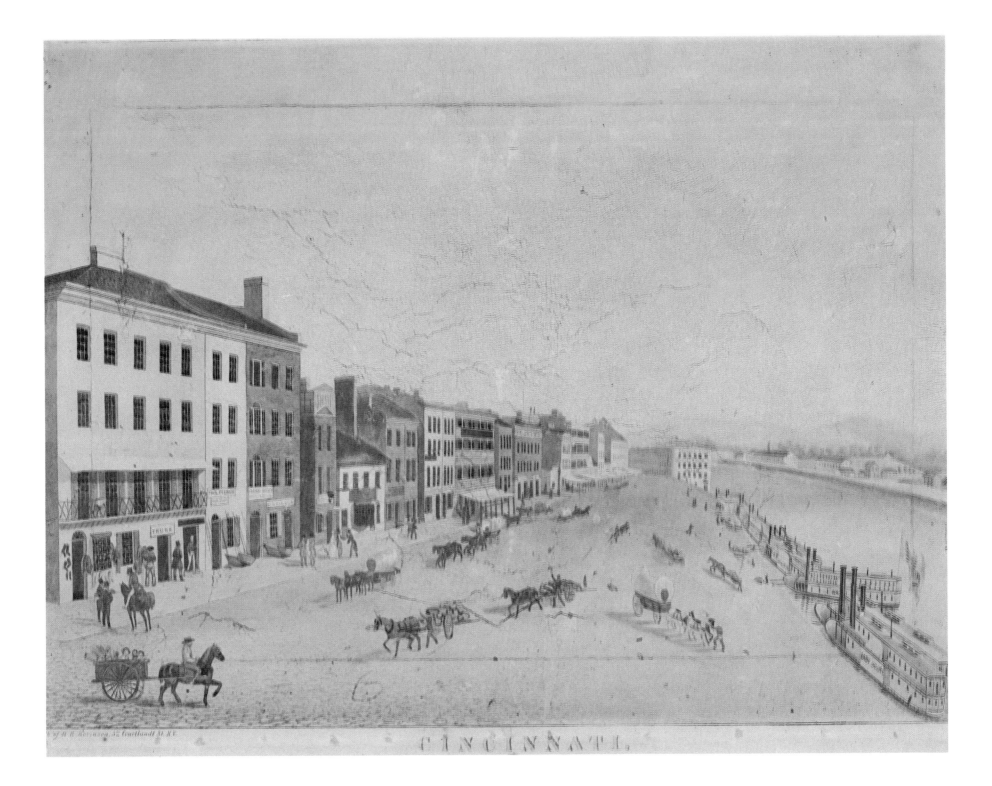

CINCINNATI. LITH. OF H. R. ROBINSON, 52 COURTLANDT ST. N. Y.
*Lithograph. About 1838. Size: 18.8 × 25.14 inches; 471 × 657 mm. Stokes Collection,
Prints Division, The New York Public Library.*

The Shakers

Near Lebanon, Pennsylvania, about 1838

A French traveler, who came to America in the early nineteenth century and watched a Sunday performance of Shaker worship in their first settlement at Niskeyuna, near Albany, was astonished by what he saw. He felt himself so culturally distant from the singing, shaking, shouting, and whirling which filled the long community hall that he perhaps would have been even more astonished to learn the origins of that emotional performance. What he had witnessed was the elaborate ritualistic dance of the French Camisards, passed on to the Shakers by members of that radical sect who had fled from France to England.

Because their Sunday worship had theatrical overtones and because they derived their creed from the Quakers, the English settlers at Niskeyuna were known as the "shaking Quakers." It was a name full of derision. Eventually that name, shortened to Shakers, transcended all contempt. The morbid curiosity that had attended everything the Shakers did and the bizarre beliefs that were attributed to them were slowly eclipsed by an attitude of admiration for the Shakers' dignified and purposeful life.

Some of the early hostility is reflected in the lithograph by Nathaniel Currier, a scene of Shaker worship at the meetinghouse in New Lebanon. The worshipers are shown in a trance so tinged with mystical fanaticism that it has rendered their features grotesque. Not one of those the artist has turned to us has a face with a natural mien. Their hands, which the French traveler described as moving with rhythmic response "in a rowing motion," are limp and awkward. Offered to us in contrast is the elegance of the outside visitors who have been permitted to watch.

Visitors were always welcome to the settlements of the Shakers, who were proud of their model farms, their industriousness, their general good health and happiness. The Shakers' appetite for hard work produced an amazing number of inventions, usually unpatented. Men and women were held to be equal (the founder saw herself as the female aspect of God's dual nature), though they were celibate and separate. A Shaker woman invented the circular saw and a man the common clothespin. Each individual within the community was encouraged to improve his or her particular talents, and all members learned to hold labor in high esteem. Many who came without skills soon contributed to the reputation of the Shakers as ingenious artisans and to the production of the superior Shaker wares. Wood, a favorite material, was worked so closely to the needs and dignity of Shaker life that most of what was made has passed into the mainstream of American folk art. There is a simplicity and artistic appeal that marks all Shaker products, from coat peg to community-sized desk. In praising the lovely forms of Shaker craftsmanship, the philosopher Thomas Merton drew on the poetry of William Blake. In a Shaker workshop, Merton said, "the secret furniture of Jerusalem's chamber is wrought."

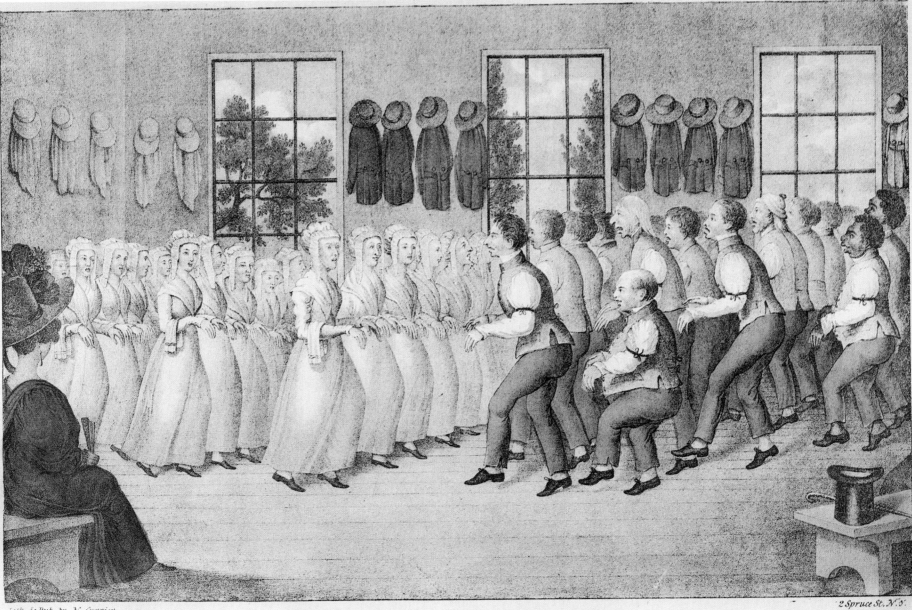

SHAKERS NEAR LEBANON.

SHAKERS NEAR LEBANON. LITH. & PUB. BY N[ATHANIEL]. CURRIER, 2 SPRUCE ST. N. Y.
Lithograph. About 1838. Size: 8.1 × 12.14 inches; 205 × 327 mm. Prints Division, The York Public Library.

Boston from Dorchester Heights: The Havell View

Boston, Massachusetts, probably 1840

Boston is a beautiful city and impresses strangers favorably, remarked Charles Dickens when he visited there in 1842. By that time Boston had been in existence well over two hundred years and had accumulated not only beauty but an impressive history. It is hard to think of its beginning, particularly in view of the reverberating effects of its Revolutionary role, as a small rocky peninsula almost entirely cut off from the mainland. The Indians called the peninsula Shawmut, and the first white settler to establish himself there was William Blaxton (or Blackstone). That was early in 1625. When John Winthrop and his Puritan followers arrived five years later, settling first at Charlestown, then moving across the Charles River near Blaxton, they called their settlement Trimountain because of the three hills.

Dickens arrived in nineteenth-century Boston on a crisp January day and was at once fascinated:

> When I got into the streets upon this Sunday morning, the air was so clear, the houses were so bright and gay; the sign-boards were painted in such gaudy colours; the gilded letters were so golden; the bricks were so very red, the stone was so very white, the blinds and area railings were so very green, the knobs and plates upon the street-doors so marvellously bright and twinkling; and all so slight and unsubstantial in appearance—that every thoroughfare in the city looked exactly like a scene in a pantomime.

As he stood by the State House on the summit of one of the historic hills, he found the panoramic view of the town charming and the suburbs even more quaint than the city:

> The white wooden houses . . . are so sprinkled and dropped about in all directions, without seeming to have any root at all in the ground; and the small churches and chapels are so prim, and bright, and highly varnished; that I almost believed the whole affair could be taken up piecemeal like a child's toy, and crammed into a little box.

Fortunately, the "cramming" in this engraving was done by one of the most skillful artisans in the craft of urban iconography—Robert Havell. He has meticulously etched his Boston within a box frame of a copperplate, in tones as soft as lithography, and given it the aspect of a European citadel. Like Paris, Istanbul, Budapest, or Rome, Boston is a city that owes its handsome silhouette to the vertical majesty of hills rising from the base of an undulating river.

The State House dominates the scene from its commanding height. Moving right across the stepping stones of the tapering steeples, we find the blunt stone structure of the Bunker Hill Monument. At the far left, parallel with the river, an engine from the Worcester Railroad sends up a puff of smoke as it pulls into Boston. At the right there is another train, from the Lowell line. Before leaving Boston, Dickens himself had journeyed on it to Lowell, and "made acquaintance with an American railroad on this occasion for the first time. . . ." "There is a great deal of jolting," he wrote, "a great deal of noise, a great deal of wall, not much window, a locomotive engine, a shriek, and a bell."[37]

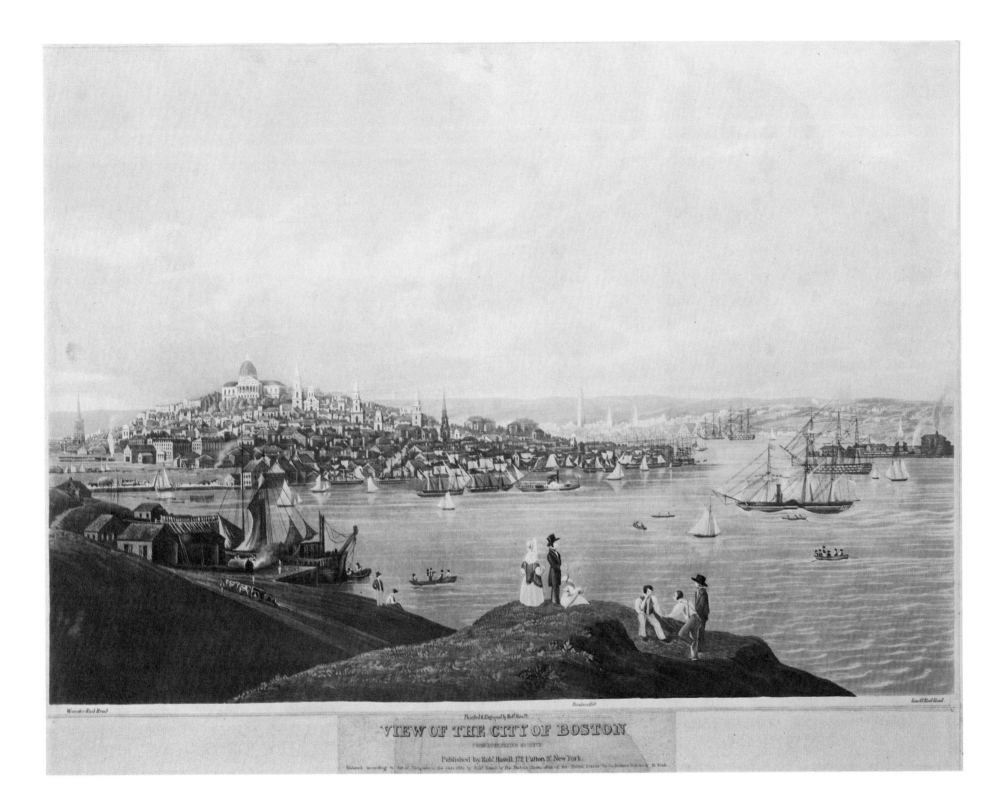

VIEW OF THE CITY OF BOSTON

Published by Robt. Havell, 172 Fulton St. New York.

VIEW OF THE CITY OF BOSTON FROM DORCHESTER HEIGHTS. PAINTED & ENGRAVED BY
ROBT. HAVELL. . . . ENTERED . . . 1841. . . .

*Aquatint. Probably 1840. Size: 12.9 × 17.13 inches; 319 × 452 mm. Stokes Collection,
Prints Division, The New York Public Library.*

Washington: Focus on the Capitol

Washington, District of Columbia, 1841; probably 1851

The inauguration of William Henry Harrison as President of the United States was a lackluster affair that seemed to match the raw, windy March fourth day. Harrison had been called out of retirement to rescue the Whigs. At the age of sixty-eight, he was the oldest President-elect in the nation's history. In the frenzied campaign waged by the Whigs and the Democrats, he had won against Martin Van Buren by a slim majority of popular votes. Frail and infirm, he was doing his best to live up to his past image of the rugged hero. As he made the two-hour trip on horseback to the Capitol, he appeared indistinguishable in his plain frock coat from those who accompanied him. The inaugural procession included veterans who had fought under him in 1811, platoons of volunteer militia, college students, Tippecanoe clubs, and schoolboys and a mixed military and civil cavalcade. Anything resembling splendor and pomp, particularly in the ungainly painted banners, was distinctly absent. John Quincy Adams, peering from his window on the parade below, pronounced the scene "showy-shabby" and contented himself with the observation that a lack of glitter was creditable to a democracy. Nor did the erudite Virginian cut a better figure when he mounted the stand. His speech was too long, his voice too dull, and his rhetoric too highblown to prevent a shifting of restless feet. He cited Caesar, Octavius, Brutus, Antony, Camillus, the Curtii, the Decii, and the Scipios and would have dragged in more ancients if Daniel Webster had not interfered in advance with an editor's quill. "In the last twelve hours," said an exasperated Webster, who had worked on the text, "I have killed seventeen Roman proconsuls. . . ."[38]

Within a month of his inauguration, Harrison was dead. His fatal pneumonia may have been brought on by the grueling pace of his new job or the long exposure to the cold on the day of his inauguration. Delivery of inaugural addresses on the outdoor Capitol steps was a fairly new practice, initiated by Andrew Jackson in 1829. Before then, acceptance speeches of incoming Presidents were given inside the Capitol facing the assembled members of Congress and guests. The Capitol building had not, of course, been ready for the first President, nor indeed had its site. Congress wandered from city to city in the years when there was no permanent seat of government. Washington himself was inaugurated on the small iron balcony of Federal Hall in New York, overlooking the crowds that squeezed into Broad Street (the building, though not new, had been renovated for the occasion). Washington's second inaugural address, and that of his successor John Adams, was given in the Senate Chamber in Philadelphia, where the government was then installed. When it was decided to choose a permanent national capital, a city rivalry ensued that ended in a furious contest between North and South. Washington favored a site on the Potomac, and he got his way.

The original plan of the city of Washington, prepared by Pierre L'Enfant under the supervision of the first President, was a masterpiece. There were some difficulties along the way, during which L'Enfant was dismissed, but in the main his plan was preserved. In 1791 the first lots were sold and the cornerstone of the city laid. After the White House, the Capitol, and other government buildings went up, they had to be virtually rebuilt as a result of the British sacking of the city in 1814. By 1851 the beauty of the city's layout was clearly apparent, and Congress had just authorized the expansion of the Capitol itself. Large wings would be added to accommodate the Senate and House, and though they would not be completed for another eight years, we see a projection of them in the Sachse lithograph. To the left of the Capitol is the Washington Monument, graced by the setting of the Potomac River. The design of the circular columned porch around the base of the monument was never carried out. In front of the monument the numerous turrets and towers that cap the rose-colored building are features of the Smithsonian landmark. At the end of broad Pennsylvania Avenue, and to its right, is the Treasury with its handsome parade of pillars. In back of it is the elegant White House.

Despite the majesty of the buildings and the spaciousness of the streets, a provincial air hung heavy over the government site. "Everybody knows that Washington has a Capitol," remarked an English visitor, Captain Frederick Marryat, in the nineteenth century, "but the misfortune is that the Capitol wants a city."

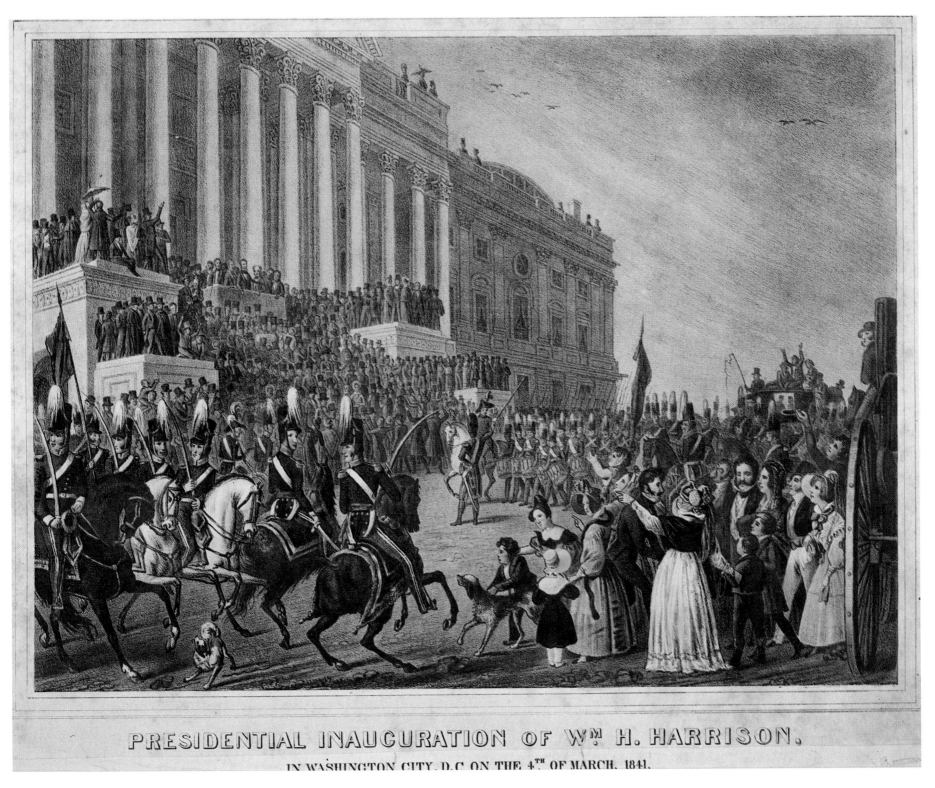

PRESIDENTIAL INAUGURATION OF Wᴹ. H. HARRISON.

IN WASHINGTON CITY, D.C. ON THE 4ᵀᴴ. OF MARCH, 1841.

PRESIDENTIAL INAUGURATION OF WM. H. HARRISON, IN WASHINGTON CITY, D. C. ON THE 4TH. OF MARCH 1841. FOR SALE AT MR. F. TAYLOR, BOOKSELLER—WASHINGTON. *Lithograph. 1841. Size: 9.12 × 13.5 inches; 247 × 338 mm. Stokes Collection, Prints Division, The New York Public Library.*

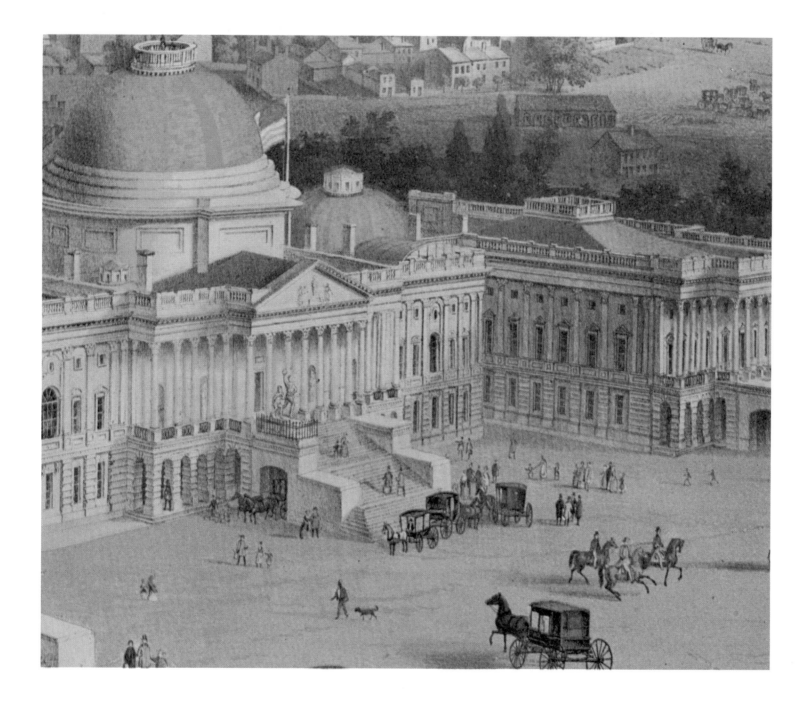

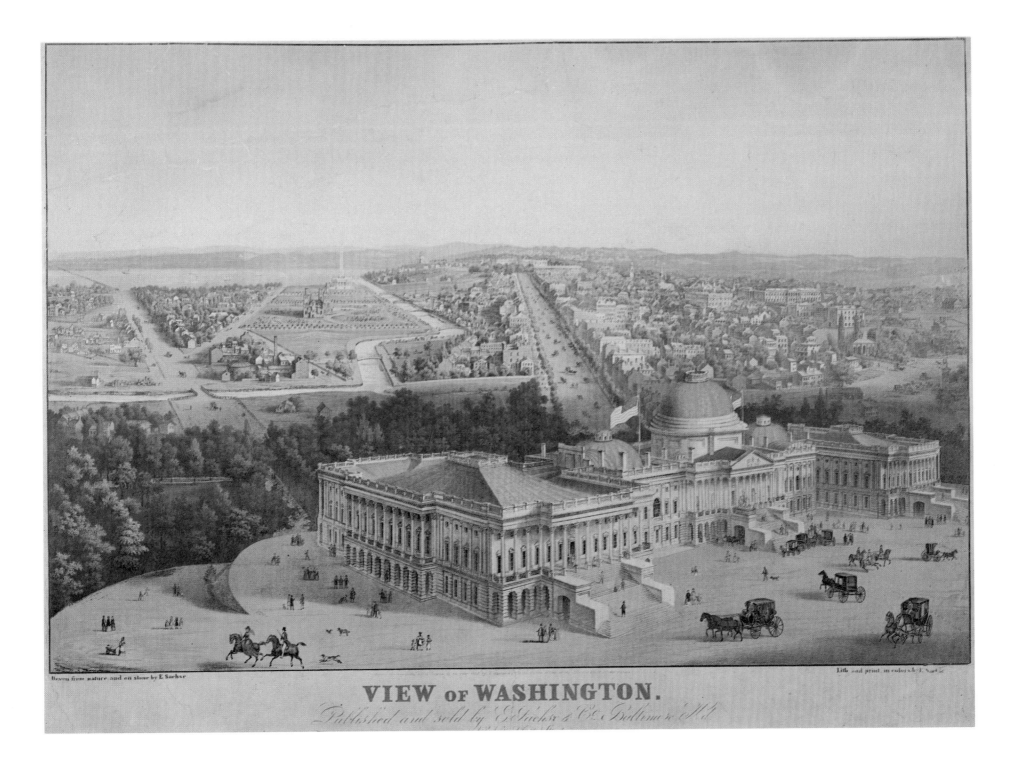

VIEW of WASHINGTON.

Drawn from nature and on stone by E. Sachse

Lith. and print. in colors by E. Sachse

Published and sold by E. Sachse & Co. Baltimore M.d.

VIEW OF WASHINGTON. DRAWN FROM NATURE AND ON STONE BY E. SACHSE. LITH.
AND PRINT. IN COLORS BY E. SACHSE. . . . ENTERED . . . 1852. . . .
Lithograph. Probably 1851. Size: 17.15 × 27.4 inches; 456 × 692 mm. Stokes Collection, Prints Division, The New York Public Library.

Niagara Falls: The Havell View

Niagara, New York, probably 1844

Betwixt the Lake Ontario and Erie, there is a vast and prodigious Cadence of Water which falls down after a surprising and astonishing manner, insomuch that the Universe does not afford its Parallel. . . . At the foot of the horrible Precipice, we meet with the River *Niagara*, which is not above half a quarter of a League broad, but is wonderfully deep in some places. It is so rapid above this Descent, that it violently hurries down the Wild Beasts while endeavoring to pass it to feed on the other side, they not being able to withstand the force of its Current, which inevitably casts them down headlong above Six hundred foot. . . . This wonderful Downfal, is compounded of two great Cross-streams of Water, and two Falls, with an Isle sloping along the middle of it. The Waters which fall from this horrible Precipice, do foam and boyl after the most hideous manner imaginable, making an outrageous Noise, more terrible than that of Thunder; for when the Wind blows out of the South, their dismal roaring may be heard more than Fifteen Leagues off.[39]

What is there left to say after this Gothic prose that brims with the splendor and the terror of the great cataract? It can hardly be matched. Yet in the nearly three hundred years since this early account was published by Father Louis Hennepin, the chaplain who accompanied La Salle on his expedition to North America, many have tried. The prodigious waters that "foam and boyl" have continued to coax the imagination of writers, painters, musicians, poets, geologists, naturalists, artists, engineers, stunt performers, and ordinary spectators. Few come away unmoved. Few come away without sharing the impact of that precipitous leap which the Niagara takes in its nearly northward course to Lake Ontario. If one has not been to Niagara, one can easily travel there through the heightened responses of others.

Geologists have had their imaginations coaxed by guessing the age of the Falls. Some say they are twelve thousand years old; others say twenty-five thousand. The Niagara River itself came into existence late in the Glacial, or Pleistocene, epoch. One way geologists have of calculating the age of the cataract is to divide its length by the average rate of recession of the downpour. But not all geologists agree that this is a good gauge. Engineers have had their imaginations coaxed in quite a different way. Out of the sheer force of the falls they have provided two countries with hydroelectric power. This was done by diverting the water on both sides of the gorge through plant installations that trap its energy. When the engineers fixed the hydroelectric capacity of the river, the talk was of beauty as well as utility. Both Americans and Canadians agreed that the diversion should never interfere with scenic grandeur.

Artists, above all, have had their imaginations coaxed. They have taken us below the falls and engulfed us in the powerful rush of the descending cataract, or they have placed us close to the shimmering water just where it makes its spectacular spill. Some have shown us the cadences of light that ripple through the curved whirlwind of the Horseshoe downpour. Others have painted the falls in all their icy whiteness of winter. Others, still, have guided us toward the huges piles of misshapen rocks that share the water's beauty and power, or enveloped us in the billowy mass of summer mists and spray. "The most favorable season for visiting the falls," wrote the British traveler Isaac Weld in 1799, "is about the middle of September . . . for then the woods are seen in all their glory, beautifully variegated with the rich tints of autumn."[40] In this aquatint by Robert Havell we are in the right season and at the right distance to take it all in.

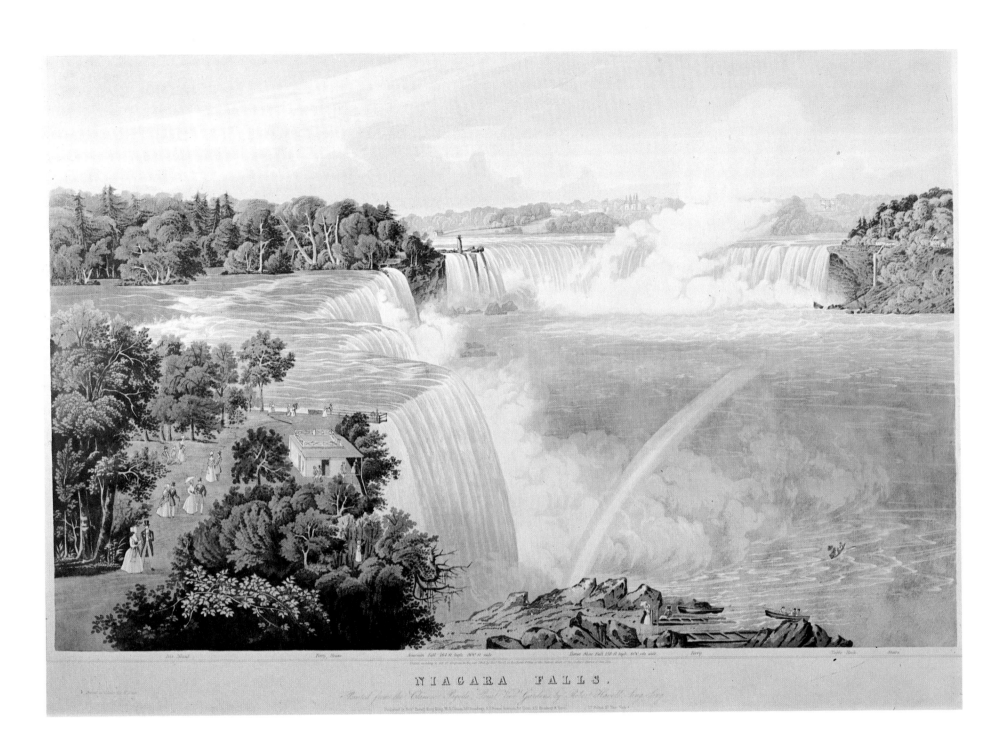

NIAGARA FALLS.

NIAGARA FALLS. PAINTED FROM THE CHINESE PAGODA, POINT VIEW GARDENS, BY
ROBERT HAVELL, SING SING. PRINTED IN COLOURS BY W. NEALE. . . . ENTERED . . .
1845. . . .
*Aquatint. Probably 1844. Size: 17.11 × 27.5 inches; 449 × 694 mm. Stokes Collection,
Prints Division, The New York Public Library.*

The Water Celebration, Boston

Boston, Massachusetts, 1848

My name is Water: I have sped
 Through strange, dark ways, untried before,
By pure desire of friendship led,
 Cochituate's ambassador;
He sends four royal gifts by me:
Long life, health, peace, and purity.
 —*James Russell Lowell*, Ode

Sophisticated Boston was still being served by common spring water in the mid-nineteenth century. This had been good enough in the early days when the city was comparatively small and confined to the geographic boundaries formed by nature. Meals were cooked, fires extinguished, gardens watered, streets cleaned, throats gargled, and all those layers of clothes laundered by a water system that was no system at all. The water was pumped from wells, and wells were dug wherever springs were found. But over the years Boston had not only changed in size, it had changed its geography. By 1845 one third of the city's population was located on land where the tides once flowed. The springs became brackish, and they were hard to find on the new man-made land. It was time for the city to bring in water from the outside.

When the question was raised before the local legislature, there was little general agreement among Bostonians as to the need for a pure water system: health officials, especially, pressed the issue from every side. But the undertaking would be of enormous magnitude, going beyond the expense of anything the city government had yet taken on its shoulders. There would be not only the initial outlay but the continual expense of maintenance. There was long consideration, too, over whether the pipes should be of iron, lead, copper, or block tin, how they should be lined, and how many gallons of water should be pumped through them. The experiences of New York and Philadelphia, cities ahead of Boston in this respect, were constantly invoked. In an estimate that was surprisingly modern, Philadelphia advised that 150 gallons daily per family would not be too much. Debates, votes, squabbles, and hesitations lasted for over two decades. Finally, in 1846 ground was broken for the construction of a water system. The water was to be obtained from Lake Cochituate in the towns of Natick and Framingham, and when the project was finished, there would be a grand celebration.

The project was completed two years later. In the early hours of October 28, 1848, to the salute of one hundred guns and fine weather, throngs of Bostonians poured into the streets in anticipation of a great spectacle. They had all been invited as "Citizens of the Metropolis" to join in a procession that they promptly turned into a fashion parade. The women came in their best cloaks, cashmere shawls, tiered dresses, and ribboned poke bonnets; the men in frock coats, cutaways, top hats, and immaculate cravats. Those who wore gloves, like the little black girl in the center foreground, fashionably tugged at them. Those who sported a pigtail, like the Chinese boy not far from her, came freshly plaited. The procession would include a cavalcade and military escort and would wend its way through the main streets onto the Common. There, the ceremonies would include a hymn sung by the Handel and Haydn Society (and swelled by the audience), an ode written especially for the occasion by James Russell Lowell, and an address by the Honorable Josiah Quincy, mayor of Boston. When all this finally came to pass, it had taken longer, much longer than the worried master of ceremonies had anticipated. But now the important moment had come. The mayor turned to the assembly, and, after asking if water should be introduced into Boston, was greeted with a tumultuous "Aye!" The Cochituate Fountain gate was gradually opened, the water rose in a strong column, and, gushing higher and higher, reached an elevation of eighty feet. Shouts rent the air and rockets streamed across the sky.

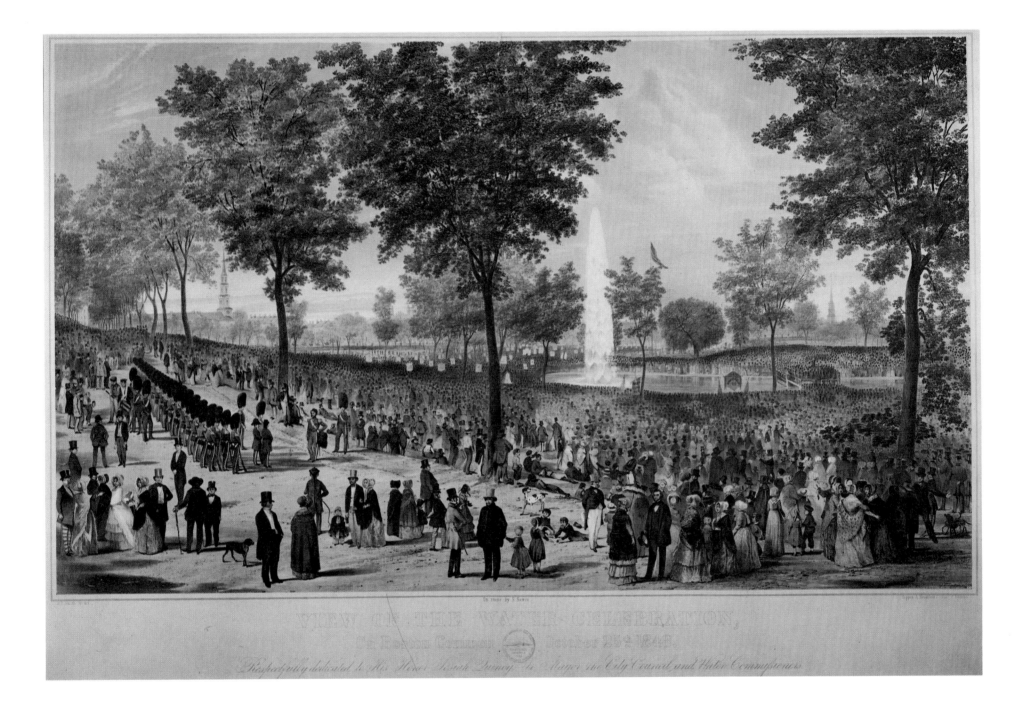

VIEW OF THE WATER CELEBRATION, ON BOSTON COMMON [SEAL OF THE CITY]
OCTOBER 25TH, 1848. . . . B. F. SMITH JR. DEL. ON STONE BY S. ROWSE TAPPAN &
BRADFORDS LITHOGY. BOSTON. ENTERED . . . 1849. . . .
*Lithograph. 1848. Size: 21 × 35.9 inches; 533 × 903 mm. Stokes Collection, Prints
Division, The New York Public Library.*

The Golden City: San Francisco

Coloma Valley and San Francisco, California, about 1849; 1851

It seems astounding, remarked a sixteenth-century cartographer as he plumped out the lines of the western hemisphere on his latest world map, that so great a mass of land should have remained so long undiscovered. The fact is even more strange, he reflected, when one considers the insatiable desire of man for gold and silver in which the Americas seem to abound.[41]

Talk of gold flowing in the new land beyond the Atlantic was as old, then, as the discovery of the land itself; yet, in the territory that would become the United States, there would be little to justify the talk for another three centuries. Sir Francis Drake would sail past the waters of the Golden City, the Spanish would open up the Pacific coast, the East would become settled, the new territory would be clawed for the bedding of canals, long and difficult trails to the West would be blazed, and still there would be no significant sign of the shimmering metal. Then one January day in 1848, somewhere in the majestic wilderness of California's Coloma Valley, it happened. A sawmill was being erected for John Sutter, and a millwright from New Jersey, reporting to his employer, had something unusual to say.

"[James] Marshall arrived in the evening, it was raining very heavy, but he told me he came on important business," wrote John Sutter in his diary.

> After we was alone in a private Room he showed me the first Specimens of Gold, that is he was not certain if it was Gold or not, but he thought it might be; immediately I made the proof and found that it was Gold. I told him even that most of all is 23 Carat Gold; he wished that I should come up with him immediately, but I told him that I have to give first my orders to the people in all my factories and shops. . . . I had a talk with my employed people all at the Sawmill. I told them that as they do know now that this Metal is Gold, I wished that they would do me the great favor and keep it secret only 6 weeks, because my large Flour Mill at Brighton would have been in Operation in such a time . . . unfortunately the people would not keep it secret. . . .[42]

No, they could not keep the secret bottled, and soon California, Sutter's Mill, and gold became household words, though John Sutter lost all his holdings in the ensuing scramble. The early lusters after gold contested the title to the mill owner's territorial claims, clever lawyers cleverly diminished his rights, and the once resourceful pioneer of Swiss origin became an object of pity. Meantime the tranquil trading posts strung along the coast from Monterey to the Golden Gate were inundated with turbulent activity. Thousands of trappers, miners, farmers, preachers, lawyers, sailors, soldiers, schoolteachers, and gold seekers of every trade and nationality made their way in 1849 to the new El Dorado, traveling and living under conditions that only the promise of gold could make them endure. And gold there was. Although the average finding in the gold fields was barely half an ounce per man per day, some two-and-one-half million ounces of gold passed through buyers' and dealers' hands in a twelve-month period. Fortunes were made and periodic panics wiped them out, but always a repeated wave of optimism built the fortunes up again.

San Francisco's new gold trade engendered every other kind of trade, and soon the city's harbor had more ships in its waters than there were houses to live in. For those who had come from hundreds, and even thousands, of miles away, news of the family and of the business (hurriedly left back home) became a commodity almost as precious as gold. The arrival of each mail packet was a cue for long lines to form outside the post office at the corner of Pike and Clay streets, and in the hope of a single letter it was sometimes worth paying as much as twenty-five dollars to hold one's place in the long, motley queue.

Not far from the post office, the newly launched San Francisco *Daily Herald*, on Montgomery Street, pondered the significance of it all with great optimism:

> Since the discovery of California gold the American republic has been constantly reminded by some of its trans-atlantic well-wishers that the precious metals of Mexico and Peru were the signal and cause for the decline of Spanish grandeur and Spanish power. . . . The American mind seems to have an abiding faith in the capacity of the country to survive the luxury engendered by the influx of gold, and the citizens of the republic have little fear that the strength of the States is to be diminished by an increase of wealth. . . .[43]

It remained to be seen.

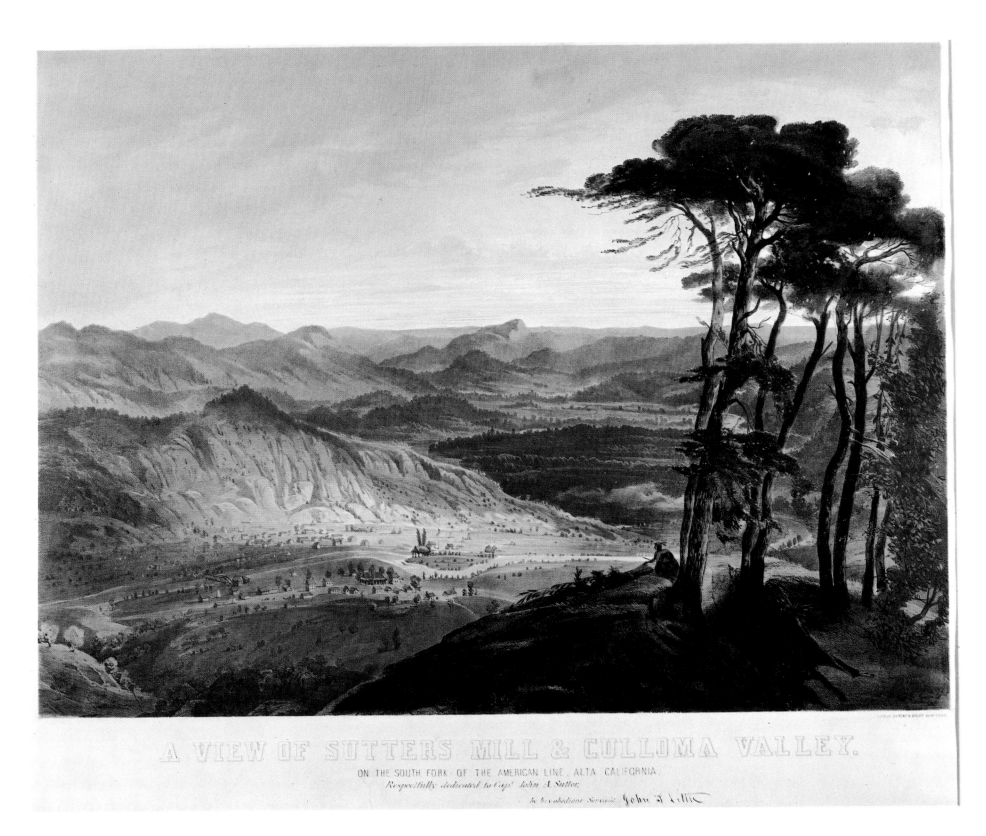

A VIEW OF SUTTERS MILL & CULLOMA VALLEY.

ON THE SOUTH FORK OF THE AMERICAN LINE, ALTA CALIFORNIA.

Respectfully dedicated to Capt. John A. Sutter,

In his obedient Servant John T Little

A VIEW OF SUTTER'S MILL & CULLOMA VALLEY. ON THE SOUTH FORK OF THE AMERI-CAN LINE, ALTA CALIFORNIA. RESPECTFULLY DEDICATED TO CAPT. JOHN A. SUTTER, BY HIS OBEDIENT SERVANT JOHN T LITTLE. LITH. OF SARONY & MAJOR NEW YORK.

Artist: William S. Jewett. Lithograph. About 1849. Size: 17.12 × 24.14 inches; 450 × 634 mm. Prints Division, The New York Public Library.

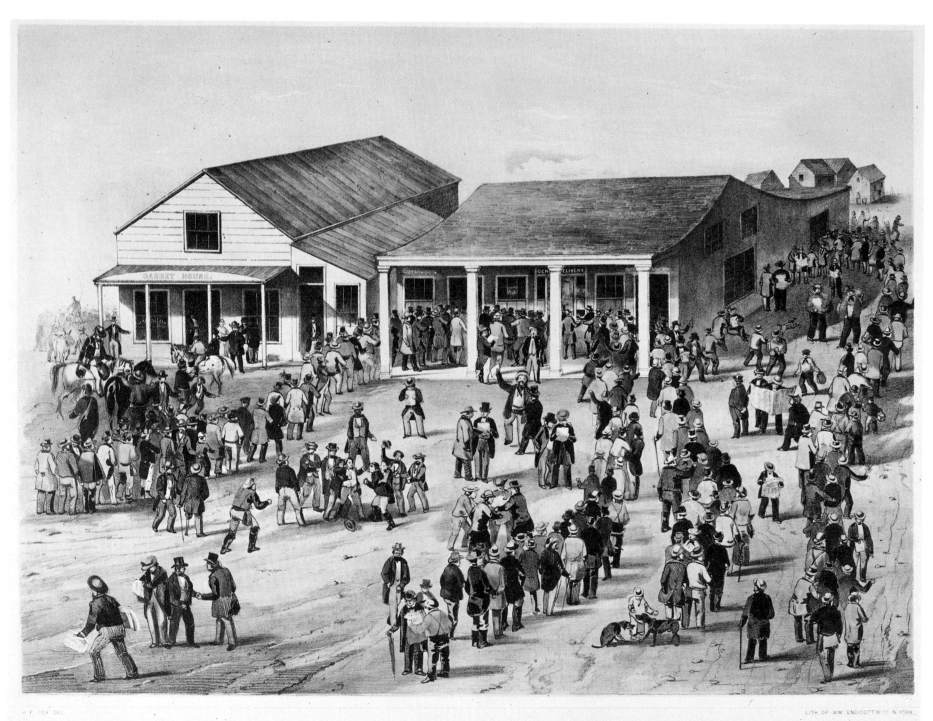

POST OFFICE, SAN FRANCISCO, CALIFORNIA.

A FAITHFUL REPRESENTATION OF THE CROWDS DAILY APPLYING AT THAT OFFICE FOR LETTERS AND NEWSPAPERS.

POST OFFICE, SAN FRANCISCO, CALIFORNIA. A FAITHFUL REPRESENTATION OF THE
CROWDS DAILY APPLYING AT THAT OFFICE FOR LETTERS AND NEWSPAPERS. H. F. COX
DEL. LITH. OF WM. ENDICOTT & CO. N. YORK.

Lithograph. About 1849. Size: 12.2 × 16.9 inches; 307 × 421 mm. Stokes Collection,
Prints Division, The New York Public Library.

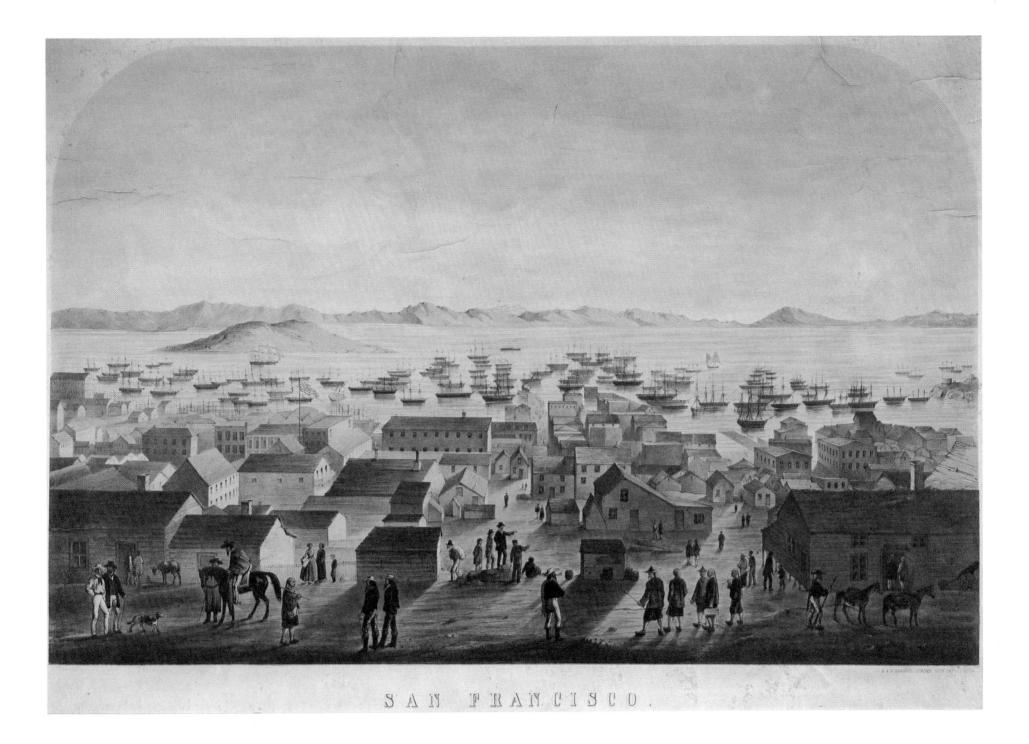

SAN FRANCISCO.

SAN FRANCISCO. S. F. [I.E., FRANCIS SAMUEL] MARRYAT DELT. M. & N. HANHART
CHROMO LITH IMPT. LONDON. LONDON, PUBLISHED 1ST JULY 1851 BY HENRY
SQUIRE & COMPY. . . .
*Lithograph. 1851. Size: 16.7 × 25.7 inches; 416 × 645 mm. Prints Division, The New
York Public Library.*

New Orleans on the Mississippi

New Orleans, Louisiana, 1851

Gothic spires poking from majestic plazas, the dramatic looping of the river in an embrace of the city, the busy quays with their clusters of steamboats, the rows of trees arching the boulevards, the open-air markets, the well-planned streets, and the low, solid silhouette of the buildings, all coax the mind into coupling New Orleans with Paris. Not that New Orleans had a solidly French background. The area had been Indian first, then French, then Spanish, then French again, then finally southern American, when a treaty, commerce, and bales of cotton rendered it so. Still, it may have been the dominant French strain in the city's heritage, or it may have been an alchemist's blending of cultures, that stirred Baudry des Lozières to look twice at its women and to gather a nosegay of flattering observations for his book. "The women . . . sparkle with freshness," wrote the eighteenth-century traveler. "One can easily say about them without flattery or exaggeration what one always hears said about the Georgians and Circassians."[44]

The French traveler may have been prejudiced; he was certainly impressed. But even Mrs. Trollope, who came for a visit to America in 1827 with a trunkful of different prejudices, admired the population. She was charmed by the large proportion of blacks she saw in the streets, and "the chant with which the Negro boatmen regulate and beguile their labour on the river." "The Negro voice," she commented, "is almost always rich and powerful." She was less enthusiastic about her arrival by sea. One of her very first declarations when she got off the boat that brought her from England was that she had "never beheld a scene so utterly desolate as this entrance of the Mississippi."[45]

It was an entrance highly prized: Napoleon, Talleyrand, the Marquis de Barbé-Marbois, Thomas Jefferson, James Monroe, and Robert R. Livingston engaged in theatrics over it. The entrance was part of a vast tract of land west of the Mississippi, owned by France and coveted by the United States. So much intrigue pervaded the negotiations for the ownership of the territory that for several years Americans were given only tantalizing glimpses of the conditions under which a deal with France would be possible. Jefferson was tempted, even willing, to bargain for New Orleans alone; he eventually held out for the whole package. When the purchase of the Louisiana Territory was finally negotiated, it cost the United States twenty-seven million dollars. Jefferson ordered a careful inventory to see what the country got for its money. With New Orleans, the United States came into possession of an excellent port, an area of abundant natural resources, fourteen hundred houses, a population of ten thousand, "two very expensive brick stores," a government house, stables and garden, a military hospital, a barracks, a large lot adjoining the king's stores, a prison, a town house, a market house, an assembly room, "some ground rents," a public school for "the rudiments of the Spanish language," "a cathedral church unfinished," a charitable hospital, and "an ill-built custom-house of wood, almost in the ruins in the upper part of the city."[46] The treaty, "*originairement rédigé et arrêté en langue française*," was signed on May 2, 1803, in Paris, or, as the French Republican calendar would have it, *le dixième jour de Floréal de l'an onze de la République Française.*

And what was the inventory of 1851? Extensive and breathtaking—far too much to even highlight here. Commanding our attention on this side of the river is the United States Marine Hospital, an elegant Spanish-style structure. Across the river we can scan the Cabildo and Cathedral of Jackson Square, the picturesque courtyard houses of the Vieux Carré, the intricate iron-lace façades of the Garden District, and the lively exchange in the open-air markets, all of which attract and detain visitors to New Orleans year after year.

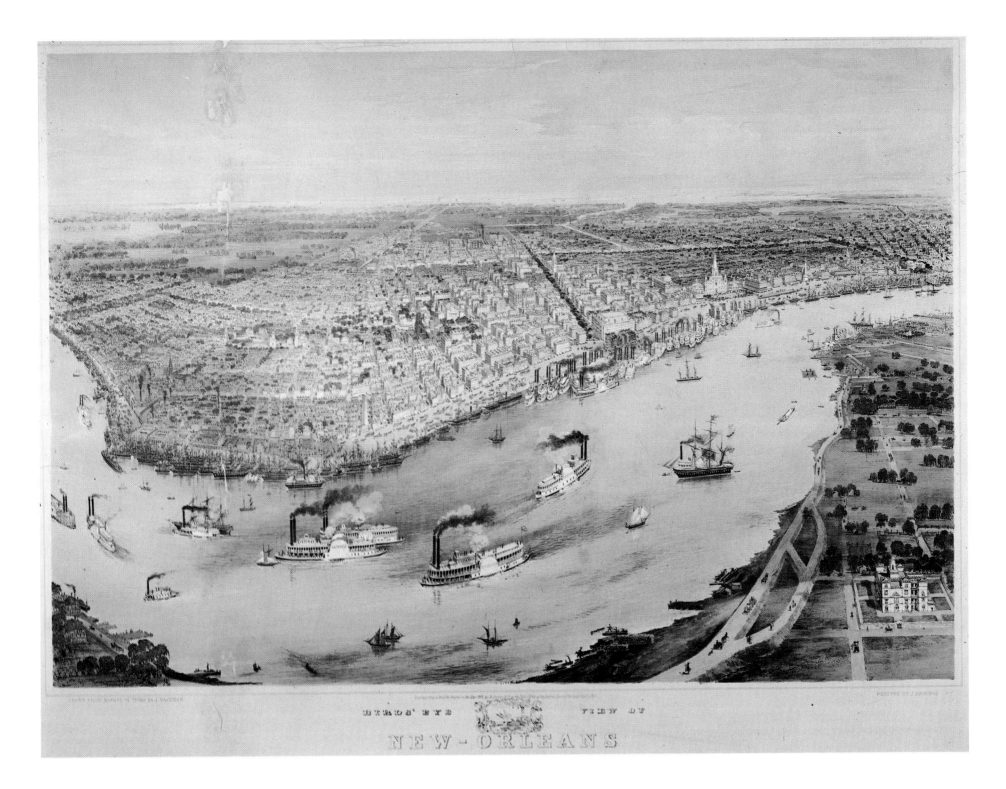

BIRDS' EYE VIEW OF NEW-ORLEANS DRAWN FROM NATURE ON STONE BY J. BACHMAN.
PRINTED BY J. BACHMAN PUBLISHED BY THE AGENTS A. GUERBER & CO. 160 PEARL
ST. NEW YORK. ENTERED . . . 1851. . . .
Lithograph. 1851. Size: 21.14 × 31.13 inches; 556 × 808 mm. Stokes Collection, Prints Division, The New York Public Library.

The Mining Boom: Grass Valley

Grass Valley, California, 1852

Grass Valley: the name itself promises beauty, and from the beginning the diminutive settlement in the majestic region of the Sierra Nevada made good its promise. Even before the area responded to the stirrings of a permanent existence, it held out beauty and bounty to those who came. To intrepid trappers who made their way over the vast succession of hills now tucked into Nevada County, the undulating surroundings offered fresh sights at every turn. Streams and lakes offered salmon, trout, perch, white fish, sucker, chub, and varieties of eel to hearty trapper appetites, and the woods offered the skins of fox, fisher, badger, martin, weasel, mink, skunk, squirrel, raccoon, deer, and muskrat. To everyone who came, then and later, the region offered limitless timber, fertile meadows, abundant grass, and a sweeping grandeur that trailed into no less spectacular a sight than the great Yosemite Valley. In 1850 the region would prove still more bountiful: it offered gold.

It was in Grass Valley, then a tiny hamlet with some twenty cabins, that the early quartz gold was found. Though it was not the first piece of gold that had fallen or been prodded from the crevice of a rock, it started a mining boom. The sloping hills surrounding the valley hamlet were soon discovered to be dotted with hundreds of quartz mines that would yield the treasured metal far into the rock depths. Mining pans were momentarily set aside while a search went out for ore-crushing tools; within a week of the quartz discovery there was a run on all the hammers and anvils for twenty miles around. With time the machinery for extracting gold became more sophisticated, and Grass Valley soon perfected the system of shaft mining that eventually supplanted most of the earlier surface techniques. Miles and miles of tunnels, shafts, and cross passages would one day run through the town's underworld of gold, and a forest of hoists, sheds, and bridges would cooperate to wrench the metal from its deeply bedded cradle. With time, too, the yield of gold became as steady as it had been startling. The prosperity of Grass Valley was nicely assured.

Within a few years after the first quartz discovery, the mining town attracted a colorful population: Indians, Mexicans, Spaniards, Russians, Canadians, Chinese, and emigrants from a score of other nations, including Lola Montez from Ireland. As elsewhere in California, the heterogeneity of a rapidly growing population caused a host of problems. Low grumblings about "foreigners," outright feuds, and nasty newspaper articles were common. "The privileges allowed to the Chinese in California, to land here, advance into the country and engage, under the protection of the law, in mining, merchandizing, washing and hiring as laborers, are wholly gratuitous on our part, and granted without the least equivalent. Our citizens are permitted no such privileges in China,"[47] fussed an 1854 editorial in the Sacramento *Steamer Union*, while granting that the Chinese had an admirable and ancient history.

At the bottom of the xenophobia was a scramble for wealth. The problem was not peculiar to Grass Valley, but it was a Grass Valley native who pondered its moral ramifications. "For this hatred of foreigners, this blind nativism, are we not all alike born to it? And what but reflection, and our chance measure of cultivation, checks it in any of us?" These were questions philosopher Josiah Royce put to himself and to his countrymen.

> Nowhere else were we Americans more affected than here, in our lives and conduct, by the feeling that we stood in the position of conquerors in a new land. . . . We Americans therefore showed, in early California, new failings and new strength. We exhibited a novel degree of carelessness and over-hastiness, an extravagant trust in luck, a previously unknown blindness to our social duties, and an indifference to the rights of foreigners. . . . But we also showed our best national traits. . . .[48]

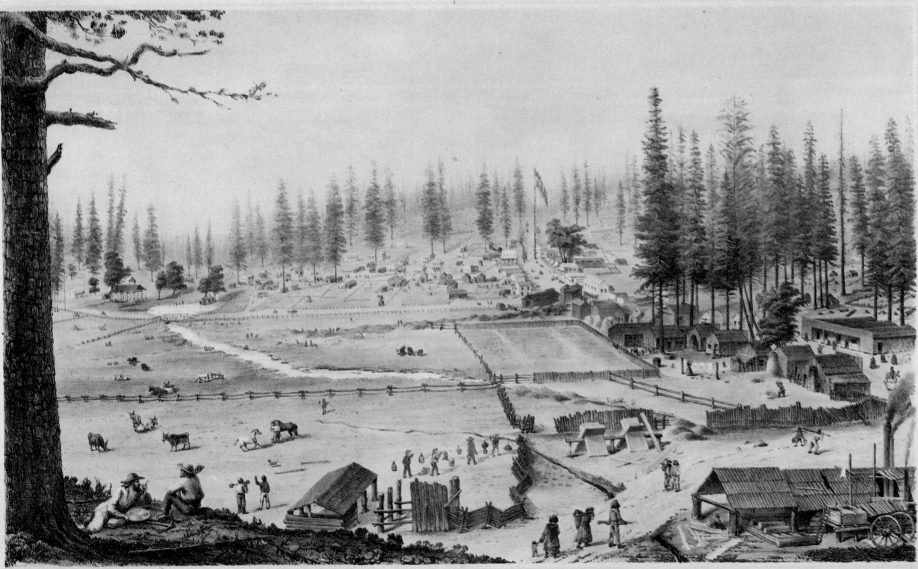

GRASS VALLEY, NEVADA COUNTY.
CALIFORNIA.

GRASS VALLEY, NEVADA COUNTY. CALIFORNIA. R. E. OGILBY. AUGT. 6TH. 1852. LITH.
OF J[OSIAH]. J. LE COUNT, SAN FRANCISCO.
*Lithograph. 1852. Size: 14.14 × 25.3 inches; 378 × 640 mm. Prints Division, The New
York Public Library.*

The Hippodrome

New York, New York, 1853

The Hippodrome was opened to amuse New Yorkers somewhat in the manner of a Roman circus. Covering nearly two acres of ground, the gaily designed building beckoned visitors to its location on Twenty-third Street and Fifth Avenue to fill the rows and rows of comfortable arena seats constructed for as many as ten thousand spectators. The most attractive feature of the building was the canopy covering. It consisted of light, waterproof canvas with alternate stripes of various colors. In the interior innumerable jets of gas, reflecting the hues of the striped covering, gave off a soft and effective illumination. The elegantly dressed spectators were offered an ambience that would magically enhance their elegance.

The Hippodrome, a name that speaks of horses and chariots, was introduced into America by a group of showmen that included Avery Smith and Richards Sands. Its guiding director was Henri Franconi, an accomplished horseman who was also one of the star performers. Appropriately enough, the arena was erected on the site of an old roadhouse known as Thompson's Madison Cottage, a favorite stopping place for turfmen. In the spring of 1853 ground was broken for the erection of two octagonal towers rising thirty feet in height and a circular brick wall rising twenty feet in height. On May 2 of that year the opening performance was held, and what a performance it was! There were gladiitorial contests, pageants, chariot races, trapeze feats, equestrian spectaculars, and whole family acts. The highlight of that first evening was a tournament called "The Field of the Cloth of Gold." The New York *Herald*, commenting on the attendance in its columns the next day, declared that there was a "dense mass of human beings, exceeding in number any assemblage . . . ever seen inside a building in this city, not excepting even the audiences attracted to the Jenny Lind concerts at the Castle Garden."

The offerings of a routine Hippodrome program were varied, and they were exotic. On one particular evening fifteen acts were billed, which drew heavily on French and Italian virtuosity and on French nomenclature. There were javelin and lance sports of the seventeenth century, ostriches chased by horses, a travestied turf scene with monkeys mounted on ponies, a grand ascension on a whirling ball, and a female chariot race. The ladies, driving their chariots at what appears to be furious speed, can be seen in the colorful parade making its way around the arena in the sheet-music lithograph. The Hippodrome offered two performances a day, and always the promise of something more sensational to come. On the same evening, for example, a program note informed its audience that a "Grand French Historical Spectacle, in which over 200 ladies will appear, is in active preparation and will be speedily produced."

In spite of the interest shown by the public and in spite of the reports by the newspapers, the Hippodrome had only a passing glory. It was a financial failure and lasted two seasons. The unusual building was eventually torn down after a fire to make way for the Fifth Avenue Hotel. Today the site is occupied by an office building and only a plaque gives a hint of the theatrical bustle which once animated that corner of New York.

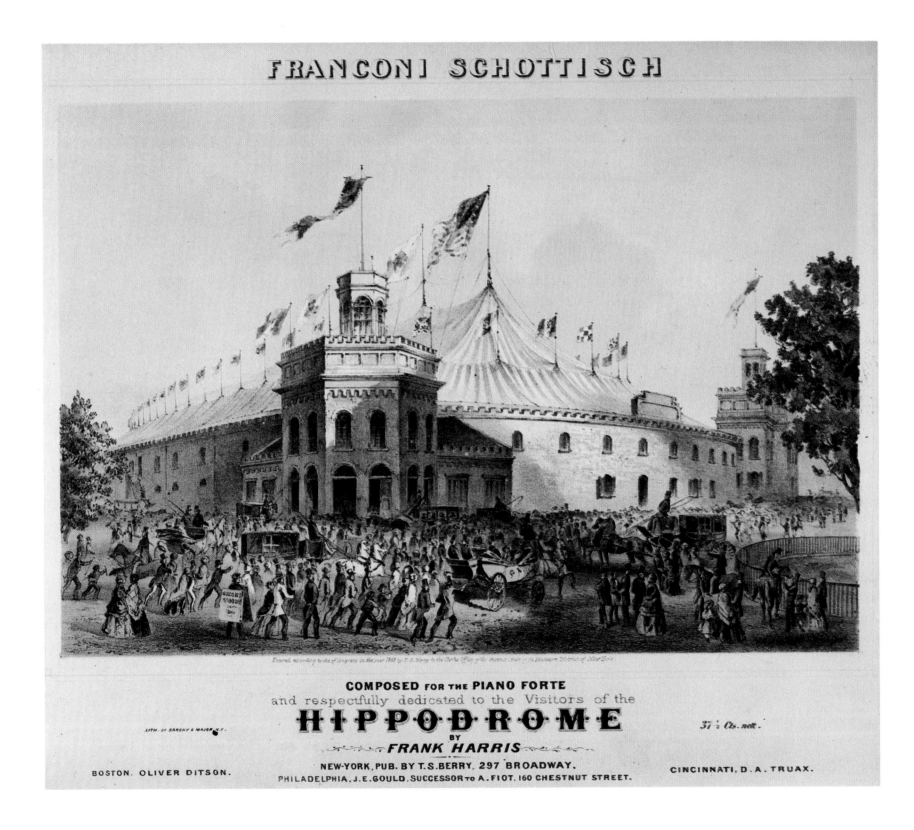

[HIPPODROME]. FRANCONI SCHOTTISCH COMPOSED FOR THE PIANO FORTE AND RESPECTFULLY DEDICATED TO THE VISITORS OF THE HIPPODROME BY FRANK HARRIS NEW-YORK, PUB. BY T. S. BERRY, 297 BROADWAY. . . . LITH. OF SARONY & MAJOR

N. Y. ENTERED . . . 1853. . . .
Lithograph. 1853. Size: 7.6 × 10.15 inches; 187 × 278 mm. Stokes Collection, Prints Division, The New York Public Library.

Franconi's Hippodrome.

Director of the Hippodrome......................Mons. Franconi
Leader of Cornet Band..........................J. C. Adams
Conductor of the Orchestra.....................T. Coates

Programme for the Evening.

PART I.

1. Grand Tournament—Field of the Cloth of Gold.
2. La Trapaze, Lofty Ærialquilibriums, by the Brother Seigrist.
3. La Course Greque, or Race with Six Horses, one mile heats, rode by M'lls. Angelina, color, Red ; Eugenie, Black and Gold ; Caroline, Light Blue ; Adelina, Blue entire ; Leontine, Red and Silver ; Marin, Dark Blue & Silver
4. Exercises of the Menage, in which Mons. Franconi will perform his Dancing Horse Johnston
5. Les Jeux de la 4me Olympiade.. Eight Horses and Four Riders, at full speed, standing up, by Messrs Marin, Sweet, Sergeant, and B. Stickney.
6. La Course des Singes—a Travestied Turf Scene, by Monkeys in Jockey Dresses, mounted on Ponies.
7. Grand Prize Race between Three Chariots—driven Two Horses abreast, by Mlle. Sylvestre, color, Pink ; Mrs. Mason, color, Blue ; and Mlle. Marin, color, Green,

Intermission of Fifteen Minutes for Refreshment and Promenade

PART II.

8. The Carousal—A new pageant, arranged under the immediate control of Mons. Franconi, illustrative of the Royal sports of the 17th Century. Part I—The hurdle ground of the Nobles—Grand flying leaps by Twenty-four male and female riders, with the "death aim" at the Sultan's head. Part 2—The Javalin sports, and Lance exercises by the full mounted Company. [Finale, The grand procession in honor of the victory,
9. Prof. J. N. Nixon, and his three Infant Children, will give an exhibition of their beautiful Jeux Icariens, upon a moving platform around the course.
10. Display of Ostriches—a number, single and harnessed to light Cars, will be chased by Horses, driven by Arab Drivers.
11. Grand Terrific Ascension, on a whirling ball, up an elevated angle, extending from one end of the Arena will be accomplished by Mons. Sylvestre.
12. Grand Steeple Chase and Hurdle Leaps, by Five Ladies, for the Prize Wreath, mounted on Fleet and Beautiful Coursers, ridden by Miles. Angelina, color, Striped Blue; Eugenie, Yellow ; Caroline, Crimson ; Leontine, Rose : Marin, Light Blue.
13. La Perche Equipoise, by the Seigrist Brothers, a performance with a pole 30 feet high, held by one and mounted by the other.
14. Contest between Two War Chariots, Four Horses abreast, at full speed driven by Mons. Marin and Mons. Franconi.
15. To conclude with a Scene from the Italian Corso, introducing a Troupe of Unsaddled Thoroughbreds, at full liberty, with flying streamers.

Doors open at half-past 2 o'clock, in the Afternoon. and at half-past 7 P. M.
Performance to commence half an hour after the opening of the House.

Performances will be given every Afternoon and Evening. The Entertainments given in the Afternoon will be equal in every respect to those of the Evening. Children under 10 years of age will be admitted to the Reserved Seats at half-price, both at the Afternoon and Evening performances. To the other Boxes, the half-price system will only be observed in the afternoon.
Tickets can be purchased at the Box Office from 7 A. M., until 11 P. M. also at the following places:—Western Hotel, Lovejoy Hotel, Astor House, New York Hotel, and at Dodworth' Music Store.
Stages and Cars will be in readiness at the end of the performances to convey passengers to the various sections of the city.

Boxes for respectable Colored Persons25 Cents

On Monday next, PROF. JOHN VISE the Successful Baloonist, will make a grand ascension from the interior of the Hippodrome.

THE GRAND FRENCH HISTORICAL SPECTACLE, in which, over 200 ladies will appear, is in active preparation and will be speedily produced.

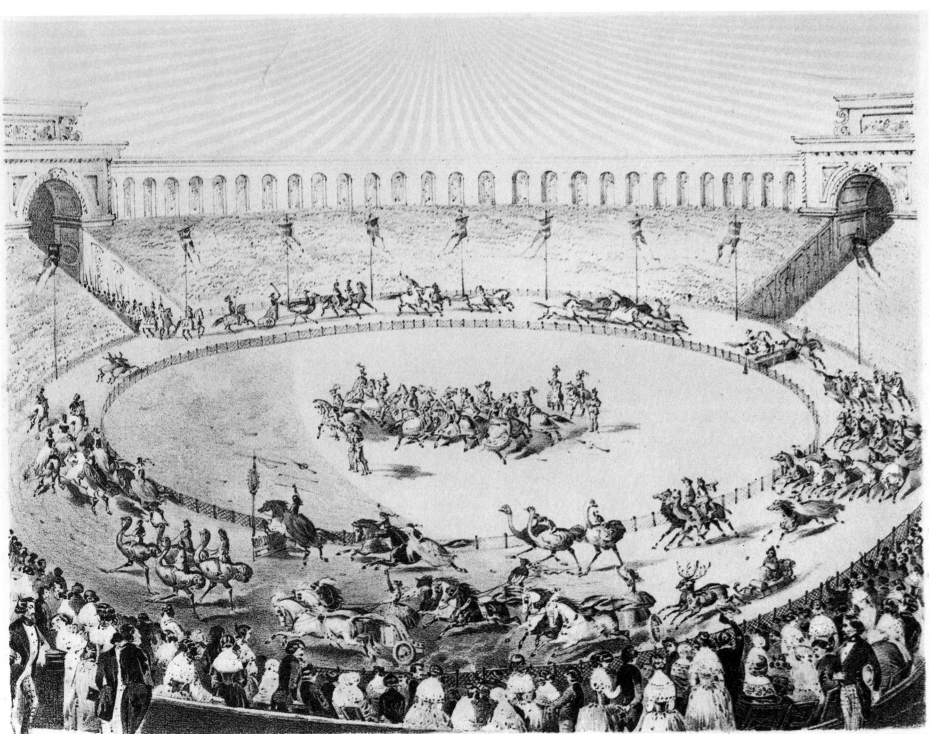

Entered according to Act of Congress in the year 1853 by T.S. Berry in the Clerks Office in the District Court of the southern District of New York.

HIPPODROME POLKA. COMPOSED FOR THE PIANO FORTE, BY P. H. VAN DER WEYDE.
NEW YORK. PUBLISHED BY T. S. BERRY 297 BROADWAY. . . . LITH. & PRINTED IN
TINTS BY SARONY & MAJOR. ENTERED . . . 1853. . . .
Lithograph. 1853. Size: 6.7 × 8.8 inches; 164 × 216 mm. Stokes Collection, Prints
Division, The New York Public Library.

New York from the Latting Observatory

New York, New York, 1855

We are high up in an observatory, courtesy of the first passenger elevator in the city of New York, and we are looking south, down the island of Manhattan. There are telescopes and maps for our use, and we can see rather far, for we are centered between Fifth and Sixth avenues and we are higher than the topmost windows of St. Paul's spire downtown. Our height is three hundred feet from the street on the third landing of the Latting Observatory. Our building is an octagonal structure of timber, well braced with iron, facing Forty-second Street and terminating in a spire. It is the world's first skyscraper (if we except the Tower of Babel) and quite safe: we are told it has been "carefully examined by scientific men, who have made a favorable report." Certainly it need not concern us that in one year's time it will burn to the ground.

Through the telescope we see two unique structures on the south side of the street. The one on the right, an elaborate glass house with a fitting name—the New York Crystal Palace for the Exhibition of the Industry of All Nations—was completed in 1853 for the World's Fair of that year. It was modeled after the Crystal Palace in London, though without the expansive surroundings, and it was constructed of iron and glass. Wood was used only for the floors, doors, and sashes. The palace was positively "fire-proof." Five years after its construction, a small blaze broke out: within twenty minutes the palace lay in a pile of incandescent ruins. Surviving the conflagration nicely was the mastaba-like structure next to it—the Croton Reservoir. Built in 1842 and opened with great pomp and pride, the stately reservoir offered water to the city and an open-air promenade for fashionable Sunday strolls. Besides the fire, the reservoir survived the putting up and pulling down so characteristic of the city; only when it was no longer needed at the turn of the century did it relinquish its site to The New York Public Library.

Moving briskly left across Fifth Avenue, past the elegant Mount Croton Garden with its hedges and fountains, past the open spaces of the eastern avenues and the elegant sloops in the unfilled bay, we can make a wide sweep with our telescope of the outer reaches of the view. We take in the bucolic aspect of Queens, the early congestion of Brooklyn Heights, the absence of any sort of bridge, the dominating silhouette of Trinity Church, the low hills of Staten Island, the green meadows of New Jersey, the belching smokestacks of the busy Hudson, and we are back to our starting point, just in time to watch a military parade making its way across Forty-second Street to the Crystal Palace. There, private coaches and public omnibuses are waiting, so we can come down from the Latting Observatory, courtesy again of the new steam elevator, and let ourselves be transported uptown. If we do, we will find that the population grows more sparse the farther north our horses take us and that the city is very little developed above Forty-second Street. Indeed, only a few streets are regulated, and the area of Central Park is littered with shanties.

As many of the omnibus lines serve lower New York, it is likely that the one in which we are traveling will take us to Barclay Street. There we can visit the Astor House, one of the city's finest hostelries. Though outdone in dimensions and decoration by some of the newer hotels, the Astor welcomes a bustle of opulence through its front doors, giving us more than a hint of its inside comforts, the sophistication of its clients, and the lavishness of its service. We can browse in the many shops on the ground floor, or we can relax in the marbled lobby and speculate on the make-up of the ballroom habitués. "Do you know," asked William Makepeace Thackeray, after a tour in America, "I haven't the heart to move my watch from New York time? [It was a fortnight since his return to England.] I pulled it out last night and showed it to the people at the ball, and said There that's the *real* time—they said Isn't this a beautiful ball and says I—Pish this is nothing—Go to New York if you want to see what a ball is . . . as if there could be any balls after New York!"[49] He was talking of the city in the year 1853.

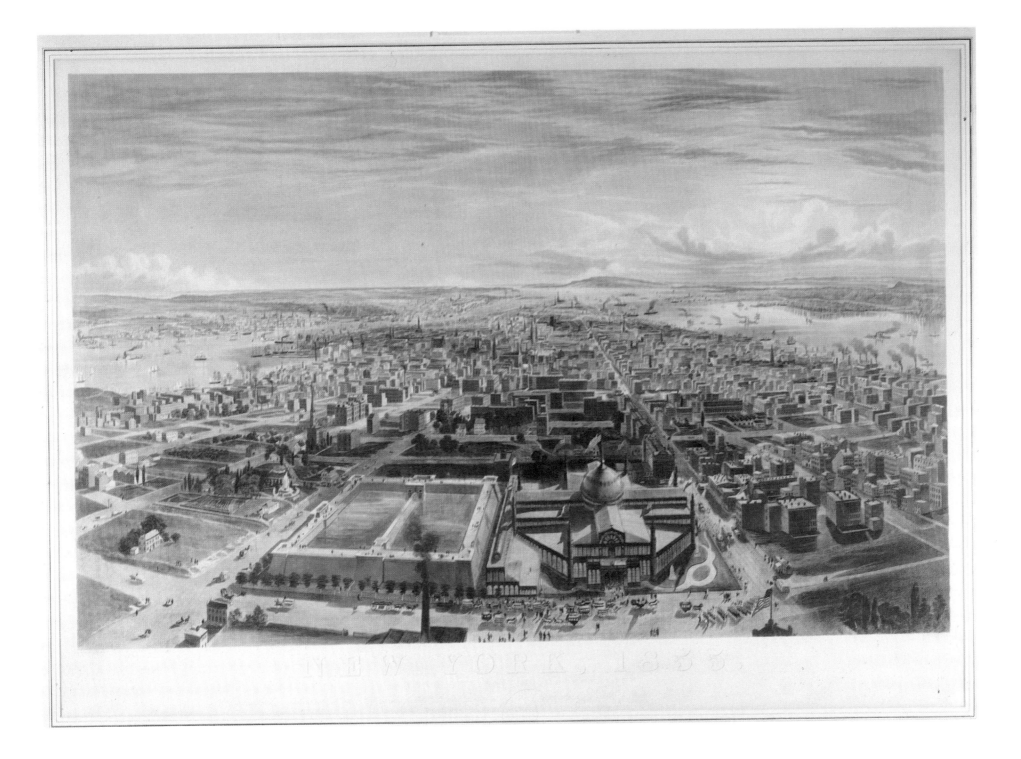

NEW YORK, 1855. FROM THE LATTING OBSERVATORY. B. F. SMITH JUN. DEL. W. WELL-
STOOD SC. . . . ENTERED . . . 1855. . . .
*Engraving. 1855. Size: 29.8 × 46.6 inches; 705 × 1151 mm. Walter Gift, Prints
Division, The New York Public Library.*

New York Amusements

Saratoga Springs and New York, New York, about 1865; 1855

The street population of New York, according to an English observer, was quite different from that of London or of large English towns. "One striking feature consists in the number of blacks, many of whom are finely dressed. . . . I saw but few well dressed white ladies, but am informed that the greater part are at present at the springs of Balstan and Saratoga."[50] And indeed they were. In 1818, the year Henry Fearon published his observations of life in America, there was already a modest throng making a yearly prigrimage to the summer charms of Saratoga. New Yorkers went there to drink the medicinal waters gushing from springs, widely reputed to relieve a variety of chronic diseases. After the steamboat was invented, and, later, when inland travel was made easier by rail, the throng to Saratoga was swelled by rich merchants from New Orleans; by polished landowners from Virginia, Georgia, and the Carolinas; speculators from Kentucky, Ohio, Missouri, and Michigan; government dignitaries from Washington; capitalists from Boston, New York, and Philadelphia; and a cluster of luminaries from the international world of money and the arts. During their stay these exquisite people drank tumblers of the healing waters assigned by their physicians, but as the century wore on, physical ailments became a transparent excuse for packing one's trunk. Saratoga had become not only a celebrated spa but a mecca for the rich and fashionable.

The mineral spring first known in Saratoga was the High Rock, and it was discovered by the Indians long before the settlers came. They were attracted there by the great quantity of game that frequented the spot as a salt lick, and they gradually became aware of the water's therapeutic powers in relieving rheumatism and similar complaints. Later, the colonists tapped many other springs that had mineral properties in varying proportions. Carbonic acid, soda, iron, lime, magnesia, muriatic acid, potassa, bromine, and iodine, the colonists found, are contained in Saratoga's waters, and because the springs have their source at a great depth in the earth, the minerals are little affected by atmospheric changes. The carbonic acid, of such high content that it acts as a powerful solvent in holding the various salts in solution, is responsible for the water's sparkling character. Not that the effervescent, saline pungency of the water appeals to everyone. Nineteenth-century habitués of Saratoga could drown any disagreeable taste in the opulence of their surroundings. Like Marienbad, Vichy, Baden-Baden, Karlsbad, and other international watering places, Saratoga and its hotels were of unusual splendor and afforded all the heady diversions of an affluent life. In 1865 Saratoga added another powerful tonic: the race track.

The thoroughbred horses of Saratoga were not the same breed of animal that operated the omnibus sleighs of crowded New York. Like most of the city's heterogenous population, the draft horses came from a more hardy stock. In 1855 the city's residents numbered over half a million, and at the bottom of the social scale were hundreds of thousands of Irish and German immigrants. Often too poor to avail themselves of the merriment New York offered in abundance, they found their entertainment in the hurly-burly of the streets. A collision of horse-drawn sleighs in front of Barnum's Museum (an emporium of freaks and improbable animals) was, for example, a perfect invitation for a snowball fray. There, at the busy corner of Broadway and Ann streets, any number of innocent targets rode or passed by. Under the cover of the uproar, a waist might be publicly squeezed or an ankle daringly exposed. In New York mischief and excitement lurked in the very quality of life Saratoga could not offer: anonymity.

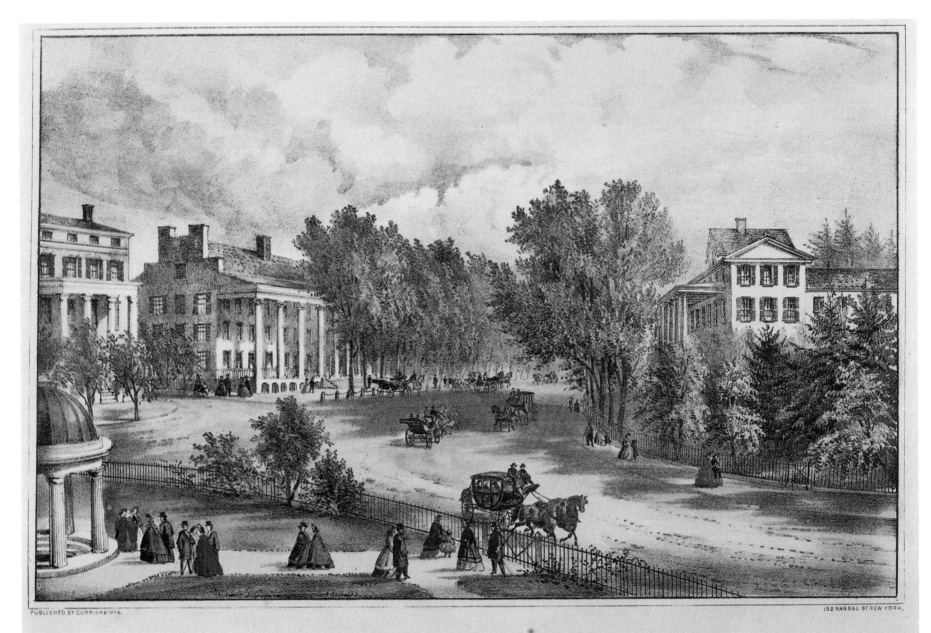

SARATOGA SPRINGS, N.Y.

SARATOGA SPRINGS, N. Y. PUBLISHED BY CURRIER & IVES, 152 NASSAU ST. NEW YORK.
*Lithograph. About 1865. Size: 8.2 × 12.10 inches; 206 × 321 mm. Stokes Collection,
Prints Division, The New York Public Library.*

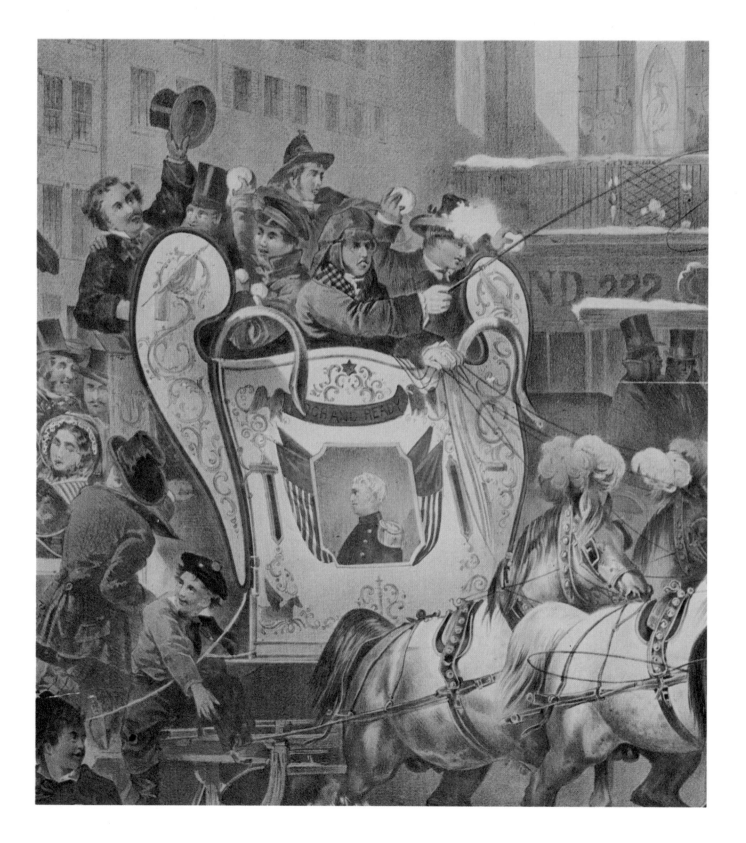

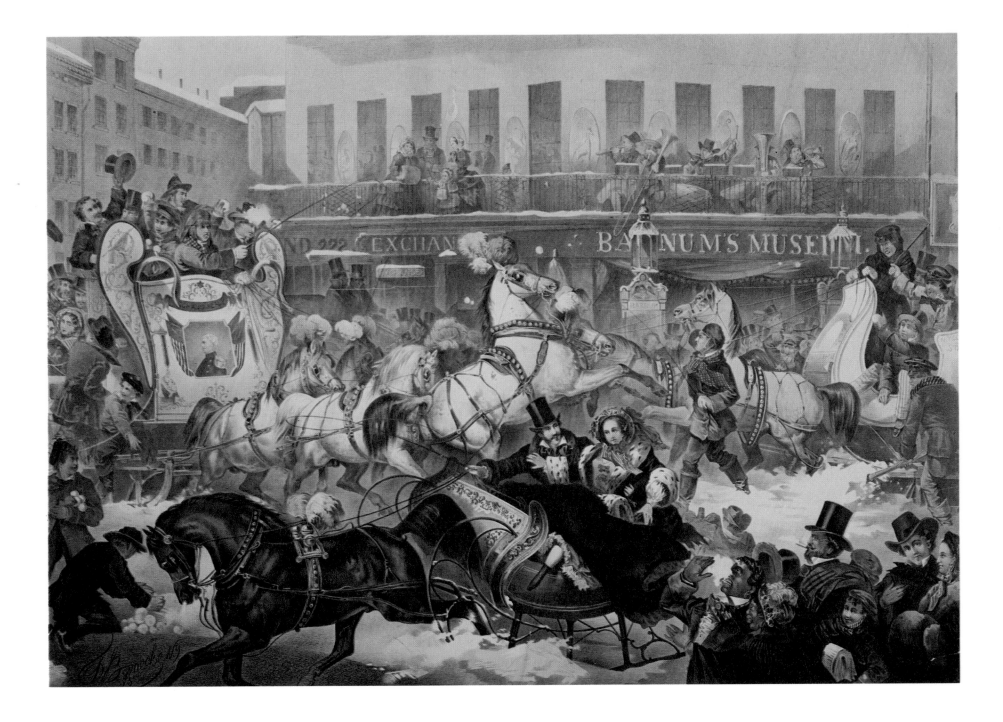

T. BENECKE NY 55 [SLEIGHING IN NEW YORK. PUBLISHED BY EMIL SEITZ, 413
BROADWAY N. Y. COMPOSED AND LITH. BY TH. BENECKE. . . .] [COPYRIGHT 1855.]
*Lithograph [margins trimmed]. 1855. Size: 21.8 × 30.8 inches; 545 × 775 mm. Eno
Collection, Prints Division, The New York Public Library.*

The University of Virginia and Monticello

Charlottesville, Virginia, 1856

The University of Virginia has often been engraved, painted, and photographed—that is because her creator left nothing to cosmetic chance. The sweeping lines of the university's rectangular design, the gentleness of the sloping terraced lawn, the parallel ranges of her classic dwellings, and the maze of hidden gardens behind serpentine walls were all part of a master design. The designer was Thomas Jefferson. "We are commencing here the establishment of a College," the former President announced in 1817, "and instead of building a magnificent house which would exhaust all our funds, we . . . shall arrange separate pavilions, one for each professor and his scholars. . . . Now what we wish is that these pavilions . . . shall be models of taste and good architecture, and of a variety of appearance, no two alike, so as to serve as specimens for the architectural lectures."[51]

For Jefferson the amateur architect, it was important that the academic center he was planning show good taste. For Jefferson the confirmed democrat, it was more important still that students and faculty mingle in a physical environment of easy, Socratic exchange. How would he achieve this? Faculty houses and student dormitories that were built side by side, he reasoned, would be one step in this direction. Then, he would avoid an overpowering central edifice. Perhaps this would help to overcome the formal, academic relationship between teachers and the taught that traditionally went with such a building.

Interestingly enough, Jefferson's first intention was not to build a new school but to improve an old one: his beloved alma mater, the College of William and Mary. It was when these improvement plans fell through that Jefferson, theodolite in hand, turned to new land and a bold new design. He chose as a site the natural amphitheater formed by the foothills of the Blue Ridge Mountains, and he staked out a plan that would fuse his ideas of living and learning into a kind of artistic democracy. He would, of course, be dogged like everyone else by the practical problems of a charter, of money, of state sponsorship, and of local encouragement. There would be problems, too, of imported stone, local timber and materials, craftsmen, workmen, and a carefully chosen faculty. There would be costly mistakes, hesitations, and imperfections. And there would be revised notions about the absence of a central building because Jefferson, amateur that he was in building design, was imaginative enough to listen to master architects. From Benjamin Latrobe he accepted the proposal of a rotunda to be placed at the pinnacle of the open court which would have the effect of unifying his independent parade of architectural units.

The first peg was pounded down in 1819. From that time on until the work was done, a stream of specifications, orders, letters, designs, and requests poured from the study in Monticello. Out on the grounds as the years of building went on, the designer could be found digging, poking, prodding, interfering, and helping—working along with the workmen who admired his talent and drive. By 1822 the energetic Jefferson had reached his eightieth year.

On March 7, 1825, the first academic session in Jefferson's innovative set of buildings opened. As we scan the whole complex of buildings in this unusually comprehensive view drawn three decades later, Monticello faces us on the opposite mountain. In the green of the open court, the exercise grounds to the right, and the majesty of the surroundings, there is ready agreement with architectural critic Ada Louise Huxtable that the design of the University "suggests the whole range of values to which American democracy aspired: unity in variety, the subordination of the parts to the whole, a humanistic order and the dignity of the individual. Delight was also there."[52]

That delight was to be made known to everyone. The creation of the University of Virginia was celebrated by Jefferson himself in his brief epitaph:

Here was buried Thomas Jefferson
Author of the Declaration of American Independence
of the Statute of Virginia for Religious Freedom
and Father of the University of Virginia.
Born April 13, 1743 Died July 4, 1826

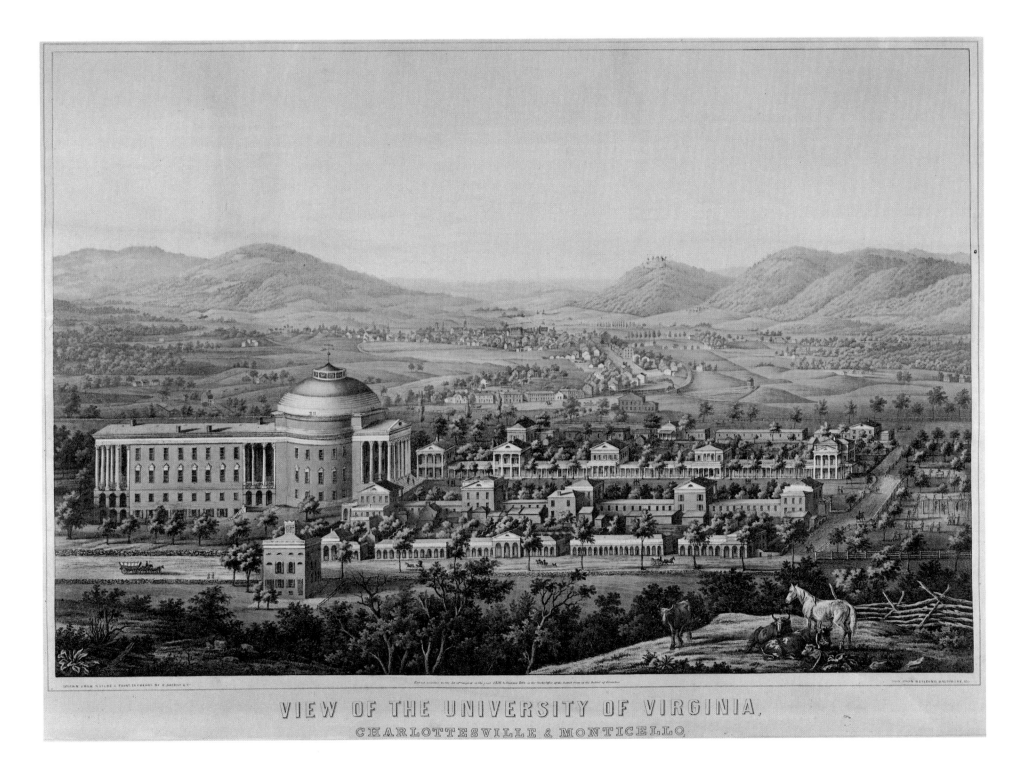

VIEW OF THE UNIVERSITY OF VIRGINIA,
CHARLOTTESVILLE & MONTICELLO

VIEW OF THE UNIVERSITY OF VIRGINIA, CHARLOTTESVILLE & MONTICELLO. DRAWN
FROM NATURE & PRINT. IN COLORS BY E. SACHSE & CO ENTERED . . . 1856. . . .
*Lithograph. 1856. Size: 17.12 × 26.10 inches; 451 × 676 mm. Stokes Collection, Prints
Division, The New York Public Library.*

The Life of a Fireman

New York, New York, about 1860

There were to be "no little summer fires outside the houses to cook by" in Peter Stuyvesant's bustling community. Already Manhattan had a history of conflagration. No sooner had Peter Minuit bought the island from the Indians in 1626 than a fire erupted that very same year. It was bad enough that some of the roofs in Stuyvesant's time were still covered with reeds, which ignited easily, and bad enough that chimneys still existed of plastered wood. Outdoor pleasure fires certainly suggested further incendiary mischief, and so the governor ruled them out.

Indispensable to daily survival in the seventeenth century, fire was also a recurring threat in the primitive settlement of New Amsterdam. Used uninterruptedly for heating, cooking, washing, and forging, a carelessly guarded fire could mean not only the loss of a single house but the loss of most of the colony. Clustered together for purposes of mutual need and defense, New Amsterdam's wooden Dutch dwellings risked by their proximity a rapid and successive conversion to ashes. Keeping an eye on what seemed to be infinite possibilities for the outbreak of a fire was therefore a steady part of the governor's burden. When the city's fire wardens asked for a clarification of their duties in 1663, Stuyvesant was very precise. Roofs covered with reeds were not to be repaired, they were to be replaced. Wooden chimneys were not to be replastered, they were to be condemned. A householder with a foul fireplace was to be fined, and tempting fragrances wafting from forbidden barbecues were not to reach the governor's nose. There was another problem as well. The city's fire ladders were being borrowed, and they were not being returned. Residents could still have access to them, Stuyvesant decreed, but there would be a fee of six stivers (twelve cents) each time they were used. When they were returned, their prescribed place was "in back of the City Hall." Most important, there was to be a fire-prevention program: city wardens would make an inspection of houses and fireplaces to check for hazards every three months.

Stuyvesant's preoccupation with fire prevention was to end abruptly: less than a year later the Dutch surrendered their colony. It was the British who were to witness Manhattan's worst conflagration, when they captured the city from a rebel army in 1776. In that fire, which brought the beautiful Trinity Church to ruins, one quarter of the entire city was destroyed. Nothing was ever to match the destruction of that year, but New York would continue with a history of fires. In the nineteenth century there were at least five blazes of serious proportions. Seven hundred houses in seventeen blocks were consumed in the winter of 1835, with the Stock Exchange, the banks, and the post office—the very heart of the city—destroyed. That fire was so beyond the resources of any fire-fighting equipment that buildings were blown up with gunpowder to contain the flames. In 1845 there were four more fires. The last of them, a summer burning on July 19, caused staggering losses. Three hundred buildings were destroyed in a holocaust that swept over virtually the same district as in 1835.

Until 1865 New York battled all these fires with cumbersome equipment and a volunteer force. So much brawn and heroism were involved in the protection of lives and property that prominent citizens joined in the heroic drama, and fire-engine companies became an important factor in the social life of the city. As membership often led to political influence and advancement, a strong rivalry developed between crews attached to different engines. An early fire department consisted of a chief engineer and his assistants, the fire wardens, firemen, hosemen, and hook-and-ladder men. Each fire warden was attached to a particular engine that he and his crew dragged to the scene of the fire and operated by hand. Even after steam power was introduced in 1840 to pump water into the hose, hand-pumped engines were not discarded for quite some time. How cumbersome all of this equipment was, and how dangerous as well as exhausting to handle, is clear in this Currier and Ives lithograph, where we can see both types of engines operating side by side. Framed by two smoke-snarling steam engines, eight pairs of arms are raised in the foreground in the act of some heavy hand-pumping; they are matched by an equal set of arms on the other side. The men are working long wooden bars seesaw fashion, and the bars in turn rock a metal beam that moves the piston pump. The water is being played on the burning store of Richard Hinsdale at 33 Murray Street and on the store of James White at the corner of Murray and Church. The dry goods in these stores feeding the blaze are sending ferocious flames against the whiteness of the moon and the City Hall's watchtower cupola. "So much has been said . . . of the . . . skill of the New York firemen," wrote an English traveler early in the century, "that I was anxious to see them in actual operation."[53]

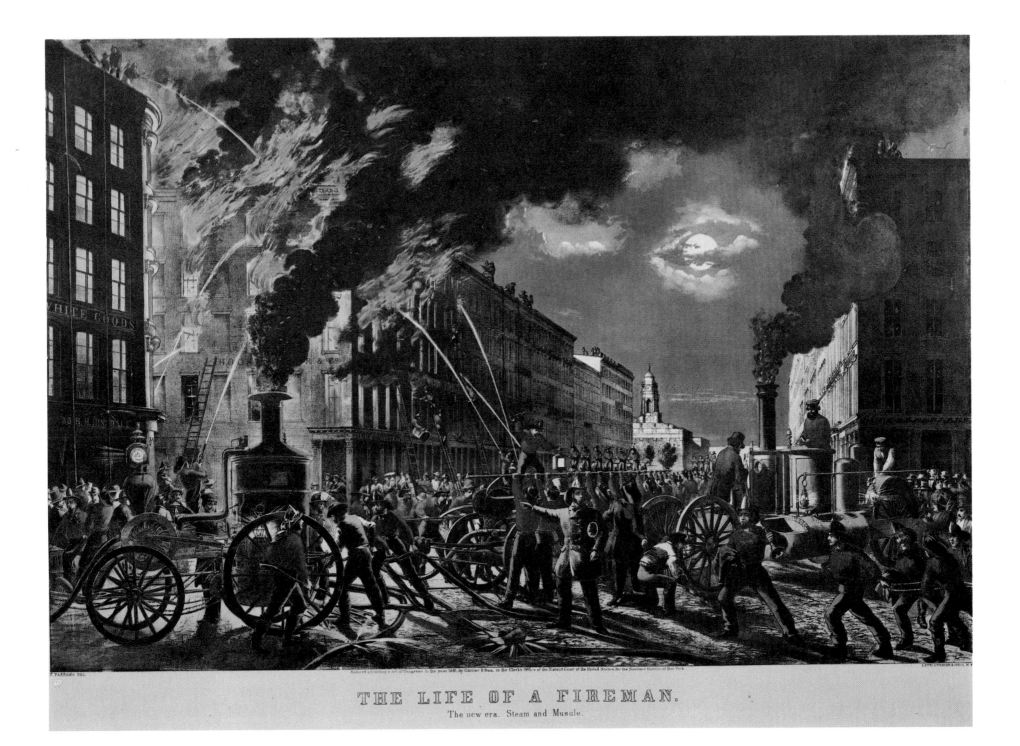

THE LIFE OF A FIREMAN.

The new era. Steam and Muscle.

THE LIFE OF A FIREMAN. THE NEW ERA. STEAM AND MUSCLE. C. PARSONS DEL. LITH.
CURRIER & IVES, N. Y. ENTERED . . . 1861. . . .
*Lithograph. About 1860. Size: 17.2 × 25.2 inches; 434 × 637 mm. Prints Division, The
New York Public Library.*

The Siege of Yorktown

Yorktown, Virginia, 1862

With its cloud of skirmishers in advance,
With now the sound of a single shot snapping like a whip, and now an irregular
* volley,*
The swarming ranks press on and on, the dense brigades press on,
Glittering dimly, toiling under the sun—the dust-cover'd men,
In columns rise and fall to the undulations of the ground,
With artillery interspers'd—the wheels rumble, the horses sweat,
As the army corps advances.

—Walt Whitman, An Army Corps on the March

In his inaugural address of 1861, President Abraham Lincoln had spoken plainly to the secessionists: "In your hands, my dissatisfied fellow countrymen, and not in mine, is the momentous issue of civil war. The government will not assail you. . . . We must not be enemies. Though passion may have strained, it must not break our bonds of affection." But the bonds were broken not long after, and the terrible Civil War erupted. In the view of many Europeans it was not possible for the North to be victorious over the South. The Confederacy had begun preparing for war several months before the Union, it had been a year ahead in adopting conscription, and it was winning most of the early battles. Then, too, secession had put the best officers of the United States Army on the side of the South; the President was being forced to choose his leaders from among civilians, men trained as soldiers but not active in military life when the war began. One such man was George Brinton McClellan.

Trained at West Point, McClellan had been a railroad official when he was chosen to replace the aging Winfield Scott as general in chief of the armies. Thrust into his new military role, he performed well, though not brilliantly. Now he was asked to assume command of a major campaign—the massive attempt by Union forces to capture Richmond. He was to organize an Army of the Potomac from a base in Washington, ship his men via Alexandria to the south, proceed by way of the peninsula between the York and James rivers, and lay siege on Yorktown. As troops poured into the capital from all directions, McClellan trained, equipped, and disciplined them. He was precise and thorough in his preparations and methodical in his outlook—qualities for which he was praised and, later, criticized. He contemplated a strong and vigorous offensive, and he had the steadfast support of the President. In the spring of 1862 he was the Union's man of the hour.

"General McClellan has his residence and head-quarters within a stone's-throw of where I am writing," reported a war correspondent for the *Morning Star* on March 28, 1862.

> The embarkation at Alexandria is carried on under his supervision, and pushed forward with all possible rapidity, but not sufficiently so to please the grumblers. . . . People in civil life have no idea of the immense train which must follow an army. Take, for instance, a single brigade of 4000 infantry. Twenty ambulances, twenty-five large army wagons, and nearly 200 horses, have to be provided for, in addition to ammunition, forage, and provisions. The force moving towards Southern Virginia by the Potomac and Chesapeake rivers, numbers at least 100,000 men, so that if we multiply the above items by 25, we may form some idea of the difficulties attendant upon the movement of an army. Recollecting the time necessary to embark our own troops and those of France at the commencement of the Crimean War, we should make proper allowance for the apparent slowness of the present operations.[54]

Allowances were made, but the siege was a disaster. McClellan performed no expected miracles for the Union, and in the fall of that year a very disappointed President was led to remove him.

An idea of the "immense train which must follow an army" is given in this lithograph of the Peninsular Campaign battlefield prepared by a soldier-artist. Tent after tent, sentry after sentry, soldier after soldier, horse after horse, carriage after carriage, cannon after cannon, lined up in the best West Point tradition, are all diminutively clear. Yorktown, its ancient ramparts shored up for the nineteenth-century siege, is in the foreground. To the right and center are the battalions of McClellan's army; to the left, the Confederate forces. Across the York River is the garrisoned town of Gloucester, while everywhere there is the exchange of fire.

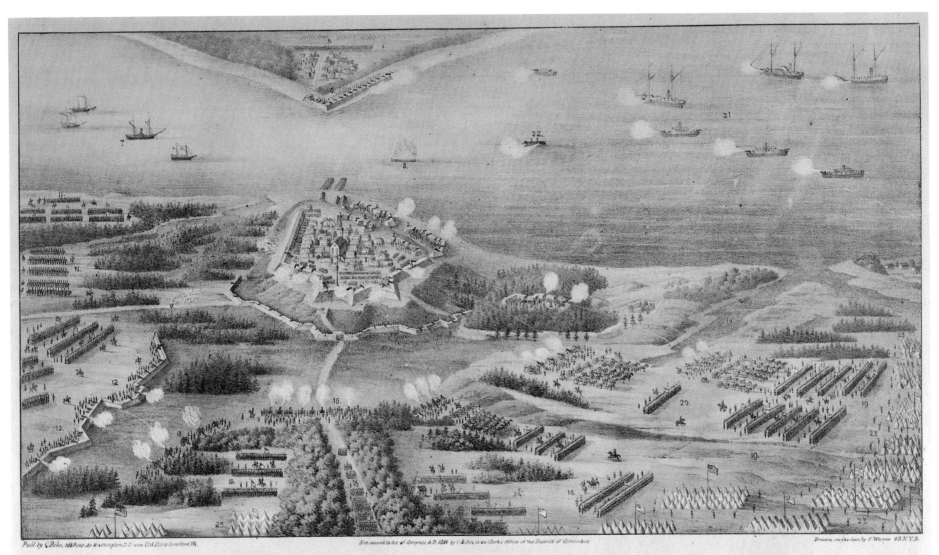

THE SIEGE OF YORKTOWN, APRIL 1862.

1 Yorktown.. 2 Four Batteries of 21 Guns, 32 and 42 Pounders & Columbiads.. 3 Columbiade.. 4 Two rifled Guns.. 5 Masked Batteries, Dahlgreen Guns.. 6 Gloucester and Battery of 18 Guns.. 7 Confederate Schooners.. 8 Cotton Bales and Pitch Turpentine.. 9 Road from Williamsburg.. 10 Wormsley Creek.. 11 Rebel Infantry and Cavalry 12. Rebel Batteries. 13 Left Wing of United States Army.. 14. Brig Gen! Casey's Command (three Brig.).. 15. General Butterfields Corps d'Armée (Centre).. 16. Headquarters of Maj. General Mc. Clellan and Staff.. 17. Gen! Sykes Reserve Regulars (one Brigade.).. 18. Gen! Smiths Division.. 19 Right Wing Maj. General Heintzelman's Command.. 20. Brig. Gen! Porters Advance (one Brigade).. General Sedgwick (four Brigades). Brig General Hamilton (four Brigades).. 21. Seven U.S. Gunboats.. 22. Naugatuck.. 23. Encampments three miles before Yorktown.

THE SIEGE OF YORKTOWN, APRIL 1862. DRAWN ON THE SPOT BY C. WORRET 20 N. Y.
R. LITH. BY E. SACHSE & CO. 104 S. CHARLES ST. BALTIMORE. . . . ENTERED . . .
1862. . . .
Lithograph. 1862. Size: 9.1 × 16.11 inches; 230 × 424 mm. Stokes Collection, Prints
Division, The New York Public Library.

Blake Street

Denver, Colorado, probably 1865

What do we want with this vast worthless area, this region of savages and wild beasts, of deserts, shifting sands and whirwinds of dust, of cactus and prairie dogs? To what use could we ever hope to put these great deserts or those endless mountain ranges, impregnable and covered to their very base with eternal snow? What use have we for such a country? Mr. President, I shall never vote one cent from the public treasury to place the Pacific Coast one inch nearer Boston than it is now.[55]

The year was 1838, the place the floor of the United States Senate, the speaker Daniel Webster, and the region of savages and wild beasts that impassioned Webster's rhetoric included the site west of the Missouri where Denver would soon rise. Those "endless mountain ranges," towering in stark and splendid contrast to the endless plains, would give the yet unfounded city a majestic panorama, the "eternal snow" would augment the joy of winter sports and the pleasure of health, and the "vast worthless area" would yield in its secret places rich mines of silver as well as gold.

It was the gold that came first. News of it broke in 1858, and within one year it had lured almost twenty thousand people from all directions across the plains. They traveled on muddy and treacherous trails under appalling conditions, bundled in ox wagons, mule wagons, private coaches, public stages, and windblown prairie schooners. They traveled a succession of wearisome days across a desert of stunted shrubs, soil white with alkali, and brackish waters often poisonous to both animals and men. If they survived the trek it was with footsore cattle and horses, and tempers as withered as the desert grass. Their headquarters, or perhaps permanent residence, were the two settlements already established on either side of Cherry Creek, and already rivals for fame and fortune. As wagons wheeled in daily full of hardware and people, the Indians of the region–Arapaho, Cheyenne, Apache, Comanche, Kiowa, Sioux, and Ute–watched the influx with awe and justified apprehension. They saw crude log huts and eventually whole villages appear among their traditional teepees and wigwams. It was an influx that made of Cherry Creek a society primitively housed and colorfully mixed. "There were Americans from every quarter of the Union," wrote a self-styled gold-rush Bedouin,

> Mexicans, Indians, half-breeds, trappers, speculators, gamblers, desperadoes, broken-down politicians and honest men. Almost every day was enlivened by its little shooting match. Denver and Auraria [the two settlements] contained about one thousand people, with three hundred buildings, nearly all of hewn pine logs. One third were unfinished and roofless, having been erected the previous winter for speculative purposes. There were very few glass windows or doors and but two or three board floors. The nearest saw-mill was forty miles away, and the occupants of the cabins lived upon the native earth. . . . One lady, by sewing together corn-sacks for a carpet and covering her log walls with sheets and table cloths gave to her mansion an appearance of rare luxury. Chairs were glories yet to come. . . . Chimneys were of sticks of wood piled up like children's cob-houses and plastered with mud. . . . [There] were Indian lodges, enlivened by squaws dressing the skins of wild animals or cooking puppies for dinner, naked children playing in the hot sand and braves lounging on the ground. . . .[56]

By 1865 the scene had somewhat changed. The two rival settlements had long since merged into the town of Denver, and the town itself had survived the disappointments of a disastrous fire, a paucity of gold, a flash flood in Cherry Creek, and friction with the Indians. There were now about six thousand residents, a large floating population, a thriving real-estate market, and commercial activity that soared to the figure of twelve million dollars. Much of Denver's business bustle took place in Blake Street, the wide thoroughfare stretching long in this lithograph. We can see an auction sale in progress and beyond it a bank conveniently located to accept the overflow. In the foreground, a mixture of the permanent and floating population—top-hatted men, hoop-skirted women, dandies, dudes, horses, cattle, mules, dogs, and pigs—all appear to be equally at home on the long and hospitable stretch of Blake Street.

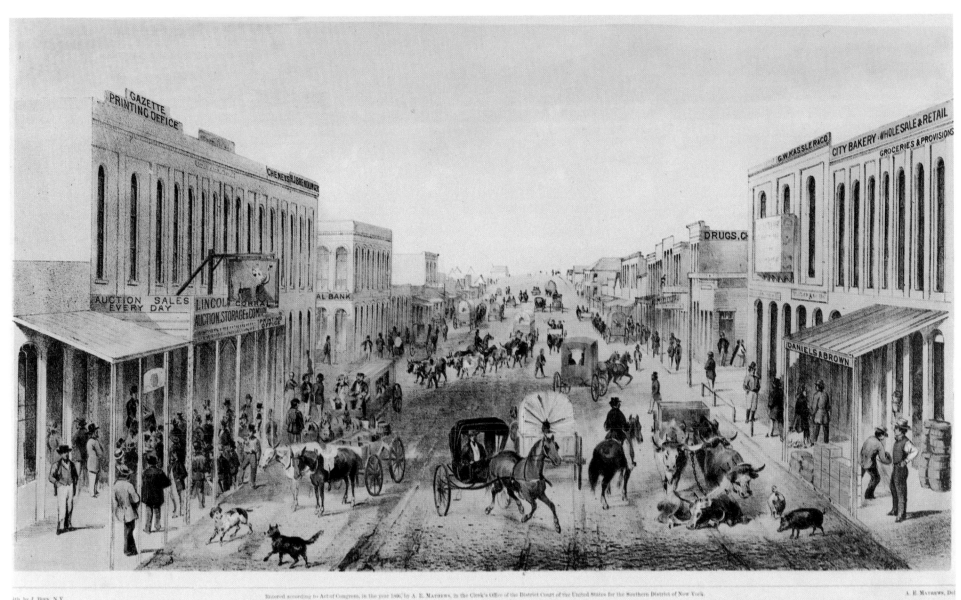

BLAKE STREET, DENVER, COLORADO.

BLAKE STREET, DENVER, COLORADO. LITH. BY J. BIEN; N.Y. A.E. MATHEWS, DEL. EN.
TERED . . . 1866. . . .
Lithograph. Probably 1865. Size: 9.11 × 16.7 inches; 247 × 418 mm. Prints Division,
The New York Public Library.

A Home on the Mississippi

Mississippi River, Mississippi, about 1871

Ol' man river
Dat ol' man river,
He must know sumpin',
But he don't say nothin',
He jus' keeps rollin',
He keeps on rollin' along.[57]

Even the Indians thought that the mighty stream flowing from the north to the Gulf of Mexico "knew something." They called it the Father of the Waters and gave it its name: *Misisipi*, which means "great river." It is so long a river that ten states—from Minnesota to Louisiana—border on it, and its course so serpentine that no one agrees on its mileage. As it meanders toward the open sea, the Mississippi (were the consonants doubled because of its length?) indulges in capricious capers, leaping and cutting through various points of land in a mischievous jab at precise cartography. The Spanish in the sixteenth century were the first after the Indians to behold the mammoth river, but their interest in it was minimal: the surrounding regions offered plenty of mud, but no gold or silver. The French appreciated its worth to the extent of gambling with it very profitably. They ceded the territory west of it to the Spanish, took it back, and then dangled it before the American ministers in Paris. Before the land was bought from Napoleon, the river loomed as an enormous threat. Immediately after the American purchase, the same river invited the young republic to unite and expand. Thereafter the Mississippi flowed into the economy and social life of the new country, and into its literature, music, drama, and legends. When the time came for the telling of its romantic history, it cleverly entrusted it to the talent of a great author. After all, "it is not a commonplace river," wrote Mark Twain, "but on the contrary is in all ways remarkable."

We learn from Mark Twain that the Mississippi is the longest river in the world: four thousand three hundred miles. He admits he fiddled with the measurements, having tucked into his calculations the main tributary of the Missouri. "It seems safe to say that it is also the crookedest river in the world," the author reasoned,

> since in one part of its journey it uses up one thousand three hundred miles to cover the same ground that the crow would fly over in six hundred and seventy-five. It discharges three times as much water as the St. Lawrence, twenty-five times as much as the Rhine, and three hundred and thirty-eight times as much as the Thames. No other river has so vast a drainage-basin; it draws its water supply from twenty-eight States and Territories; from Delaware, on the Atlantic seaboard, and from all the country between that and Idaho on the Pacific slope—a spread of forty-five degrees of longitude. The Mississippi receives and carries to the Gulf water from fifty-four subordinate rivers that are navigable by steamboats, and from some hundreds that are navigable by flats and keels. The area of its drainage-basin is as great as the combined areas of England, Wales, Scotland, Ireland, France, Spain, Portugal, Germany, Austria, Italy, and Turkey. . . .[58]

These heady statistics tell little of Twain's passionate affair with the river, but a well-known affair there was: it wove itself not only into the author's historical account but into much of his fiction. It is most likely that the setting of the Currier and Ives view is in the Mississippi region, south of the city of St. Louis, that Twain knew so well. The view allows a glimpse of the high-decked river steamboat, especially designed for the treacheries of the Mississippi by Henry Miller Shreve, and imaginatively piloted by Twain. It also offers a larger look at the foliage and routine of gracious southern life along the water's banks. Mrs. Trollope, traveling up the river to Memphis in one of the earlier steamboats, remarked on the scenery: "The unbroken flatness of the banks of the Mississippi continued unvaried for many miles above New-Orleans; but the graceful and luxuriant palmetto, the dark and noble ilex, and the bright orange, were everywhere to be seen, and it was many days before we were weary of looking at them."

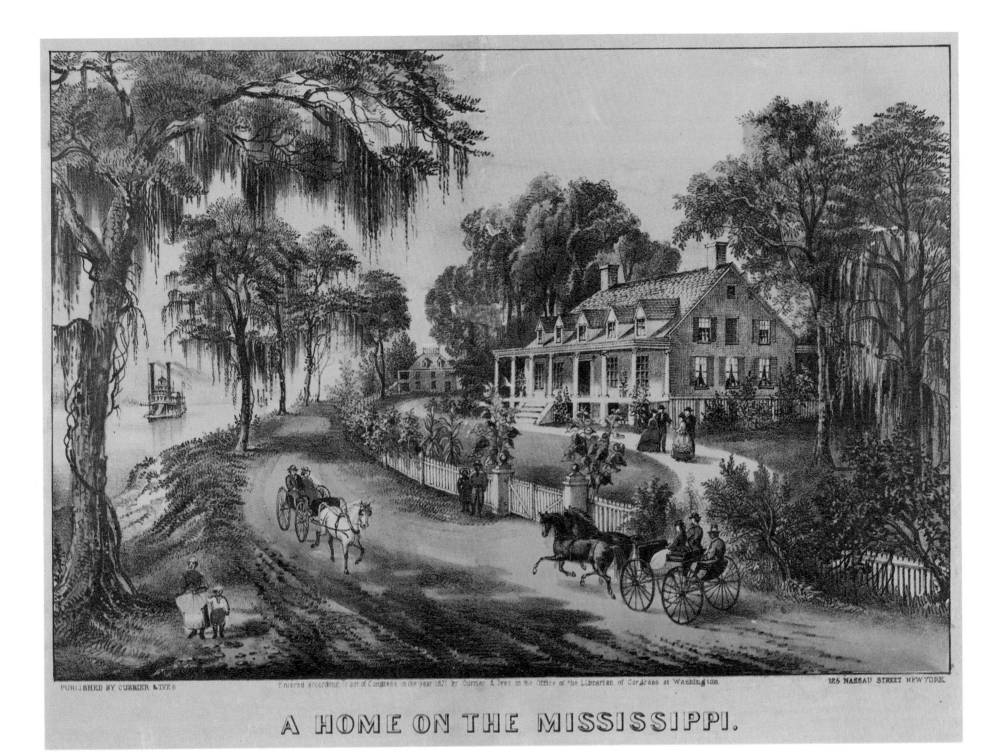

A HOME ON THE MISSISSIPPI. PUBLISHED BY CURRIER & IVES 125 NASSAU STREET NEW
YORK. ENTERED . . . 1871. . . .
Lithograph. About 1871. Size: 8.8 × 12.8 inches; 217 × 318 mm. Prints Division, The
New York Public Library.

The Great Fire at Chicago

Chicago, Illinois, 1871

We saw the fire grow, wrote Samuel Pepys, and as it grew darker it

> appeared more and more, and in corners and upon steeples, and between churches and houses, as far as we could see up the hill of the City, in a most horrid malicious bloody flame, not like the fine flame of an ordinary fire. . . . We staid till, it being darkish, we saw the fire as only one entire arch of fire from this to the other side of the bridge, and in a bow up the hill for an arch of above a mile long: it made me weep to see it. The churches, houses, and all on fire and flaming at once; and a horrid noise the flames made, and the cracking of houses at their ruine.[59]

It was the great London fire of 1666 about which Pepys was writing, so terrible a conflagration that it would consume nearly five sixths of the city within its walls.

Pepys made more than one entry in his diary to lament the fire. Most of what he described—the long drought, the combustibility of everything, "even the very stones of churches," the sick carried in beds, the confusion of the poor, the scramble for carts, wagons, and boats to save one's "good goods," the fire running with the wind, the terror that it would never end—can all be read as documentation of a fire that overtook Chicago a little more than two hundred years later. Though the blaze which broke out in the American city did not rage for four days and four nights as did the fire in England, it was equally uncontrollable and savage. It, too, had humble beginnings. The London fire began in a baker's house in Pudding Lane. The Chicago fire began in a barn on De Koven Street. Both were products of drought and were fed by a mischievous wind. So capricious was the gale that blew on the night of October 9, 1871, in Chicago that people protected themselves from the downpour of hot cinders with wet umbrellas. Driven by that gale, the path of the fire was wayward and confusing. It took a diagonal direction from the southwest of the city to the northwest, straying maddeningly here and there from its northward course. To everyone's horror, it even leapt across the Chicago River. When the gasworks blew up, the ghastly rumor spread that the waterworks had gone, too. As probably no city had a better supply of water, everyone's hope for the city's survival lay there, and, although the tunnels below the surface were safe, the pumping engines were damaged early. In rapid succession the great buildings fell: the grand Pacific Hotel, the Court House, Crosby's Opera House (just about to be rededicated), the Sherman House, the Tremont House, the "fire-proof" structure of the *Tribune*, the Palmer House, and the Union depot. All the bridges on the north side of the river fell, too. Like an expanding scythe cutting larger and larger swaths through the city, the blaze rolled on. Dwelling after dwelling gave way, block after block gave way, and family after family, driven into exile, fled, dragging prized furniture, lugging bundles and mattresses, and rescuing pets and valueless possessions in the daze of escaping to no one knew quite where. Horses and mules mingled with men, women, and children in the mêlée, and everything that could move—coaches, wagons, carts, and wheelbarrows—was wheeled into service. All the while, the insistent hurricane of pelting cinders, blazing bits of timber, and spattering sparks made a nightmare of the exodus. "With one's face in the wind," Pepys had commented, "you were almost burned with a shower of fire-drops."

Sometime between two and four o'clock on Tuesday morning, October 10, the fire stopped. It had begun in the evening of October 8 and had spread several miles north of the Chicago River. Gunpowder had been systematically applied, the forces of the city's fire-fighting equipment exhaustively employed, and help enlisted from the outside. Ultimately, it was a lull in the wind and a slight rain falling at the same time that assured the end. When that came, about eighteen thousand buildings had been destroyed. Those that were left standing emphasized the ruins around them, and hordes of visitors came to view the battered metropolis. Chicago, for a very short while, was a phantom city.

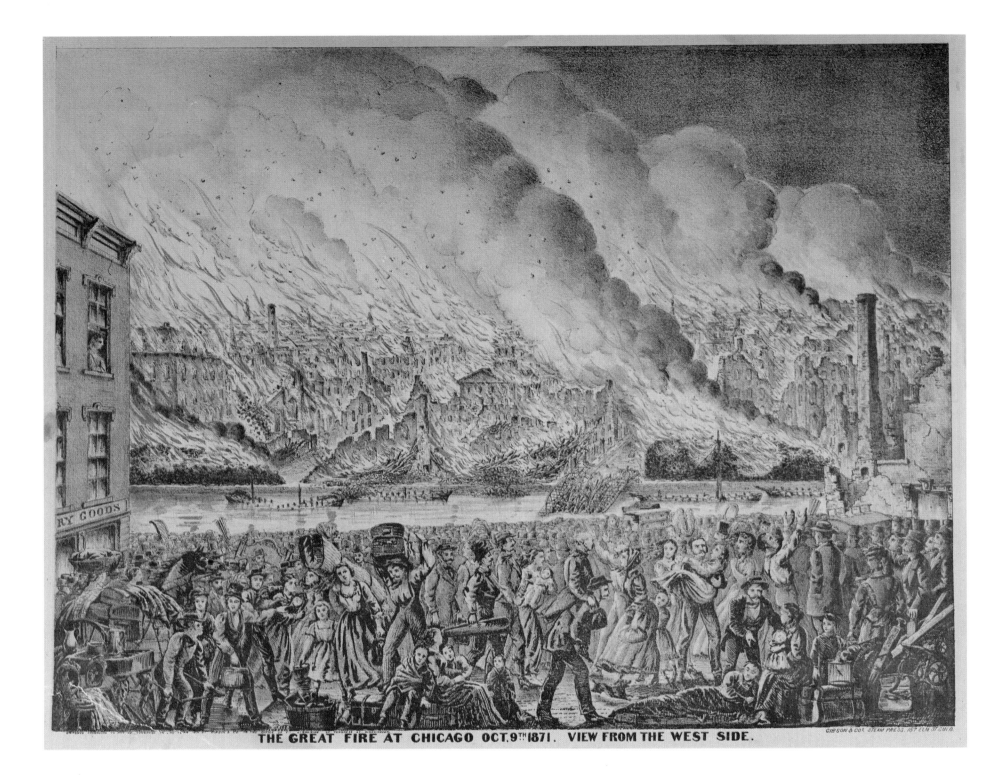

THE GREAT FIRE AT CHICAGO OCT. 9TH. 1871. VIEW FROM THE WEST SIDE.

THE GREAT FIRE AT CHICAGO OCT. 9TH. 1871. VIEW FROM THE WEST SIDE. GIBSON &
CO.S STEAM PRESS. 167 ELM ST. CIN. O. ENTERED . . . 1871. . . .
*Lithograph. 1871. Size: 11.9 × 15.10 inches; 294 × 397 mm. Stokes Collection, Prints
Division, The New York Public Library.*

Yosemite Valley

Yosemite Valley, California, 1873

The Yosemite Indians knew of the beauty of the region long before the settlers came. When the majestic gorge in the Granite Peak of the Sierra Nevada eventually passed to the white man, it was fitting that it should bear their name: Yosemite Valley. The seven-mile wonderland of granite cliffs, foaming waterfalls, and flowering woodlands, soaring high above the level of the sea and paralleling the grandeurs of Europe, shares its enchantment with all who come. In the nineteenth century the painter Albert Bierstadt traced its seasonal wonders on canvas, the naturalist John Muir pried into the mystery of its formation. The writer Helen Hunt Jackson—schoolmate of Emily Dickinson and friend of the Indians and the Valley alike—challenged its wilderness:

> As I looked up to the dark line of firs on either side of the Great Fall, I pictured to myself the form of that six-year-old boy of the Ah-wah-ne-chee, who, when the white men entered the valley, was seen climbing, naked, like a wild chamois, on the glistening granite face of the rock-wall, midway between heaven and earth, to escape the enemy. . . .
>
> Almost at once, by the first two or three bends of the trail, we were lifted so high above the valley, that its walls seemed to round and close to the west, and the green meadow and its shining river sank, sank, like a malachite disk, slowly settling into place, at bottom. The trail was steeper than any we had seen. Even Murphy [a guide] muttered disapprovingly at some of its grades, and jumped down and walked to make the climb easier for his old gray. On our left hand rose a granite wall, so straight that we could see but a little way up, so close that we had need to take care in turning corners not to be bruised by its sharp points, and so piled up in projecting and overlapping masses that, mountain as it was, it seemed as if it might topple at any second. On our right hand—space! nothing more; radiant, sunny, crisp, clear air: across it I looked over at the grand domes and pinnacles of the southern wall of Ah-wah-ne; down through it I looked into the depths of Ah-wah-ne; away from it I turned, dizzy, shuddering, and found the threatening rocks on the left friendly by contrast. Then, with impatience at my own weakness, I would turn my face toward the measureless space again, and compel myself to look over, and across, and out and down. . . .
>
> At last Murphy shouted triumphantly from ahead: "Here's the trail. Fetched it this time; now keep up, sharp"; and he rode off down a steep and rocky hillside, at a rate which dismayed me. The trail was faint, but distinct: at times on broad opens, it spread out suddenly into thousands of narrow dusty furrows: these had been made by flocks of sheep driven through earlier in the season. From some of these broad opens were magnificent views of the high Sierras; we were six thousand feet high, but they were five and six and eight thousand feet higher still; their glistening white peaks looked like ice-needles, sharp, thick-set against the far blue sky; between us and them, a few miles off, to the left, lay the beautiful granite-walled, meadow-paved abyss of Ah-wah-ne, but its narrow opening made no perceptible break in the grand surfaces of green and gray over which we looked to the horizon. It seemed long before we reached the river. At first sight of its gleam through the trees, Murphy drove his spurs into his horse, and galloped towards it. Slowly he rode up and down the bank, looking intently at the water. Then he turned and rode back to me.[60]

Helen Hunt Jackson's *My Day in the Wilderness* first appeared in the same year that this chromolithograph of Yosemite Valley was issued.

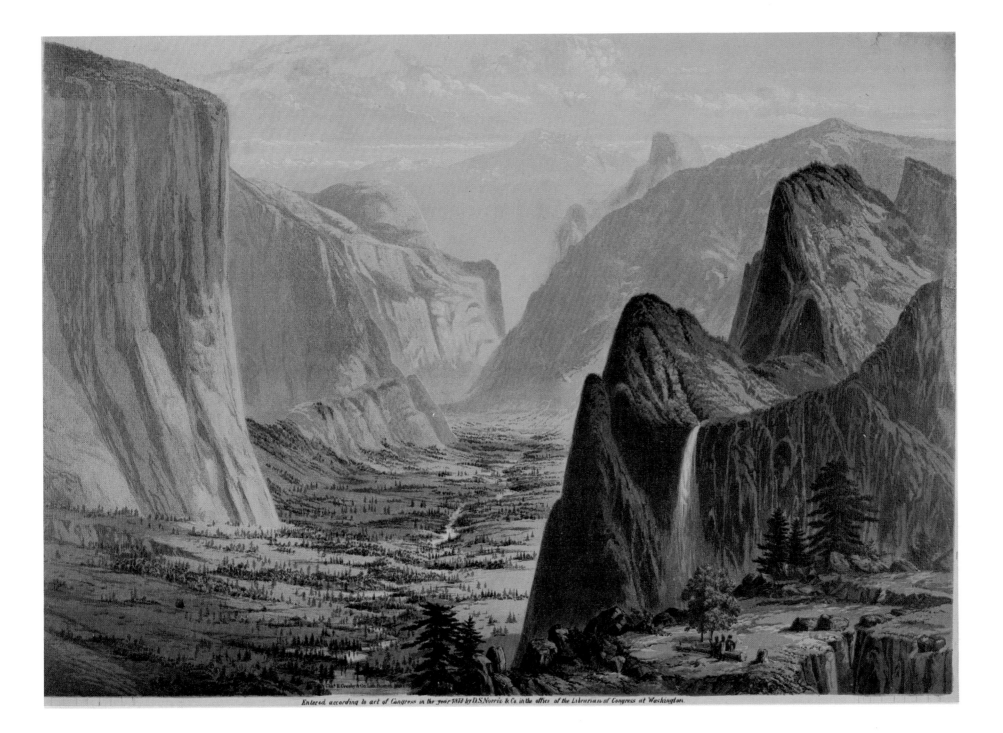

Entered according to act of Congress in the year 1873 by D.S.Norris & Co. in the office of the Librarian of Congress at Washington.

[VIEW OF YOSEMITE VALLEY, CALIFORNIA]. CHAS. H. CROSBY & CO. LITH. BOSTON, MASS. ENTERED . . . 1873. . . .
Chromolithograph. 1873. Size: 14.2 × 19.15 inches; 359 × 508 mm. Prints Division, The New York Public Library.

The Centennial Celebration in Philadelphia

Philadelphia, Pennsylvania, 1875–1876

The first one hundred years had passed. There were two foreign wars on the ledger, and one terrible Civil War—the wounds were still fresh from the domestic conflict. Still, the tone in 1876 was optimistic, and notions of unity, prosperity, and happiness were linked with the magic of industry. "We are now celebrating our first Centennial Anniversary," declared the official government bulletin. "The grandest exhibition of the arts, sciences, and manufactures . . . that the world has ever witnessed, is now in the course of commemoration. The history of this enterprise is that of a gigantic undertaking, whose origination is attributable to no one mind, but was seemingly the outgrowth of the spontaneous 'happy thought' of the entire American people. . . ."[61] President Ulysses S. Grant came to the ceremonious opening, and, soon after, thousands and thousands of industrial objects produced by American and European ingenuity were offered for inspection. They were housed in a complex of specially designed buildings, themselves a display of architectural ingenuity.

Philadelphia was doing the honors for the Centennial. Selected over other cities that had competed for the glory, Philadelphia offered her Fairmount Park, with its almost three thousand acres, for the splendid array of exhibition halls. It was an attractive spot, with the Schuylkill River running through the park and the buildings spread along some of the most beautiful banks of the waterway. There were innumerable buildings of all shapes and sizes and various kinds of transport to whisk people to and from the very doors. There were buildings for various states, about twenty or so, and one building named "The South." The German Empire was represented, as well as the Empire of Brazil. Great Britain alone required two exhibit halls. There was also a Japanese Dwelling, a Woman's Pavilion, a French Restaurant, a Photograph Gallery, a Sweden School House, and a World's Ticket Office. Large companies like Singer Sewing Machine had buildings of their own, while the rectangular compound, with a Byzantine flavor, housed the great Agricultural Hall. To the left was Machinery Hall, a domed palace with diminutive palace extensions. Dominating this architectural array was the Main Building. Designed in the form of a parallelogram, it stretched upward from the Schuylkill, across the exhibition grounds, to a length of almost two thousand feet.

The preparation of all this had been made with a long glance toward Europe. Always before the eyes of the planners, the builders, and the promoters were the models of the dazzling fairs that had been held abroad in London, Paris, and Vienna. Statistics as to their size, their visitors, and their success were constantly invoked. How many visitors had there been to the London Exhibition of 1851? How many days had the Paris Exhibition of 1867 lasted? How large were the gate receipts at the Vienna Exhibition of 1873? The questions were prompted by a feeling that America could outdo Europe. Neither the succession of scandals that was rocking Washington, nor the worst industrial depression of the century, could dim the country's bright expectations. The focus of the Centennial celebration was on national pride and on a projection of unprecedented prosperity. The pride had been eloquently expressed by the poet Walt Whitman:

> I am
> One of the Nation of many nations, the smallest the same and the largest the same,
> A Southerner soon as a Northerner, a planter nonchalant and hospitable down by the Oconee I live,
> A Yankee bound my own way ready for trade, my joints the limberest joints on earth and the sternest joints on earth,
> A Kentuckian walking the vale of the Elkhorn in my deer-skin leggings, a Louisianian or Georgian,
> A boatman over lakes or bays or along coasts, a Hoosier, Badger, Buckeye. . . .
>
> — Song of Myself

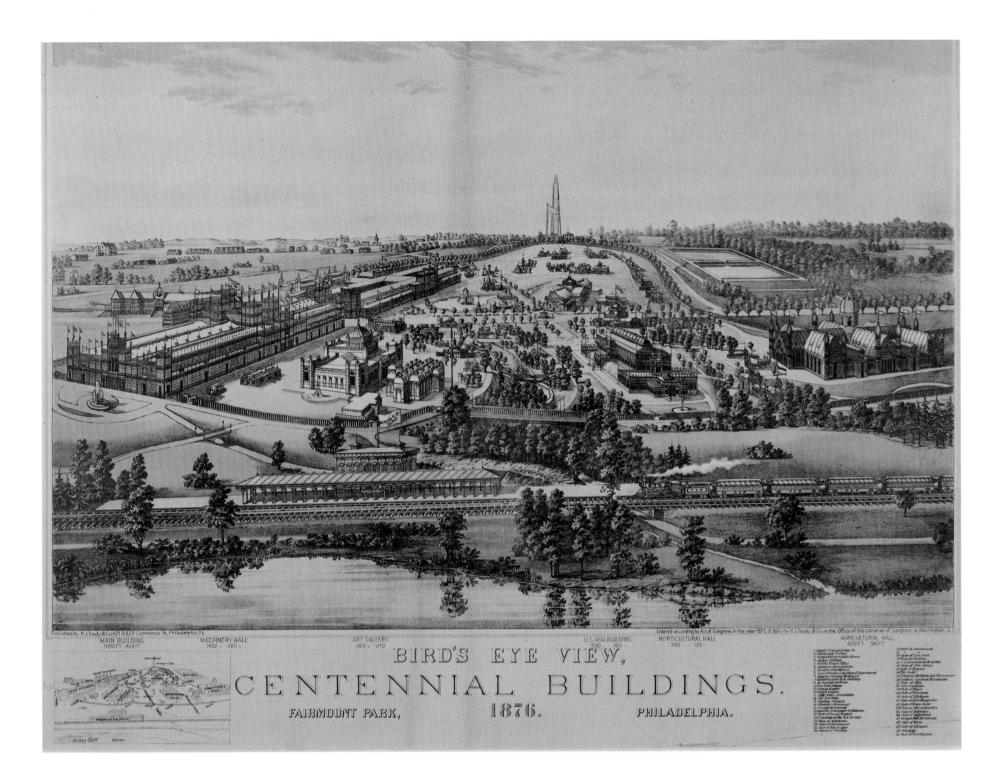

BIRD'S EYE VIEW, CENTENNIAL BUILDINGS. FAIRMOUNT PARK, 1876. PHILADELPHIA.
PUBLISHED BY H. J. TOUDY & CO., 621 AND 623 COMMERCE ST., PHILADELPHIA, PA.
ENTERED . . . 1875 & 1876. . . .
Lithograph. 1875–1876. Size: 14.4 × 22.8 inches; 362 × 570 mm. Stokes Collection,
Prints Division, The New York Public Library.

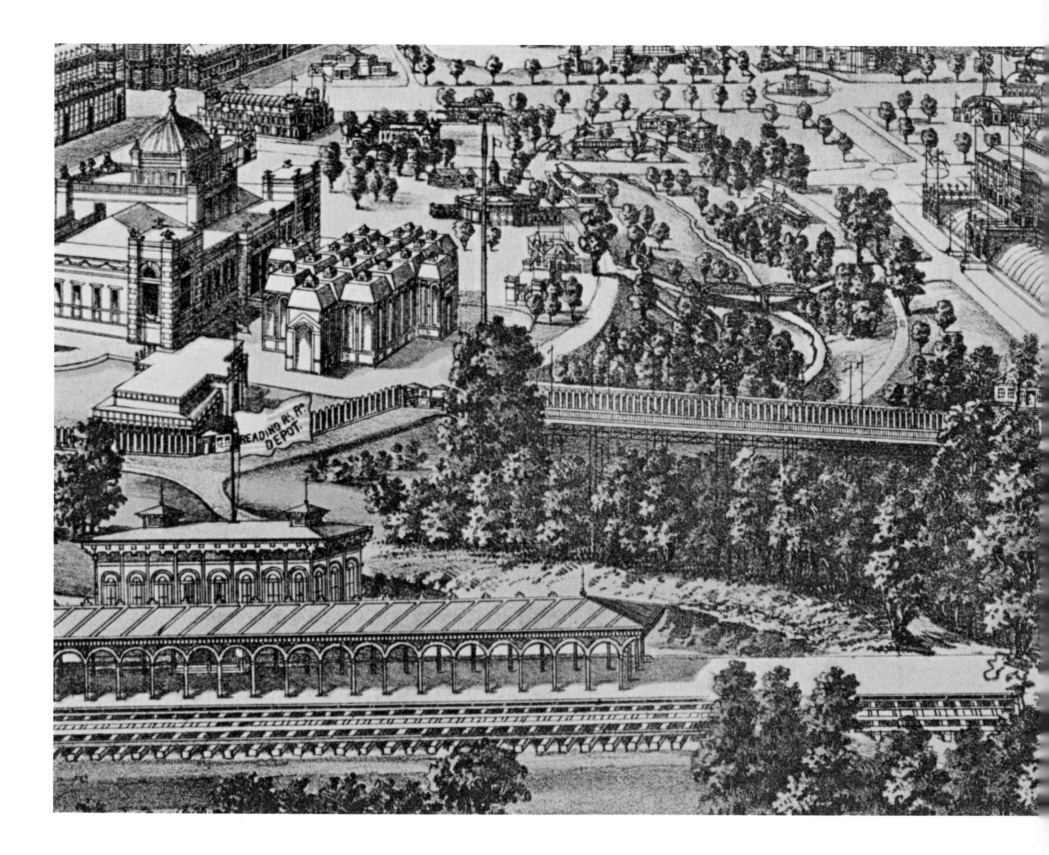

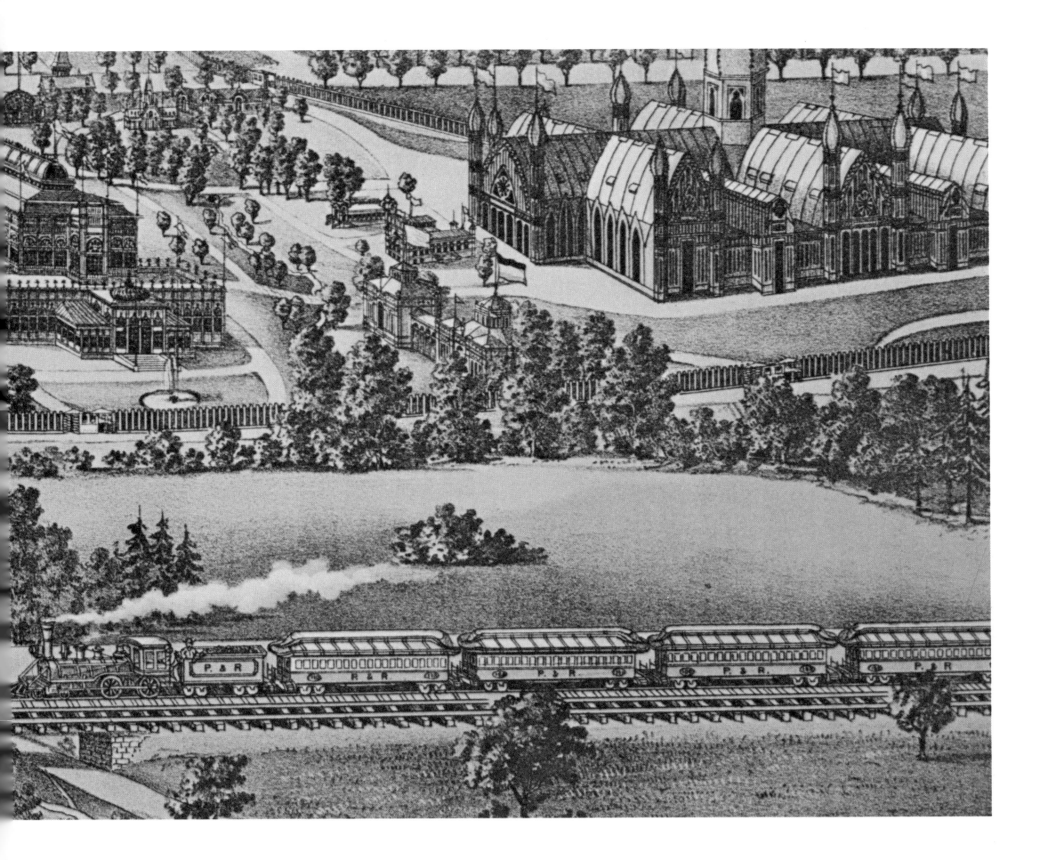

Baldwin's Hotel and Theater

San Francisco, California, 1876

"There is almost nothing to see in San Francisco that is worth seeing," wrote Anthony Trollope in 1875. "There is a new park in which you may drive for six or seven miles on a well made road, and which, as a park for the use of a city, will when completed, have many excellencies. There is also the biggest hotel in the world—so the people of San Francisco say, which has cost a million sterling—5 millions of dollars—and is intended to swallow up all the other hotels. It was just finished but not open when I was there."[62]

The hotel intended to swallow up all other hotels was The Palace, and when its doors were opened in the fall of 1875, after the British traveler's departure, it was the talk of hotel architects, owners, decorators, managers, staff, and patrons who admired lavish living the world over. The statistic that caused the greatest stir was the number of bathtubs: four hundred and thirty-seven to serve eight hundred and fifty rooms. Not only was the building held to be fireproof but it was held to be as near earthquake-proof as human skill could make possible, and so commodious was the structure that the aggregate length of its corridors stretched for two and a half miles. When the Baldwin Hotel was completed two years later, it could take only second place to so great and imposing a palace.

Hotels of such size and splendor in a city that had had its economic birth less than thirty years earlier pointed to a meteoric rise in wealth. Peopling so many rooms on so elegant a scale could not mean that there was "almost nothing to see in San Francisco," nor did the extravagant hotel facilities for gambling, wenching, dining, and dancing indicate that there was not very much to do. Sparking these social activities was the business life of San Francisco, which filled the air with a captivating rush and whirl. It was dominated by an extremely active trading in stocks, stimulated by the continued development of the nearby Nevada mines. Mining for gold, now a question of complicated machinery rather than of individual effort, required a large investment before the mines could be worked, and much of the capital was obtained in San Francisco. A majority of the new mining companies in the West came gradually to be owned and financed by San Francisco speculators. There were, of course, panics and declines on the mining market, but trading was steadily revitalized by new discoveries, and a new wave of speculation had just reached a crest in 1876.

One speculator who enjoyed the mysteries of mining-stock maneuvering was E. J. "Lucky" Baldwin, a native of Ohio who arrived in California in 1853. Reckless market trading was congenial to his ambitious nature, and the success of his manipulations brought him a major fortune. His success also brought him the means for some major indulgences: two of the city's fleetest thoroughbreds and a hotel with his name. The Baldwin Hotel was an ambitious project, conceived in a style compatible with the aspirations of parvenu America. Located on Market and Powell streets, it also housed the Baldwin Academy of Music, and the theatrical stock company of the Academy became one of the celebrated institutions of the city. The hotel's Corinthian columns, classic cornices, and mansard roof—patterned after French Renaissance motifs of the Second Empire—were impurely designed with modern combinations and ornaments. Its architectural flamboyance culminated typically in the cupola: a mark of wealth and a prerogative of the American merchant prince.

In one of the cupolas was a "cosy little room, elegantly carpeted, and furnished with luxurious chairs and sofas; with tables to write upon; and, in the midst of all, two or three of the most superb billiard tables, designed for none other than fair soft hands to play upon."[63] This was a discreet description of the *ladies'* billiard room, and word of it circulated, like the wood engraving of the hotel, far in advance of the Baldwin's opening.

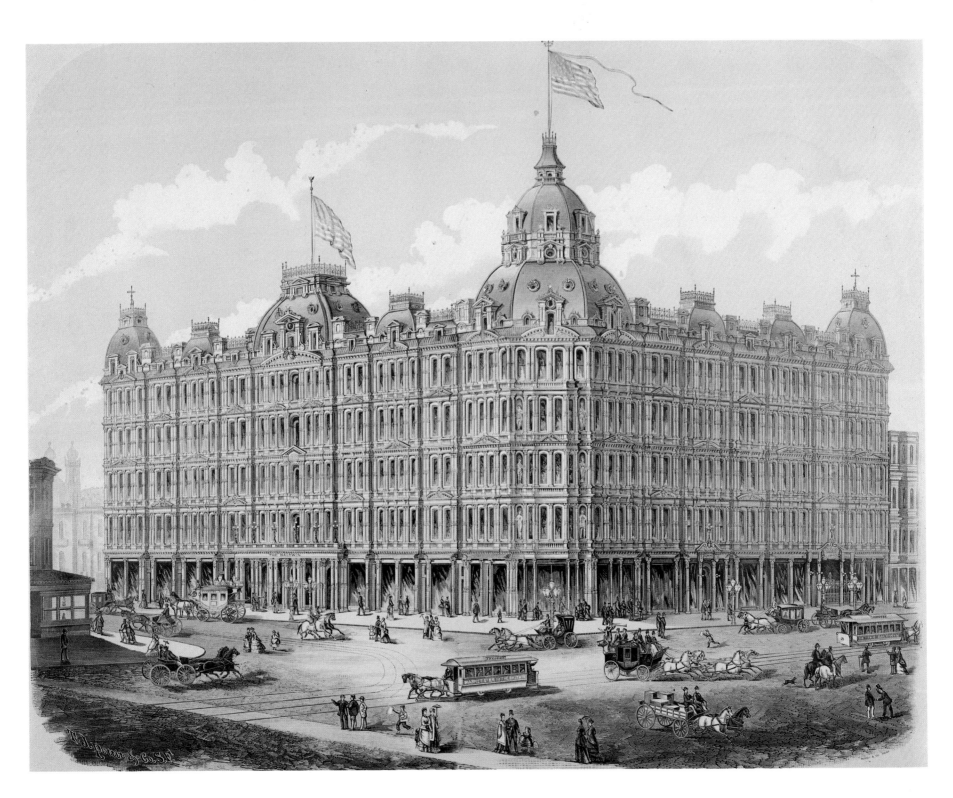

BALDWIN'S HOTEL AND THEATRE, SAN FRANCISCO, CAL. T. J. PETTIT & CO., S. F. BOSQUI & CO PRINT J. A. REMER, ARCHITECT, SAN FRANCISCO. ENG. ON WOOD BY T. J. PETTIT & CO., 528 CALIFORNIA ST.
Wood engraving. 1876. Size: 18.13 × 24.11 inches; 477 × 627 mm. Prints Division, The New York Public Library.

The Grand Opening of the Brooklyn Bridge

Brooklyn and New York, New York, 1883

"What do your Lordships understand regarding the Ferry between this City [of] New Amsterdam and Breucklen—is it granted to this city or not?"

The question was put, by mail, to the directors in Holland in 1654. At the bottom of it was a scramble for city revenue. A lively ferry service had developed between the two fledgling cities on the banks of the East River. People were ferried across; cattle, horses, oxen, wagons, carts, trunks, boxes, bundles, and the destinies of entire families were ferried across as settlers made their way to the wooded loveliness of the island heights across from Manhattan. But the ferry service was in private—and mischievous—hands, and the local burgomasters saw no reason why this should be so. Besides, the crossing was so miserable and so much a matter of whim and weather that the situation was in dire need of being regularized. Passengers were sometimes stranded out in the open for whole days and nights because of winds, blizzards, tides, fog, storms, and ice jams. Then, atop these capricious performances of nature, passengers were sometimes stranded because of disputes with the ferrymen. A ferryman might take it into his head to ask double the fare; he might row his clients over in a crowded or risky boat, separate passengers and possessions, or decide not to make the crossing at all: that is, if the weather threatened or the tavern beckoned!

To remedy these vexations, Peter Stuyvesant issued the first ferry ordinance. Henceforth, no one but the authorized lessee of the ferry was permitted to carry passengers or cattle. Fees were regulated, and the ferryman was ordered to have a sufficient number of boats and a sufficient number of men to operate them. He was to be on duty in the summer from five in the morning until eight at night and in the winter from seven until five, although he was not bound "except he please, to convey anyone over in a tempest, or when the Windmill hath lowered its sail. . . ." There was to be a covered shed or lodge on both sides of the river to shelter passengers, and government agents were to glide over the waters free. By 1700 Stuyvesant's wooden lodge was replaced on the Brooklyn side of the river by a two-story house of stone and brick. There, men and horses might have "good Accommodation att Reasonable Rates," and, there, the ferry agent was ordered to keep a "publick house of Entertainment."[64]

It was exactly over the site of this modest colonial structure that the first tower of the Brooklyn Bridge rose like a colossus. The time was 1875; the bridge would not be completed for another eight years, but already its appearance was thoroughly familiar from the engravings that projected its wonder. Not since the tower of Babel and the great pyramid of Egypt had there been a construction conceived in such massive proportions—so went the excited talk. As an engineering feat the bridge was the achievement of John and Washington Roebling, father and son, and the devices by which they would make the high suspension possible were examined with interest and awe at the Philadelphia Centennial Fair. Once construction got under way, there were the usual mishaps, the running out of money, the death of the older Roebling, hesitations, jealousies, accidents, and the shattered nerves of the son. But on May 24, 1883, all that wire, stone, steel, and wood, so long shuffled in random piles, had at last been cunningly woven into a soaring arch. There were multitudes in attendence, even the President of the United States. With the setting of the sun and a new round of activities programmed for the evening, thousands of rocket flares splashed the sky. The Brooklyn Bridge—all one thousand five hundred ninety-five feet of it—was opened to traffic.

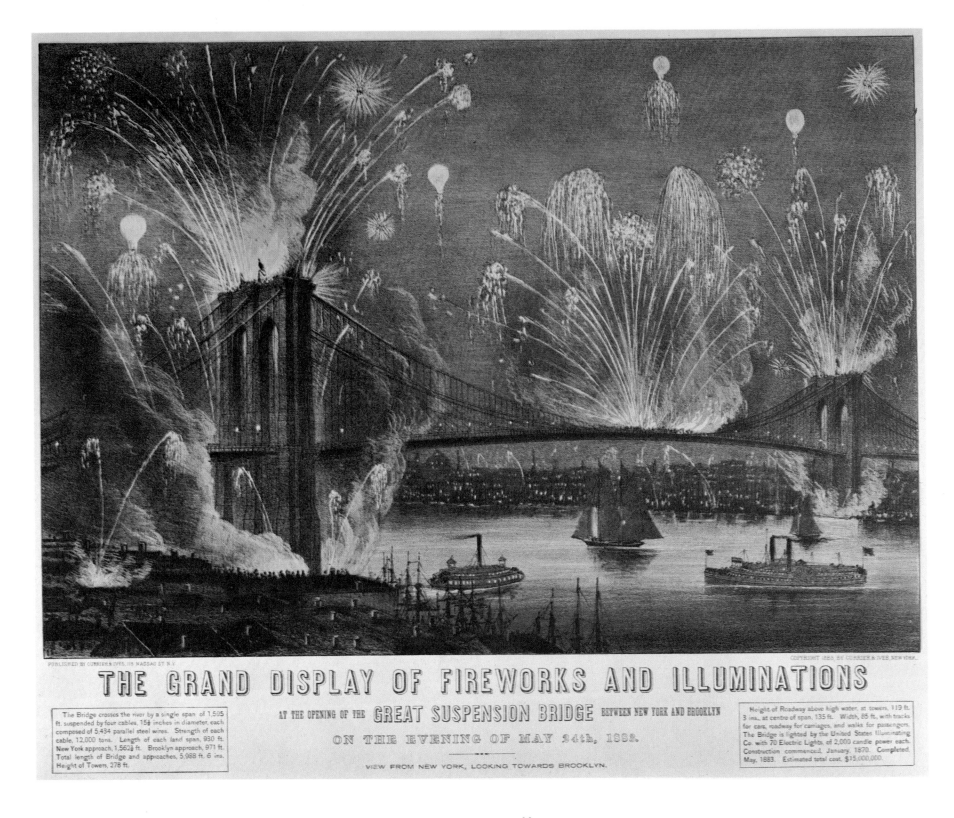

THE GRAND DISPLAY OF FIREWORKS AND ILLUMINATIONS AT THE OPENING OF THE GREAT SUSPENSION BRIDGE BETWEEN NEW YORK AND BROOKLYN ON THE EVENING OF MAY 24TH, 1883. . . . PUBLISHED BY CURRIER & IVES, 115 NASSAU ST. N. Y. COPY-RIGHT 1883. . . .

Lithograph. 1883. Size: 12.0 × 17.8 inches; 305 × 445 mm. Prints Division, The New York Public Library.

References

Bibliographical references for the quotations used in the essays accompanying the illustrations of the prints and drawings

Page 18

1. Giovanni Battista Ramusio, *Terzo volume delle navigationi et viaggi . . .* (Venice, 1556), pp. 420–22.

2. Theodor de Bry, *Brevis Narratio Eorum Quae in Florida . . . Gallis Acciderunt . . .* (Frankfurt, 1591); *Narrative of Le Moyne, an Artist Who Accompanied the French Expedition to Florida under Laudonnière, 1564,* tr. from the Latin of de Bry (Boston, 1875), pp. 3–4.

Page 22

3. Thomas W. Griffith, *Sketches of the Early History of Maryland* (Baltimore, 1821), p. 32.

4. *The Baltimore Weekly Magazine,* April 26, 1800.

Page 24

5. John Cosens Ogden, *An Excursion into Bethlehem & Nazareth, in Pennsylvania, in the Year 1799* (Philadelphia, 1800), p. 84.

Page 26

6. Henry Pelham, letter to Paul Revere, Boston, March 29, 1770, in *Letters & Papers of John Singleton Copley and Henry Pelham, 1739–1776* ([Boston] Massachusetts Historical Society, 1914), p. 83.

Page 28

7. George Washington, "General Orders," Headquarters, New York, July 10, 1776, in *The Writings of George Washington from the Original Manuscript Sources . . .* ed. John C. Fitzpatrick, 39 vols. (Washington: U.S. Govt. Printing Office, 1931–44), v: 246.

Page 30

8. *The Iconography of Manhattan Island, 1498–1909,* ed. I. N. Phelps Stokes, 6 vols. (New York: Robert H. Dodd, 1909; rpt. New York: Arno Press, 1967), v: 1001.

Page 32

9. General Nathanael Greene, letter to Henry Knox, Fort Lee, November [17], 1776, in Francis Samuel Drake, *Life and Correspondence of Henry Knox* (Boston, 1873), p. 34.

Page 34

10. Sir William Howe, report to Lord George Germain, September 23, 1776, in *Iconography,* ed. Stokes, v: 1022.

Page 36

11. Eliza S. M. Quincy, *Memoir of the Life of Eliza S. M. Quincy* (Boston, 1861), p. 51.

Page 38

12. "Autobiography of William Russell Birch," typewritten copy in the Manuscripts and Archives Division of original unpublished manuscript in a private collection, p. 23; quoted from W. M. Hornor, Jr., "William Russell Birch, Versatile Craftsman," *The Antiquarian* 14 (February 1930): 76.

13. William Birch & Son, *The City of Philadelphia, in the State of Pennsylvania, North America; as It Appeared in the Year 1800 . . .* ([Philadelphia], 1800).

14. Hornor, "William Russell Birch," p. 78.

Page 42

15. John Bernard, *Retrospections of America, 1797–1811* (New York, 1887); quoted in *America through British Eyes,* ed. Allan Nevins (New York: Oxford University Press, 1948), p. 25.

16. George Washington, address to Congress resigning his commission [Annapolis, December 23, 1783], in *Writings,* ed. Fitzpatrick, xxvii: 285.

Page 44

17. Gorham A. Worth, *Random Recollections of Albany, from 1800 to 1808, with Some Additional Matter* (Albany, 1850), pp. 4–5.

Page 46

18. Herman Melville, *Moby-Dick; or, The Whale* (New York, 1851), pp. 35–36.

Page 48

19. Jean Guillaume, Baron Hyde de Neuville, *Mémoires et souvenirs du Baron Hyde de Neuville,* 3 vols. (Paris, 1890–92), 1: 457.

Page 50

20. Henry Clay, *The Life and Speeches of the Hon. Henry Clay,* ed. Daniel Mallory, 2 vols. (New York, 1857), 1: 304–305.

Page 52

21. Jacques-Gérard Milbert, *Itinéraire pittoresque du fleuve Hudson . . . ,* 3 vols. (Paris, 1828–29), 1: 43.

22. Alice Crary Sutcliffe, *Robert Fulton and the "Clermont,"* (New York: Century Co., 1909), pp. 202–203.

Page 54

23. Philip Hone, *The Diary of Philip Hone, 1828–1851,* ed. Allan Nevins, 2 vols. (New York: Dodd, Mead, 1927), 1: 324.

24. James Silk Buckingham, *America, Historical, Statistic, Descriptive,* 3 vols. (London, 1841), 1: 54.

Page 58

25. *Iconography,* ed. Stokes, v: 1256.

Page 62

26. William Wirt, *The Letters of the British Spy* (Richmond, 1805), pp. 10–11.

27. Edgar Allan Poe, letter to F. W. Thomas, Baltimore, June 1841, in *The Complete Works of Edgar Allan Poe*, ed. James A. Harrison, 17 vols. (New York: G. D. Sproul, 1902), XVII: 91.

Page 66

28. Milbert, *Itinéraire pittoresque*, I: 99.

29. *Iconography*, ed. Stokes, IV: 342.

Page 68

30. Buckingham, *America*, I: 49–50.

Page 70

31. Daniel Denton, *A Brief Description of New-York: Formerly Called New-Netherlands* (London, 1670), pp. 3–4.

32. Walt Whitman, *Walt Whitman's New York*, ed. Henry M. Christman (New York: Macmillan, 1963), p. 56.

Page 72

33. *The City of Detroit, Michigan, 1701–1922*, ed. Clarence M. Burton, 2 vols. (Detroit: S. J. Clarke Publishing Co., 1922), I: 305.

Page 74

34. James Bennett Nolan, *Neddie Burd's Reading Letters* (Reading: Berks County Bar Association, 1927), pp. 71–72; the complete letter of "15th Apl 1776," which is copyright 1927 J. Bennett Nolan, is reprinted with the permission of the publisher.

35. Nolan, *George Washington and the Town of Reading in Pennsylvania* (Reading: Chamber of Commerce of Reading, 1931), p. 136.

Page 76

36. Frances Trollope, *Domestic Manners of the Americans* (London, 1832), pp. 54, 55–56.

Page 80

37. Charles Dickens, *American Notes for General Circulation* (Philadelphia, 1874), pp. 29, 30, 71.

Page 82

38. *The Presidents Speak*, annotated by Davis Newton Lott (New York: Holt, Rinehart & Winston, 1969), p. 73.

Page 86

39. Louis Hennepin, *A New Discovery of a Vast Country in America* (London, 1698), pp. 29–30.

40. Isaac Weld, Jr., *Travel Through the States of North America*, 2 vols. (London, 1799), II: 134.

Page 90

41. Abraham Ortelius, *Theatrum Orbis Terrarum* [Antwerp, 1595].

42. John Augustus Sutter, *The Diary of Johann August Sutter*, intro. by Douglas S. Watson (San Francisco: Grabhorn Press, 1932), pp. 43–45.

43. San Francisco *Daily Herald*, December 21, 1850.

Page 94

44. Louis Narcisse Baudry des Lozières, *Voyage à la Louisiane . . .* (Paris, 1802), p. 15.

45. Trollope, *Domestic Manners*, p. 25.

46. *An Account of Louisiana, Laid before Congress by Direction of the President of the United States, November 14, 1803 . . .* (Providence, 1803), pp. 26–27.

Page 96

47. Sacramento *Steamer Union*, August 15, 1854.

48. Josiah Royce, *California . . .: A Study of American Character* (New York, 1886), p. 277, 2.

Page 102

49. William Makepeace Thackeray, *The Letters and Private Papers of William Makepeace Thackeray*, ed. Gordon N. Ray, 4 vols. (Cambridge: Harvard University Press, 1946), III: 261.

Page 104

50. Henry Bradshaw Fearon, *Sketches of America* (London, 1818), p. 9.

Page 108

51. William Lambeth and Warren Manning, *Thomas Jefferson as an Architect and a Designer of Landscapes* (Boston: Houghton Mifflin Co., 1913), pp. 4–5.

52. Ada Louise Huxtable, *New York Times* (March 9, 1975).

Page 110

53. Basil Hall, *Travels in North America*, 2 vols. (Philadelphia, 1829), I: 14.

Page 112

54. Frederick Milnes Edge, *Major-General McClellan and the Campaign on the Yorktown Peninsula* (London, 1864), p. 31.

Page 114

55. Daniel Webster, speech, in U.S. Senate, 1838; quoted in Nolie Mumey, *History of the Early Settlements of Denver (1599–1860)* (Glendale: Arthur H. Clark Co., 1942), p. 22.

56. Albert D. Richardson, *Beyond the Mississippi* (Hartford, 1867), pp. 186–87.

Page 116

57. "Ol' Man River," by Jerome Kern and Oscar Hammerstein II Copyright © 1927 T. B. Harms Company. (Copyright renewed.) Used by permission.

58. Mark Twain, *Life on the Mississippi* (Hartford, 1901), p. 15.

Page 118

59. Samuel Pepys, *The Diary of Samuel Pepys*, ed. Henry B. Wheatley, 8 vols. (London, 1895; rpt. New York: AMS Press, 1968), V: 421.

Page 120

60. Helen Hunt Jackson, *My Day in the Wilderness* (San Francisco: Book Club of California, 1939), pp. 1, 4, 12.

Page 122

61. *The National Centennial Bulletin of America 1776–1876* (Washington, 1876), p. 2.

Page 126

62. Anthony Trollope, *A Letter from Anthony Trollope Describing a Visit to California in 1875* (San Francisco: Colt Press, 1946), p. 5.

63. Benjamin E. Lloyd, *Lights and Shades of San Francisco* (San Francisco, 1876), p. 372.

Page 128

64. *Iconography*, ed. Stokes, I: 245–46.

Index to Places, Artists, and Engravers